Canon®
Speedlite System

Digital Field Guide

2nd Edition

Brian McLernon

WILEY

Wiley Publishing, Inc.

Canon® Speedlite System Digital Field Guide, 2nd Edition

Published by
Wiley Publishing, Inc.
10475 Crosspoint Boulevard
Indianapolis, IN 46256
www.wiley.com

Copyright © 2010 by Wiley Publishing, Inc., Indianapolis, Indiana

Published simultaneously in Canada

ISBN: 978-0-470-56065-5

Manufactured in the United States of America

10 9 8 7 6 5 4 3 2 1

WILEY

About the Author

Brian McLernon is a commercial studio and location photographer, educator, and writer based in Portland, Oregon. Originally from New Jersey, he shoots primarily for editorial, commercial, corporate, and lifestyle clients, and his work includes shooting locations, portraits, products, travel, public relations events, weddings, high school seniors, artwork, sports, special events, and more; this work offers him the chance to capture moments and tell visual stories.

To share his passion for photography, Brian conducts workshops in photography and lighting for the Portland Community Colleges adult education series. He is often a guest speaker for several artistic associations, communication groups, and business organizations, and enjoys speaking to student groups as well. When he's not photographing in the studio or on location, Brian spends time with his wife and daughter, family and friends, camping, travelling, white-water rafting, doing winter sports, and of course, photographing nature and all kinds of motorsports.

This is his second book for Wiley Publishing.

Credits

Senior Acquisitions Editor
Stephanie McComb

Project Editor
Jama Carter

Technical Editor
Michael Guncheon

Copy Editor
Marylouise Wiack

Editorial Director
Robyn Siesky

Editorial Manager
Cricket Krengel

Business Manager
Amy Knies

Senior Marketing Manager
Sandy Smith

Vice President and Executive Group Publisher
Richard Swadley

Vice President and Executive Publisher
Barry Pruett

Project Coordinator
Patrick Redmond

Graphics and Production Specialists
Ana Carrillo
Andrea Hornberger
Jennifer Mayberry

Quality Control Technician
Lauren Mandelbaum

Proofreading and Indexing
Cindy Lee Ballew / Precisely Write
Christine Karpeles

To Gayle and Brenna, who continually show me the light.

Acknowledgments

Although only one name appears on the cover of this book, a project like this brings an entire team of people together in seemingly unrelated ways that all contribute to the creation of this *Digital Field Guide*. We live in an age of community today, and I would be remiss if I didn't mention mine — these wonderful folks who inspired me or answered my calls, spending hours discussing technical details or volunteering time and equipment to help me create this book.

To Dean Collins, the master of lighting and Photoshop guru who showed me that photography is all about the light, not the gear. His knowledge of how to manipulate light and his entertaining teaching style have made a lasting impression on me. Though Dean is no longer with us, I am forever in his debt.

To photographer Rick Becker, of Becker Studios in New York City, who opened up his Pandora's box of lighting techniques and shared with me the secrets of studio lighting.

To Bob and Shirley Hunsicker of Pharos Studios, my early mentors in studio photography and business, whose guidance and friendship contributed immeasurably to my photographic career.

To Michael Paul Wyman of Pro Photo Supply, my local pro camera shop, who single-handedly allowed me access to all the gear and technical data of the Canon Speedlite System that I needed to create this book.

To photographers David Hobby, Joe McNally, Syl Arena, and John Harrington, who share their lighting and business expertise through blogs and Web sites in their selfless desire to see all photographers succeed. I am indebted to them for sharing their experiences and setting examples that guide me in all phases of my work.

To Mark Fitzgerald of the Digital Darkroom, my local Photoshop guru, who was never too busy to respond to my calls and e-mails with answers to my questions, and for providing his invaluable insight into the book-writing process.

To videographer, photographer, and friend John Waller, who scales the highest peaks and rides the deepest rapids in search of *the* shot, for allowing me to babysit some of his equipment for extended periods of time, thus contributing immeasurably to the creation of this field guide.

To my many friends in the Portland photographic community, but especially to photographers David Lutz, Barbara Hill, Roland Simmons, Cyndie Planck, and video producers Vernon Vinciguerra and Lyle Morgan, who contributed assistance and camaraderie, and even posed for some of the example portraits in this book. Even though I had my *list*, your passion for my project came through in your ideas, suggestions, changes to

the lighting setups, and endless critiques of the images we made. You guys made this book better than it should have been and for that, you truly rock!

To Reba Akin, Rebecca Perry, Mimi the clown, Tessa Duncan, Damien and Isabelle Wiggins, Sander Raymond, and Jacqueline Joseph for graciously giving their time and patience and for allowing me to photograph them for this book under all sorts of difficult and interesting (windy) lighting configurations, and still managing to remain upbeat about it! You gave life and looks to lighting concepts that I knew in my head but needed to define and articulate, and your enthusiasm for the sessions was encouraging and very much appreciated.

To Stephanie McComb, my Acquisitions Editor, for her excellent bedside manner, hand-holding, and gentle yet firm adherence to the deadlines. She kept me on track, organized the many details involved in producing this field guide, and was always quick to reply to my many questions.

To Jama Carter, my Project Editor, for her attention to every detail of this book, including her advice on image selection, captions, tables, and sentence structure. Her contributions never failed to make this book better.

To Courtney Allen, my first contact at Wiley, for bringing me into the Wiley fold, taking me under her wing, and providing lasting friendship and encouragement — may you rock to the metal always.

To my fine editing team at Wiley Publishing for their marketing insight, skillful editing, and continuous support and encouragement.

Finally, to my wife Gayle and daughter Brenna, who allowed me to disappear into my studio cave to shoot and write and make my deadlines, all the while providing those smiles, hugs, support, and laughter that life is all about!

Contents

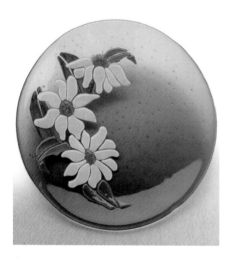

CHAPTER 3
Flash Photography Basics **51**

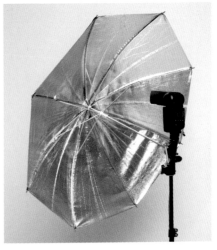

CHAPTER 4
Wireless Flash Photography with the Speedlite System 87

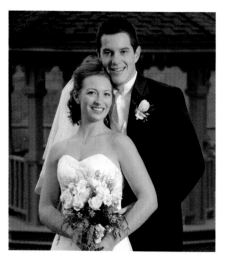

CHAPTER 5
Setting Up a Wireless Studio 107

CHAPTER 6
Everyday Applications of Your
Speedlites 131

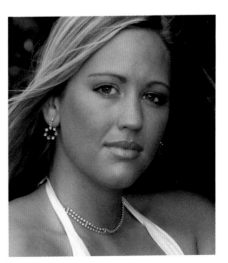

APPENDIX A
Posing Basics **183**

APPENDIX B
Rules of Composition 199

APPENDIX C
Resources 213

APPENDIX D
How to Use the Gray Card and
Color Checker 217

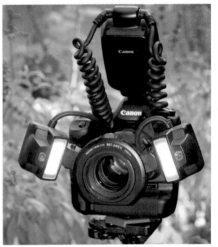

Glossary 219

Index 227

Introduction

Welcome to the new Wiley *Digital Field Guide* for the Canon Speedlite System. Whether you are holding this book or your new Canon Speedlite in your hands, you are holding a fantastic tool that will assist you in creating awesome photographs that you will be proud to display and share with your family and friends. Much has changed in the technology of flash equipment in recent years, and this book aims to provide you with a solid basis for understanding the Speedlite System, the nuances of lighting, and camera flash terminology.

With the Canon Speedlite System, you can literally just point and shoot! A Canon Speedlite is able to do the complex exposure calculations for you, balancing the flash exposure with the ambient lighting and allowing for a more natural look to your images.

Learning how to properly use Speedlites is only the beginning to creating great flash photographs. You will also learn about the subtleties of lighting and light modifiers, and when, how, and why you should use them. I will also cover light placement and styles of lighting for different and creative effects. This book will take you beyond the everyday use of flash equipment and start you on the path to creating truly dazzling images.

Short History of Canon's Speedlite System

The first Canon Speedlite that offered any type of automatic flash was the 300TL, introduced in 1986, which employed the TTL (Through-the-Lens) metering system and was designed to be used with the Canon T90 film camera.

Essentially, how the process of standard TTL auto flash worked was that a sensor in the camera measured the light reflected off of the film plane. When the sensor determined there was enough light to sufficiently expose a neutral subject, the flash

automatically cut off. Although TTL was better than manually setting the flash, it did not always produce great results. Canon set out to improve this when it introduced A-TTL (Advanced Through-the-Lens).

The A-TTL auto flash system, first seen on the Canon T90 camera, was a great improvement, considering that before this, all calculations had to be done by hand: measuring the distance from the flash to the subject, figuring out the Guide Number of the flash power, and deciding how much power to use for the selected aperture that was required for the image.

A-TTL was Canon's advancement on standard TTL auto flash. Available with the EZ-model Speedlites, A-TTL fired a preflash before the actual exposure while the camera was metering, thus determining the proper flash exposure while retaining readings for the ambient light. The camera then used both of these readings to provide a natural-looking picture by using the ambient light for the main exposure and light from the Speedlite as a fill-flash. This was known in Canon's nomenclature as "auto-fill reduction." When the camera meter determined that there was not enough ambient light for proper exposure, the flash was then used as the main light for the subject's exposure.

Although A-TTL seemed like a good thing, it had a few hurdles that it could not surmount. Some of these included using a sensor on the flash to determine the light output instead of using a sensor in the camera, and having the preflash fire when the Shutter button was half-pressed. It also wasn't very useful when attempting to employ bounced flash techniques.

In 1995, Canon introduced E-TTL or Evaluative Through-the-Lens flash metering. The advancement on A-TTL was that E-TTL fired a low-power preflash immediately before the shutter opened, rather than when the Shutter button was half-pressed.

Canon's E-TTL metering system also improved on A-TTL by providing a more subtle and natural-looking fill flash when used in a daylight situation. It did this by partly basing the exposure on the autofocus point that was locked onto the subject rather than using an average of the light from multiple zones, as it had done in the past.

In 2004, with the advent of the EOS 1D Mark II, Canon introduced the E-TTL II metering system. This is very similar to the original E-TTL with a couple of improvements. One improvement Canon made is in the way E-TTL II meters the scene. With E-TTL II, the camera takes a reading of the scene both before and after the preflash fires to help reduce false readings that can be caused by small, reflective substances in the scene. A second improvement was adding the capacity to use distance information supplied by the camera's lens to help obtain the correct flash exposure.

What You'll Learn from This Book

While this book strives to be a great resource for learning about the Canon Speedlite System, there are a few things it is not. It is not meant to be the definitive Bible of all things Speedlite. Rather, it is a digital field guide, small enough to fit conveniently in your camera bag, that helps you to understand the technical data and offers up creative ideas to make your flash photographs pop.

This book offers you a solid foundation of flash lighting theory, along with tips, tricks, and advice based on the real-world experiences of a working commercial photographer who has been using small flash lighting for many years. I am excited to be a part of your journey, a tour guide if you will, on your path to producing fantastic flash-lit images with the Canon Speedlite System.

Quick Tour

For many photographers, their first experience with electronic flash comes with the small pop-up version that came with their cameras. These built-in flashes are great for introducing photographers to the concept of fill-in flash. They can also be effective for creating catch lights in the subject's eyes and for brightening up small, shadowy areas.

However, their small size and close proximity to the lens axis can cause overexposure to physically close subjects and harsh shadows when used as the main or key light source. After dealing with these limitations and the resulting poorly lit pictures, photographers are ready to step up to external flash units such as the models offered by the Canon Speedlite System.

This section gets you up to speed quickly, introduces you to some of the Speedlite

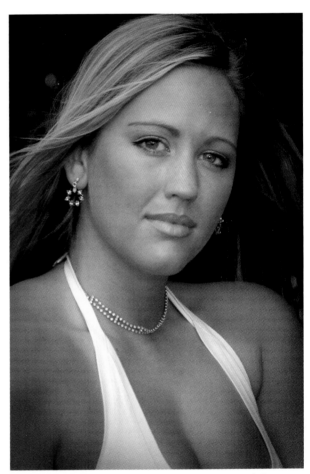

Model Erin Mulligan photographed for her portfolio using a 580EX II Speedlite mounted on camera. Exposure: ISO 400, f/8, 1/50 second with an EF 70-200mm f/2.8L USM lens.

features, and encourages you to get out there and give your new flash a test drive.

Getting Up and Running Quickly

As with any new piece of photography gear, you'll want to start using your new Canon Speedlites right away, so let's get started. All you really need to do is insert some batteries, attach the Speedlite to your camera's hot shoe, and then turn both the Speedlite and the camera on. You'll be truly amazed at the quality of flash photos you can take with the Speedlite as soon as you start using it.

NOTE The Speedlites accept alkaline, lithium, or NiMH rechargeable AA-sized batteries.

To attach the Speedlite to your camera:

1. **Turn the camera and Speedlite off before connecting.** This is a good habit to get into before connecting any type of electronic equipment together.

2. **On the Speedlite, press the Lock release button in, and turn the mounting foot's locking lever to the left to the unlock position.**

3. **Slide the Speedlite hot shoe into the camera's hot shoe, and turn the Speedlite mounting foot's locking lever to the right until it clicks to lock the Speedlite into place.**

4. **Place the flash head in the normal horizontal position.** You'll be repositioning the flash head differently later on, but for now, leave it in the normal position. You reposition the flash head by pressing the flash head tilting/rotating lock release, and then moving the flash head up or down to the desired angle.

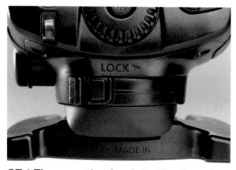

QT.1 The mounting foot's locking lever in the unlock position

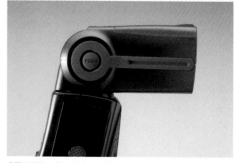

QT.2 The flash head in the normal horizontal position. Normal is the first click up from the down position.

 When using the 580EX II, if the flash head is not in the normal, horizontal position, the flash's LCD panel shows a blinking flash head icon to warn you that it's not in the normal position.

5. **Turn on your camera.**

6. **Turn on your Speedlite.** The On/Off switch for the Speedlite is located on the back panel.

7. **Check that the flash is ready.** The pilot lamp first glows green and then red when the flash is fully charged and ready.

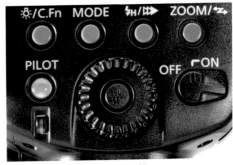

QT.3 The back of the 580EX Speedlite

After you power up your Speedlite and camera with the flash head in the horizontal position, the flash and camera communicate with each other and E-TTL is possible.

That's all there is to it. You're now ready to start your journey of learning to light with the amazing power and flexibility of external Speedlites.

Taking Your First Photos with the Speedlite

After you get your flash attached and turned on, the flash sets itself to E-TTL or E-TTL II mode by default. The camera body determines this and will use either E-TTL or E-TTL II. This is a firmware/hardware configuration issue and is not user-selectable.

E-TTL stands for Evaluative Through-the-Lens, which means that the light meter in the camera takes a reading through the lens and decides how much flash exposure you need, depending on your camera settings.

The primary difference between E-TTL and E-TTL II is that E-TTL is strongly biased toward the focus point and evaluates the flash exposure primarily at that focus point. E-TTL II does not have this high focus-point biasing, and the flash exposure is calculated using more of an evaluative metering pattern.

Depending on which of the following metering patterns your camera is set to, the flash will either add fill flash or expose for the subject only:

▶ If your camera meter is set to evaluative metering, which means the light meter is taking a reading of the whole scene, then the camera adjusts the flash exposure to match the ambient light, adding fill flash to create a more natural look.

▶ If your camera is set to spot meter the scene, the flash sets E-TTL II mode. The camera's meter takes a reading of the subject and exposes just for that, not taking into account any of the background light.

I recommend setting your camera to evaluative metering mode and using the E-TTL II mode when you are just getting started. When set to evaluative metering, the camera measures the light intensity in several points in the scene and then combines the results to find the settings for the best exposure.

 When starting out, I recommend also trying your flash outside with sunlight. This is where E-TTL fill flash excels. The Speedlite fills in the harsh shadows created by the bright sun.

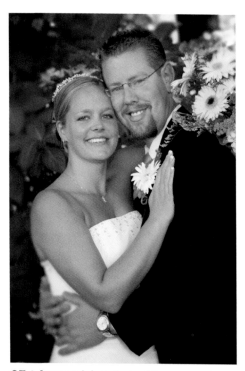

QT.4 **Amy and Joe shot with on-camera flash E-TTL II with evaluative metering. Exposure: ISO 800, f/6.3, 1/125 second with an EF 70-200mm f/2.8L USM lens.**

The use of controlled lighting in photography can be overwhelming at first, but Speedlites make the endeavor easy and fun. The camera/flash combination makes all of the adjustments for exposure for you and automatically adjusts the flash head zoom to match your lens. The flash head zoom is a feature of the Speedlite that adjusts the flash tube location to match the focal length of the lens you're using.

Don't be concerned if you don't completely understand how E-TTL or E-TTL II flash works or why the flash head zoom is important — I'll get to all that with examples as you read through this book. In the meantime, this Quick

Tour is intended to introduce you to flash photography concepts and terminology, and get you comfortable with using your new flash equipment.

The best way to get comfortable is just go out and start taking pictures. Set your camera to Program (Program AE), Aperture-priority (Av), or Shutter-priority (Tv), and let the Speedlite and camera combination make the settings for you. This is the easiest way to begin and frees you up to learn about your flash.

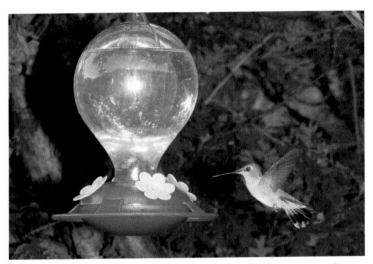

QT.5 A quick snapshot of a hummingbird in midflight at one of our feeders. Exposure: ISO 640, f/11, 1/100 second with an EF 70-200mm f/2.8L USM lens.

I find many people try to cover too much ground too quickly when learning about photography and lighting. Try to avoid this approach when just starting out. The fewer camera settings you have to worry about, the more you can focus on the lighting patterns and quality.

Look for simple subjects that you would normally photograph, but this time use your Speedlite. They can be anything close by, such as your immediate surroundings, loved ones, or pets. Get a feel for how the camera and flash system work together, and pay attention to how the flash illuminates subjects and fills and creates shadows.

People you know may be an easy source of subject matter to try lighting in different locations. Other photographers who want to learn about flash could also be good subjects and may even take flash photos of you. Many photographers in my town do just that, getting together once a month to practice using their lighting equipment and skills on each other.

Your first attempts at using flash may not produce the results you're looking for. Keep shooting and watch what the light does. Don't get too hung up on all the details, settings, and so on just yet. Digital photography makes it easy to experiment, and the learning curve is considerably shortened by the ability to immediately review your images on the camera's LCD.

In the coming chapters, you learn about the quality of light and ways to shape it. As you become more comfortable with your Speedlite, start noticing how flash-to-subject, flash-to-background, and subject-to-background relationships all play a part in the whole image. Make little diagrams in a notebook of some of your better shots to refer to later. Some photographers carry a mini cassette or digital recorder in their breast pocket and describe the situation audibly for later review. Remember, it's all about learning and opening yourself up to seeing light in a new way.

QT.6 An outdoor portrait of motivational speaker Jani Ashton. Notice the pleasing catchlights in the eyes and a small amount of surface shine on her face because of the on-camera Speedlite. Exposure: ISO 400, f/8, 1/100 second with an EF 24-70mm f/2.8L USM lens.

QT.7 Anya's senior portrait in my outdoor studio. The shadow under her chin, while not too distracting, gives away the use of flash. Exposure: ISO 640, f/5.6, 1/60 second with an EF 70-200mm f/2.8L USM lens.

Exploring the 580EX II and 430EX II Speedlites

The 580EX II and 430EX II are the flagships of the Canon Speedlite System, and in conjunction with E-TTL II and some simple lighting modifiers, they can create some extraordinary light in challenging situations. A revolution of small-flash lighting techniques has captured photographers who were used to carrying around all sorts of heavy studio lighting gear, and who now have the ability to carry a small studio arsenal in one bag. Set aside for a moment what you've previously thought about flash photography because it's a whole new world out there.

This chapter gets you acquainted with the main features and functions of the two major flash units of the Canon Speedlite System: the 580EX II and the 430EX II. I also cover all the features and functions of the other parts of the Canon Speedlite

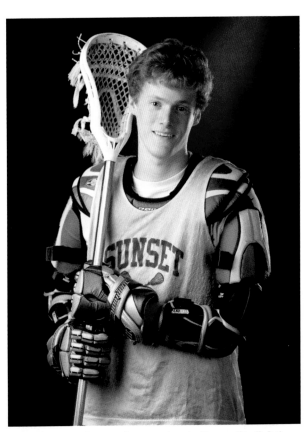

Speedlites can be used to create studio-quality lighting, as in this portrait of high school lacrosse player Greg Stearns. Three Speedlites were used in this photo: one with a purple gel for the background, one undiffused for the edge light at camera-right, and one for the main, fired through a white translucent umbrella, at camera-left. Exposure: ISO 100, f/5, 1/200 second with an EF 70-200mm f/2.8L USM lens.

System, including the ST-E2 wireless transmitter, along with an overview of a smaller entry-level Speedlite and the two macro Speedlite options.

Features of the Canon Speedlite System

The main components of the Canon Speedlite System are any Canon dSLR camera and the feature-rich 580EX II and 430EX II Speedlites, which replace the 580EX and 430EX respectively in Canon's lineup. Additional components include the OC-E3 Off-Camera Shoe Cord 3, the Speedlite Transmitter ST-E2, the Macro Twin Lite MT-24EX, the MR-14EX ring-lite, and the new 270EX Speedlite, which replaces the 220EX flash. All Canon EOS dSLRs can be used with the Canon Speedlite System.

In this section, let's look at some of the cool features that are available with the Canon Speedlite System.

▶ **E-TTL II.** Canon's most advanced flash metering system uses preflashes and flash metering algorithms to determine the proper flash exposure. The E-TTL II system reads information from all metering zones before and after the preflash. Areas with little change in brightness are then weighted for flash metering. This is done to prevent a highly reflective surface or overly bright area from creating a false reading, thereby causing underexposure. When using certain EF lenses, distance information is also reported back to the flash and entered into the algorithm.

▶ **Flash Exposure Lock (FEL).** FEL enables you to pop the flash to meter the subject, get a reading for the proper flash exposure, and lock in that information. Pressing the FEL button enables you to meter the subject via a test flash and then recompose the shot while maintaining the proper flash exposure for that subject.

 Some Canon camera bodies have a separate FEL button, while others have buttons that can be assigned to the FEL function.

▶ **Wireless lighting.** This feature allows you to use your Speedlites wirelessly. When using wireless lighting, you need to have either a 580EX II, either of the Macro Speedlites or an ST-E2 wireless transmitter set as a master unit. A master unit fires a preflash, which then transmits information back and forth between the camera and the flash. The master unit can control multiple Speedlites wirelessly, allowing for more creative lighting setups.

▶ **High-speed sync.** This feature allows you to use your flash at higher shutter sync speeds than your camera body is rated for. This setting is often used to freeze action or when you want to shoot outdoor images that require a wide aperture and higher shutter speed.

▶ **AF-assist beam.** The 580EX II and 430EX II have a built-in, red LED that projects a gridded light pattern onto the subject to aid the camera's autofocus (AF) system in very dark or low-contrast situations. This beam typically offers coverage for up to a specific number of AF points.

▶ **Flash color information communication.** As flash duration becomes longer, the color temperature changes slightly. The Canon Speedlites transmit this change to the camera body, ensuring a more accurate white balance.

580EX II

The flagship of the Speedlite lineup, the 580EX II debuted in May 2007 and has many improvements over its predecessor, the 580EX; it also includes many features that offer a great deal of versatility. These upgrades include a 20-percent-faster recycle time, metal mounting foot, mounting lock lever, power switch design, receive-only external PC terminal, and dust- and water-resistant seals (a blessing for sports and photojournalism photographers). This is Canon's first weather-resistant flash.

580EX II specifications and features

This section provides a brief look at different features that are available on the 580EX II Speedlite.

▶ **Guide number (GN).** A flash unit's guide number is used to determine the proper exposure when shooting manual flash without a flash meter. With today's advanced flash systems, guide numbers are most often used to compare power output between flashes. Guide numbers are usually given for both feet and meters so be sure you use the right one in your calculations. The guide number varies with the zoom settings, from GN 28/92 (meters/feet) at 24mm to GN 58/190 (meters/feet) at 105mm. See your owner's manual for more information on GNs for specific zoom ranges.

▶ **Automatic zooming flash head.** This provides lens coverage from 24mm to 105mm. It supports up to 14mm coverage with the built-in wide-angle lens panel.

▶ **E-TTL.** The 580EX II supports E-TTL II, E-TTL, and TTL, along with full manual flash output operation.

▶ **Wireless lighting.** You can control up to three different groups of Speedlites in E-TTL II or Manual mode.

Understanding the Guide Number

Although the actual power of the flash is fixed, the guide number (GN) of the flash changes with the ISO setting of the camera and also varies with the zoom setting of the flash. This is due to the increased sensitivity of the sensor and the actual dispersion of the light when set to a specific zoom range. When the ISO is at a higher setting, the sensor is more sensitive to light, in effect making the flash more powerful, hence a higher GN.

Also, when the zoom is set to a wide angle, the flash tube is positioned farther back in the flash head, spreading the light and giving it wider coverage. This makes the flash somewhat less bright, thereby warranting a lower GN.

Remember that the guide number is exactly that — a guide. In reality, it is nothing more than a number assigned by the manufacturer to assist you in obtaining the correct exposure (and also a means of comparing light output among different Speedlites). Refer to your owner's manual for a table with the GN of the Speedlite at specific zoom ranges.

▶ **Second-curtain sync.** This function fires the flash at the end of the exposure, as opposed to the beginning of the exposure. This helps you capture more natural images when shooting long exposures, as it causes a trail to appear behind a moving subject and not in front of it, which occurs when the flash is fired at the beginning of the exposure.

▶ **AF-assist beam.** The 580EX II emits a grid of light from a red LED to assist in focusing in low-light situations.

▶ **High-speed sync (FP flash).** This function allows you to shoot with a shutter speed higher than the rated sync speed of the camera. This feature is useful when shooting portraits in bright light using a wide aperture with fast shutter speeds.

▶ **Flash Exposure Lock (FEL).** You can use this feature to get a reading from your subject and then recompose the shot while retaining the original exposure.

▶ **Flash Exposure Compensation.** Similar to the way exposure compensation is set on the camera, this function allows you to adjust the light output up or down in 1/3-stop increments over a +/– 3-stop range and still enjoy all the benefits of E-TTL II flash metering.

▶ **Modeling flash.** The 580EX II fires a short burst of flashes, allowing you to see what the light falling on your subject will look like.

▶ **Multi-Stroboscopic Flash mode.** The 580EX II fires a user-specified number of flashes per second, similar to a strobe light, for creative effect.

▶ **Tilting/rotating flash head for bouncing flash.** This allows you to tilt the flash head up to bounce light from the ceiling, or to the side to bounce light off of a wall. The 580EX II also allows you to tilt the flash head downward −7 degrees for close-up subjects.

▶ **Wide panel.** A pull-out wide panel is included to extend flash output to 14mm lens coverage. This is a huge plus when doing group photography in tight quarters or using a wide-angle lens for flash work.

▶ **Catchlight panel.** Just above the wide panel is a retractable white catchlight panel that allows you to create catchlights in your subjects eyes that add sparkle and vitality to the portrait.

▶ **PC terminal.** Included for the first time is a receive-only PC terminal for triggering the Speedlite with radio frequency remotes like PocketWizards or optical slave attachments.

▶ **External power supply socket.** For faster recycling times and longer flash shooting sessions, an external power supply socket is provided for the Canon CP-E4 Compact Battery Pack or third-party power supplies such as those marketed by Quantum and Digital Camera Battery.

▶ **External Speedlite control.** The latest Canon cameras include a menu option that allows you to set some or all of your Speedlites controls directly from the camera depending on the model of Speedlite. The benefit of this is that the camera's External Speedlite control menu provides more detail for the settings than the Speedlite's LCD.

Main components

The 580EX II Speedlite is an awesome tool for creating beautiful lighting and will start you on your way to "making" pictures instead of "taking" them. This is all the more reason why this flash can at first seem a little daunting to understand. I'll begin by going over all the buttons and controls and describing what each one does. I'll get to the "why" in later chapters.

▶ **Flash head/Wireless transmitter.** This is where the flashtube is housed. Inside is a mechanism that zooms the flashbulb forward and back to provide flash coverage for lenses of different focal lengths. The flash head is adjustable; it can be tilted upward to a full 90 degrees and downward to −7 degrees. It can also be adjusted horizontally 180 degrees to the left or to the right.

▶ **Bounce Lock Release button.** This button releases the flash-head lock, allow-ing you to adjust the angle of the flash head for bounce flash.

▶ **Battery compartment cover.** This cover is a vast improvement over the old 580EX. You slide the center button left and then downward to open the spring-loaded battery compartment to load or change the batteries.

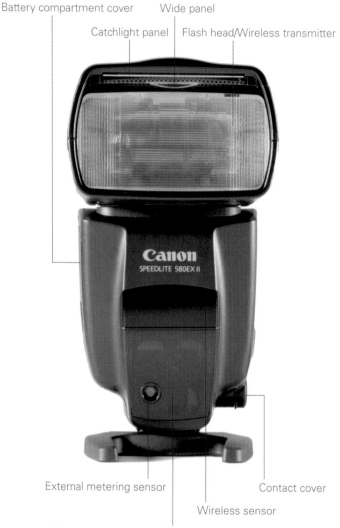

1.1 The front of the 580EX II Speedlite

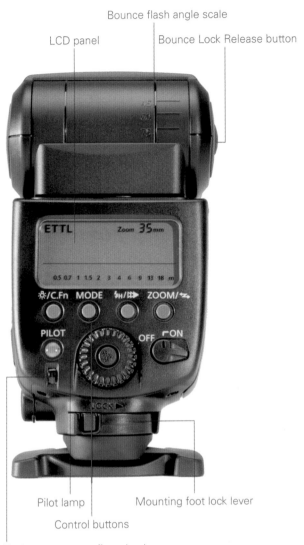

1.2 The back of the 580EX II Speedlite

▶ **Wireless sensor for E-TTL II wireless flash.** This sensor reads signals from the master unit, enabling wireless flash operation.

▶ **External metering sensor.** The external metering sensor allows the flash to cal-culate its own light output without relying on the camera's metering system. The flash has to know camera settings (ISO, shutter speed, aperture) to calculate the

correct amount of output. Similar to older Thyristor-type flashes, external metering has to be set to manual mode and all the camera setting must be entered into the flash manually.

▶ **AF-assist beam emitter.** The 580EX II projects a red LED light-grid onto the subject to aid the camera's autofocus system to operate successfully in low-light or low-contrast situations. The AF-assist beam is compatible with 28mm and longer lenses.

▶ **Wireless remote ready light.** This operates as a ready light when the Speedlite is being used as a remote flash.

▶ **Flash head tilting-angle scale.** This feature allows you to tilt the flash head from normal (0) to 45, 60, 75, or 90 degrees and to –7 degrees for close-ups. While the flash head has detents at the values indicated on the scale, you can operate the flash at any angle between the detents.

▶ **Flash head rotation scale.** This feature denotes the horizontal rotation of the flash head from 0 to 60, 75, 90, 120, 150, and 180 degrees from the left. To the right, it can be adjusted from 0 to 60, 75, 90, 120, 150, and 180 degrees. While the flash head has detents at the values indicated on the scale, you can operate the flash at any angle between the detents.

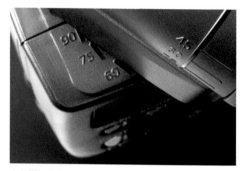

1.3 Flash head tilting- and rotating-angle scales for bounce or creative flash

▶ **LCD panel.** This is a display panel where you view all of the Speedlite settings, Custom Functions, and controls.

▶ **Control buttons.** You can use the control buttons to specify settings and Custom Functions on the Speedlite.

▶ **Pilot lamp.** This light indicates that the Speedlite is ready to fire. After the Speedlite is fired, this light glows green for Quick flash, then red when the Speedlite is fully recycled and ready to fire again. Quick flash allows the flash to be fired again before it has totally recycled to its full power capacity once the lamp glows green. Quick flash is limited to between 1/6 and 1/2 of the full light output and is ideal for close subjects and when you want a shorter recycling time. Quick flash will not operate in Continuous shooting, FEB, Manual flash, or Multi-Stroboscopic Flash modes.

▶ **Flash exposure confirma-
tion lamp.** This indicator
glows green for about three
seconds when standard flash
exposure is attained.

▶ **Mounting foot locking
lever.** This is a huge improve-
ment over the old 580EX.
This lever locks the Speedlite
with a click into the camera's
hot shoe or the included
Speedlite stand.

▶ **Wide panel.** This built-in dif-
fuser enables you to use the
Speedlite with a lens as wide
as 14mm without having light
fall off at the edges of the
image.

▶ **Catchlight panel.** This white
plastic card reflects light back
into the eyes, providing a
catchlight when the flash is
used in the bounced position.

▶ **External power source
socket.** Canon's optional
Compact Battery Pack CP-E4
external power source or a
third-party power supply can
be plugged into this socket.

▶ **Bracket mounting hole.** This
is used to attach the Speedlite
to the Canon SB-E2 Speedlite
bracket. The SB-E2 allows the
Speedlite to be attached to
the side of the camera rather
than to the hot shoe.

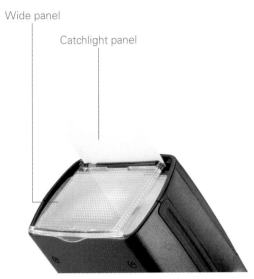

Wide panel

Catchlight panel

**1.4 The wide panel and the built-in catchlight
panel**

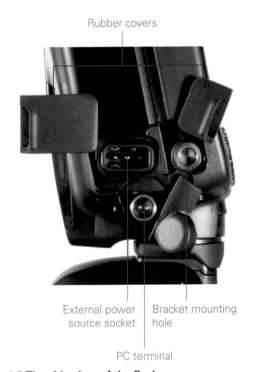

Rubber covers

External power
source socket

Bracket mounting
hole

PC terminal

1.5 The side view of the flash

15

▶ **PC terminal.** New on the 580EX II, this receive-only PC (Prontor-Compur) terminal accepts a standard flash sync cord and allows the unit to be fired by a sync cord, third-party wireless remotes such as PocketWizards or Radio Poppers or optical slaves.

▶ **Hot shoe mounting foot.** A major improvement over the mounting foot of the old 580EX, this new one is now made of metal and coupled with the new locking lever that securely connects the flash with the camera. This connector slides into the hot shoe on your camera body, locks the Speedlite to the camera with the locking lever, and is the important electrical communication connection between the flash and the camera.

1.6 The hot shoe mounting foot

Control buttons and Select dial

There are several control buttons, a dial, and a switch on the back of the 580EX II, so I'll describe how each one operates in order to get the best results from your new Speedlite. Some of them are obvious, such as the On/Off switch, but others control the menus and settings that you select. Spend some time getting acclimated to these controls so you can be ready to make future adjustments on the fly.

▶ **LCD Panel Illumination/Custom Functions (C.Fn) button.** Pressing this button once turns the LCD light on for about 10 seconds for viewing settings in dim light. Pressing and holding this button brings you to the Custom Functions menu. You can scroll through the Custom Functions using the Select dial and choose them by pressing the Select/Set button.

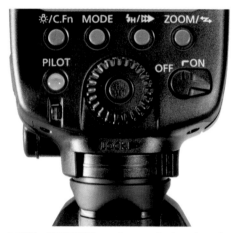

1.7 The 580EX II's main panel, showing the control buttons and Select dial

See Chapter 2 for tables displaying all the Custom Functions and their applications.

▶ **Mode button.** The Mode button is used to cycle among the different flash exposure modes of the 580EX II Speedlite and during wireless operation to manually adjust flash output. The three modes are:

- **E-TTL.** The exposure is determined by a brief pre-flash before the main flash in order to obtain a more correct exposure and measures the light coming through the lens. The camera then uses this information to blend the flash output with the ambient light.

- **M (full Manual mode).** You can use guide numbers or determine the flash output power by taking test shots then reviewing on the camera's LCD monitor. Output is adjustable in 1/3-stop power settings so that you can fine-tune your lighting or dial in each Speedlite individually in multi-flash lighting setups. You can also use an external flash meter to determine the flash and camera settings.

- **Multi-Stroboscopic Flash.** This mode allows you to fire the flash multiple times during a single exposure for creative effect.

▶ **High-Speed Sync (FP flash)/Second-Curtain Sync button.** Pressing this button once allows you to set the flash to High-Speed Sync. A digital camera shutter is comprised of two "curtains," one that opens the shutter to begin the exposure and one that closes it to end the exposure. High-speed sync allows you to shoot flash photos at higher than normal sync speeds due to the flash perfectly pulsing out light as the shutter curtains move across the sensor instead of just one pop when the shutter first opens.

Pressing it a second time turns on the second-curtain sync feature. In standard flash photography, the normal operation sequence is the shutter opens and the flash fires immediately. In this mode, the flash fires at the very end of the exposure, just before the second curtain closes. To return to standard flash, push the button once again.

Both of these features only work in ETTL and Manual flash modes, and not in Multi-Stroboscopic or wireless modes.

▶ **Zoom/Wireless Select/Set button.** Press this button to manually change the flash head zoom using the Select dial/Set button. Press and hold this button to enter the wireless control menu, where you set master/slave status, channel number, group designations, and slave ratios.

▶ **Pilot Lamp button.** Press this button when lit to test-fire the 580EX II to ensure it is functioning properly or to take a test reading using a handheld flash meter. This button also lets you know when the flash is fully charged and ready to fire. When the lamp glows green, the unit is ready for Quick flash; when it glows red, the flash is ready to fire at full power.

▶ **Select dial and Select/Set button.** You rotate the Select dial left and right, and confirm the settings by pressing the center Select/Set button.

 • **Left and right.** When scrolling left or right, you use this button to change the zoom of the flash, select custom functions settings, flash exposure compensation, manual flash output, wireless status, master/slave settings, multi-stroboscopic frequencies, or flash bracketing settings.

 • **Select.** The center button is the Select/Set button. You use this button to confirm the flash settings that you have selected by turning the Select dial.

▶ **On/Off switch.** You use this thumb switch to turn the Speedlite on or off.

580EX II accessories

The Speedlite ships with a soft, ballistic nylon case for storing and carrying your 580EX II, and includes a tabletop Speedlite stand that enables you to mount your flash to a light stand or tripod.

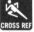 Third-party manufacturers such as Sto-Fen and ExpoImaging market other accessories for your 580EX II, and these accessories are discussed in detail in Chapter 5.

430EX II

Introduced in the fall of 2008, the 430EX II is the middle child in the Canon Speedlite System; it includes many of the improvements built into the 580EX II, such as wireless control, a built-in wide-angle lens panel, and the very popular metal mounting foot and quick lock/quick release lever to securely mount it to your camera. The 430EX II is a step up for photographers used to shooting with their camera's built-in flash, and offers more power, a higher guide number, and a tilting/rotating flash head for bounce-flash lighting techniques, which is not possible with the pop-up flashes.

430EX II specifications and features

As the intermediate flash in the Canon line, the 430EX II has less power, a few less features, a lower guide number range, and about 35-percent less reach than the 580EX II. Its major limitation for advanced use is that it cannot be used as a wireless controller in a multiple flash system. It can only operate as a slave, and so a master control capable Speedlite (550EX, 580EX, or 580EX II) , a Speedlite Transmitter ST-E2, or either of the Macro Speedlites must be mounted on the camera's hot shoe in order to use a 430EX II wirelessly off camera as a fill flash.

The 430EX II also cannot be run from an external power source, which may be required to extend flash capacity and shorten recycle time in high-use situations such as weddings.

This section provides a brief look at different features that are available on the 430EX II Speedlite. It is important to note, however, that some of its features may not be available, depending on the camera body you are using.

▶ **Guide number (GN).** The guide number varies with the zoom settings of the flash head, from GN 25/82 (meters/feet) at 24mm to GN 43/141 (meters/feet) at 105mm. Guide numbers are usually given for both feet and meters so be sure you use the right one in your calculations. See your owner's manual for more information on GNs for specific zoom ranges.

▶ **Automatic zooming flash head.** The 430EX II provides lens coverage from 24mm up to 105mm. It provides 14mm with the included wide panel.

▶ **E-TTL.** The 430EX II supports E-TTL II, E-TTL, TTL, and full manual operation.

▶ **AF-assist beam.** The 430EX II emits a grid of light from a red LED to assist in focusing in low-light situations.

▶ **High-speed sync (FP flash).** This function allows you to shoot with a shutter speed higher than the rated sync speed of the camera. This feature is useful when shooting portraits in bright light using a wide aperture with fast shutter speeds.

▶ **Flash Exposure Lock (FEL).** You can use this feature to get a reading from your subject and then recompose the shot while retaining the original exposure.

▶ **Flash Exposure Compensation.** Similar to the way exposure compensation is set on the camera, this function allows you to adjust the light output up or down in 1/3-stop increments over a +/– 3-stop range and still enjoy all the benefits of E-TTL II flash metering.

▶ **Modeling flash.** The 430EX II releases a short burst of flashes, allowing you to see what the light falling on your subject looks like.

▶ **Tilting/rotating flash head for bouncing flash.** This allows you to tilt the flash head up to bounce light from the ceiling, or to the side to bounce light off of the wall.

▶ **Wireless sensor for E-TTL II wireless flash.** This sensor reads signals from the master unit, enabling wireless flash operation. The 430EX II can only be used as a slave unit in wireless flash operation.

Main components

The main controls of the 430EX II are located in the same configuration as the 580EX II with the exception of the Select/Set dial, which has been replaced with +/– buttons to the left and right of the Set button.

▶ **Flash head.** This is where the flashtube is housed. Inside is a mechanism that zooms the flashbulb forward and back to provide flash coverage for lenses of different focal lengths. The flash head is adjustable; it can be tilted upward to a full 90 degrees. It can also be adjusted horizontally 180 degrees to the left or 90 degrees to the right.

▶ **Flash-Head Lock Release button.** This button releases the flash-head lock, allowing you to adjust the angle of the flash head for bounce flash.

▶ **Battery compartment cover.** You slide the cover downward to open the battery compartment to load or change the batteries.

▶ **Wireless sensor for E-TTL II wireless flash.** This sensor reads signals from the master unit, enabling wireless flash operation.

▶ **AF-assist beam emitter.** The 430EX II projects a red LED light-grid onto the subject to aid the camera's auto focus system to operate successfully in low-light or low-contrast situations. The AF assist beam is compatible with 28mm and longer lenses.

▶ **Wireless remote ready light.** This operates as a ready light when the Speedlite is being used as a remote flash.

▶ **Flash head tilting-angle scale.** This feature allows you to tilt the flash head up from 0 (normal) to 45, 60, 75, or 90 degrees and down -7 degrees. While the flash head has detents at the values indicated on the scale, you can operate the flash at any angle between the detents.

Flash head Wide panel

Bracket mounting hole/cover

Battery campartment cover AF-assist beam/
Wireless remote ready light

Wireless sensor

1.8 The front of the 430EX II Speedlite

▶ **Flash head rotating-angle scale.** This feature denotes the horizontal rotation of the flash head from 0 (normal) to 60, 75, 90, 120, 150, and 180 degrees from the left. To the right, it can be adjusted to 60, 75, and 90 degrees. While the flash head

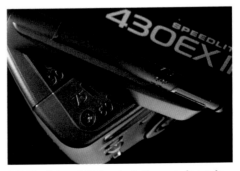

1.9 Flash head tilting/rotating-angle scale

21

has detents at the values indicated on the scale, you can operate the flash at any angle between the detents.

▶ **LCD panel.** This is a display panel where you view all of the Speedlite settings, Custom Functions, and controls.

▶ **Control buttons.** You can use these buttons to specify settings and Custom Functions on the Speedlite.

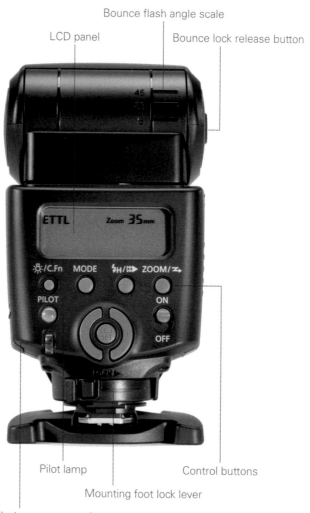

1.10 **The back of the 430EX Speedlite**

▶ **Pilot Lamp button.** Press this button when illuminated to test-fire the 430EX II to ensure it is functioning properly or to take a test reading using a handheld flash meter. This button also lets you know when the flash is fully charged and ready to fire. When the lamp glows green, the unit is ready for Quick flash; when it glows red, the flash is ready to fire at full power.

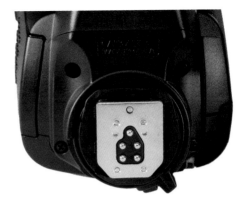

1.11 Hot shoe mounting foot and lock lever

▶ **Flash exposure confirmation lamp.** This indicator glows green for about three seconds when standard flash exposure is attained.

▶ **Mounting foot locking lever.** This is a huge improvement over the old 430EX. This lever locks the Speedlite with a click into the camera's hot shoe or the included Speedlite stand.

▶ **Wide panel.** This built-in diffuser enables you to use the Speedlite with a lens as wide as 14mm without having light fall off at the edges of the image.

1.12 Wide panel

Control buttons

There are eight control buttons and a switch on the back of the 430EX II, so I'll describe how each one operates in order to get the best results from your new Speedlite. Some of them are obvious, such as the On/Off switch, but others control the menus and settings that you select. Spend some time getting acclimated to these controls so that you can be ready to make future adjustments on the fly.

▶ **LCD Panel Illumination/Custom Functions (C.Fn) button.** Pressing this button once turns the LCD light on for about 10 seconds for viewing settings in dim

light. Pressing and holding this button brings you to the Custom Functions menu. You can access the Custom Functions by using the +/– buttons, and choose them by pressing the Select/Set button.

 See Chapter 2 for tables displaying all the Custom Functions and their applications.

▶ **Mode button.** The Mode button is used to cycle among the different flash exposure modes of the 430EX II Speedlite and in wireless operation is used to manually set flash output. The two modes are:

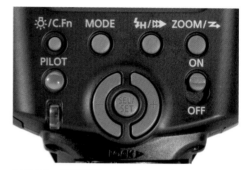

1.13 **The 430EX II control panel**

- **E-TTL.** The exposure is determined by a brief pre-flash before the main flash in order to obtain a more correct exposure and measures the light coming through the lens. The camera then uses this information to blend the flash output with the ambient light.

- **M (full Manual mode).** You determine the flash power by guide numbers or taking test shots and then reviewing on the camera's LCD monitor. Output is adjustable from 1/1 (full) to 1/64 power in 1/3-stop intervals so that you can fine-tune your lighting or dial in each Speedlite individually in multi-flash lighting setups. You can also use a flash meter to determine the flash and camera settings.

▶ **High-Speed Sync (FP flash)/Second-Curtain Sync button.** Pressing this button once allows you to set the flash to High-speed sync. A digital camera shutter is comprised of two "curtains," one that opens the shutter to begin the exposure and one that closes it to end the exposure. High-speed sync allows you to shoot flash photos at higher than normal sync speeds due to the flash perfectly pulsing out light as the shutter curtains move across the sensor instead of just one pop when the shutter first opens.

Pressing it a second time turns on the second-curtain sync feature. In standard flash photography, the normal operation sequence is the shutter opens and the flash fires immediately. In this mode, the flash fires at the very end of the exposure, just before the second curtain closes, freezing your subject yet retaining any movement trails due to a longer exposure. High-speed sync produces a

more natural look to moving subjects. To return to standard flash, push the button once again.

▶ **Zoom/Wireless Selection/Set button.** Press this button to manually change the flash head zoom using the +/– buttons. Press and hold this button to enter the wireless control menu, where you set slave status, channel number, and slave groups.

▶ **Pilot Lamp button.** Press this button when lit to test-fire the 430EX II to ensure it is functioning properly or to take a test reading using a handheld flash meter. This button also lets you know when the flash is fully charged and ready to fire. When the lamp glows green, the unit is ready for Quick flash; when it glows red, the flash is ready to fire at full power.

▶ **Select/Set and +/– buttons.** You press the right and left +/– buttons to change the settings, and confirm them by pressing the center Select/Set button.

　● **+/– buttons.** You use these buttons to change the zoom of the flash, flash exposure compensation, manual flash output, wireless status, slave settings, flash bracketing settings or when setting custom functions.

　● **Select.** The center button is the Select/Set button. You use this button to confirm the flash settings that you have selected by turning the Select dial.

▶ **On/Off switch.** You use this thumb switch to turn the Speedlite on or off.

430EX II accessories

The Speedlite ships with a soft case for storing and carrying your 430EX II, and includes a tabletop Speedlite stand that enables you to mount your flash to a light stand or tripod.

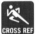

Third-party manufacturers such as Sto-Fen and ExpoImaging market other accessories for your 580EX II, and these accessories are discussed in detail in Chapter 5.

Other Components of the Speedlite System

Becoming familiar with your new flash equipment is the first step in learning about lighting and understanding the creative possibilities of wireless flash. As exciting as that might seem, it's only the first phase of the complete Canon Speedlite System.

There are five more major items that round out the system, and each is designed for specific tasks to light your subjects just the way you want them.

270EX

Released in May 2009, the Speedlite 270EX replaces the 220EX as Canon's entry-level Speedlite. Compact and lightweight, the 270EX expands your camera's capabilities over the on-board pop-up flash in a highly portable unit that fits in a shirt pocket. The 270EX is powered by two AA batteries instead of four, like almost all other Speedlites, and this seriously lightens the weight of this flash.

The Canon Speedlite 270EX flash's biggest improvement over the 220EX is the bounce-capable flash head. While the adjustment range is limited (90 degrees tilt, no rotation), the bounce capability is a big improvement over a fixed flash head like the 220EX. A new 2-position manual Tele-zoom option allows the 270EX to concentrate its light on the subject, making more efficient use of its power and extending its useful distance.

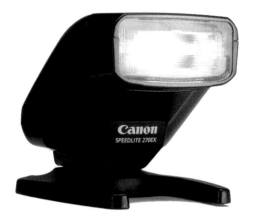

1.14 The Canon Speedlite 270EX

Several features incorporated in Canon's newer flashes are inherited by the 270EX. These include the ability to control flash settings from a compatible camera's menu (including Manual flash mode settings), the communication of color temperature information with a compatible camera (for optimal white balance), and silent recycling.

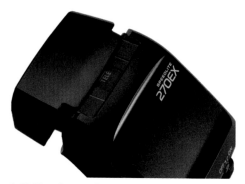

1.15 The Canon Speedlite 270EX Tele-zoom/bounce head

OC-E3 Off-Camera Shoe Cord

The Canon OC-E3 Off-Camera Shoe Cord supports all Speedlites and maintains all on-camera flash functions, including E-TTL II for Canon Speedlites used off-camera at distances up to 2 feet. It is compatible with all Canon EOS cameras, except for the 630 and RT.

One end of the cord mounts in the camera hot shoe, and the Speedlite mounts in the hot shoe foot at the other end of the cord. The foot is threaded so that it can be mounted on a tripod. The OC-E3 is an improvement on the now-discontinued Off-Camera Shoe Cord 2.

The OC-E3 has been improved with better sealing against dust and moisture, similar to the weather-resistant design of the EOS 1D Mark III and the 580EX II flash. It also now features a sturdier metal foot.

1.16 The Canon OC-E3 Off-Camera Shoe Cord 3

The Off-Camera Shoe Cord allows you to use your flash either handheld or with a flash bracket. Using the cord with a flash bracket allows the flash to stay above the lens axis, and communicate with the camera whether in a horizontal or vertical position.

Shooting flash off axis from the lens allows you to light your subject directionally and adds three-dimensionality to your flash photos by having the light come from the side, thus creating highlights and shadows.

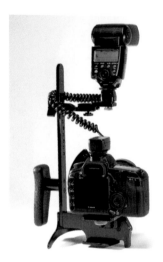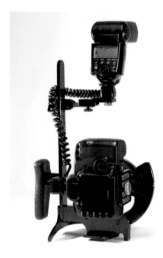

1.17 The Canon OC-E3 Off-Camera Shoe Cord used with a flash bracket

ST-E2 wireless transmitter

For the ease of controlling multiple wireless Speedlites, or when the OC-E3 Off-Camera Shoe Cord is just not long enough, the Speedlite Transmitter ST-E2 is an attractive option. Attached to the camera's hot shoe, the ST-E2 is an infrared wireless master control unit for the Canon Speedlite System. It functions in much the same way as the 580EX II does in master mode. This wireless flash controller transmits an infrared trigger, exposure information, and flash ratios to all EX-series Speedlites. The ST-E2 also includes a powerful infrared AF-assist beam, a welcome feature in night-time shooting or for EOS cameras that lack one.

The ST-E2 transmitter slides into the hot shoe of your camera like any other Speedlite and is used to wirelessly control the Speedlites. It is smaller and lighter than any Speedlite, and its power source is a 2CR5 lithium battery, common in older EOS film cameras. It attaches to the camera with a plastic mounting foot much like older Speedlites, but it includes a very secure shoe lock slider switch instead of a mounting lock wheel.

1.18 The Canon ST-E2 wireless transmitter

Each channel can be used to control any number of flashes in two groups. From the ST-E2, you can control the output of each group individually in a ratio of up to a 3-stop range in 1/2-stop increments. The wireless range is greater indoors than outdoors, but I have achieved good communication results by turning the Speedlite's base to face the camera/transmitter and repositioning the flash head toward the subject.

The ST-E2 transmitter also has four independent channels, for those rare situations where you may be working near other photographers using ST-E2 wireless transmitters. You can change your wireless setup to a different channel so that someone else's transmitter won't fire your flashes and your transmitter won't fire theirs. I have never come upon this situation, but it's nice to know the technology is there.

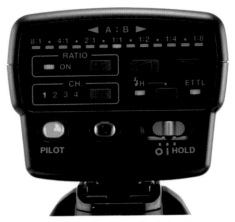

1.19 The rear control panel of the Canon ST-E2 wireless transmitter

The ST-E2 transmitter is a great tool for wireless control of Canon Speedlites, but it does have a few limitations. The main one for me is that it only allows you to shoot in E-TTL mode. This is fine for those setups where I'm only using a few Speedlites off camera, and I want to control the flash output ratio of the flashes right from the camera. But when things really get creative out in the field, I'll switch to Manual exposure, and replace the ST-E2 with PocketWizards for wireless control and full manual output. Secondly, the ST-E2 has a much shorter range and effectiveness outdoors. This is because the triggering signal is light based (infrared) unlike the radio frequency operation of remotes such as PocketWizards or radio Poppers. It also only controls two groups of flashes, A + B, while the 580EX II set as the Master can control three, A + B + C.

Macro Twin Lite MT-24EX

Macro photography presents the photographer with specific problems to overcome. Often, the close subject distances of macro photography require smaller aperture openings to obtain adequate depth of field. Smaller f-stops require a lot of light or very slow shutter speeds, which is not always possible with subjects such as swaying

flowers or flying bees. Slower shutter speeds usually necessitate the use of a tripod and a stationary subject.

The Macro Twin Lite MT-24EX addresses these concerns in a compact and balanced unit. Two small flash heads complete with connect to a mount ring that attaches directly to the front ring of the Canon EF 50mm f/2.5 Macro lens, Canon EF 100mm f/2.8 Macro USM lens, MP-E 65mm 1–5x f/2.8 Macro lens, or Canon's new EF 100mm f/2.8L Image Stabilized USM lens.

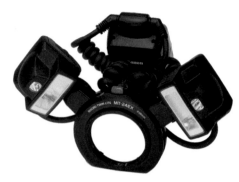

1.20 The Canon Macro Twin Lite MT-24EX

To mount the Canon Macro Twin Lite on the Canon EF 180mm f/3.5 L USM Macro lens, you need the optional Canon Macro Lite Adapter 72C. These flash heads can be positioned, locked in place, individually turned on or off, or even removed from the mount ring and repositioned for greater creative control.

Two features are included to make focusing and illuminating your subject easy. On-board focusing lamps in each of the flash heads light up for twenty seconds or until you depress the Shutter button. Modeling flash releases a short burst of flashes, allowing you to see what the light falling on your subject looks like.

The MT-24EX incorporates many of the features of the top-of-the-line Canon flashes, such as Flash Exposure Compensation, Flash Exposure Bracketing, high-speed sync, and adjustable output ratios between the two flashes by a 3-stop range in 1/2-stop increments.

The MT-24EX supports wireless operation and can act as a master to trigger other compatible Speedlites for full E-TTL flash metering. It can also be set up to work in conjunction with any number of other Speedlites on the same or different channels. To further fine-tune your macro lighting, you can set flash IDs A and B for the built-in flash heads and set any additional slave units to A, B, or C. This is helpful when you want to use a slave flash for backgrounds that typically go black in macro photography.

Other convenient features include full E-TTL exposure, as well as M (Manual) for full control, incandescent focusing lamps, modeling flash operation from camera buttons, and many user-set Custom Functions.

A more typical use for an additional slave flash is to set the unit to its own channel to control the lighting of the background. Because light fall-off from the main flash heads used with small apertures often renders a background black, a slave flash can be utilized to add light behind the subject. Individual flashes can be repositioned or turned on or off as well.

The Macro Twin Lite MT-24EX is powered by four AA lithium, alkaline, or NiMH rechargeable batteries and includes a socket for Canon's optional Compact Battery Pack CP-E4 external power source or a third-party power supply.

For general macro photography, you may find the flash illumination to be a little harsh. To resolve this situation, you can change the ratios so that one flash is stronger than the other; Sto-Fen also makes a nice little set of frosted diffusers specifically for the MT-24EX to soften the light for a more natural look.

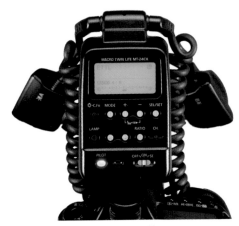

1.21 Control panel of the Macro Twin Lite MT-24EX

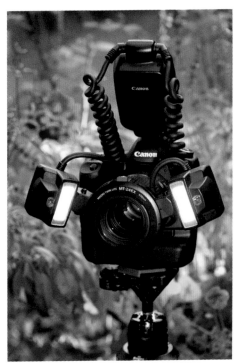

1.22 Photographing flowers and insects in the field with the Canon Macro Twin Lite MT-24EX

Chapter 6 covers more macro lighting techniques and examples.

CROSS REF

Macro Ring Lite MR-14EX

Similar in design to the Macro Twin Lite MT-24EX, the Macro Ring Lite MR-14EX is a Speedlite flash that is geared toward macro and close-up photography but yields a different look due to its unique construction. Two output-adjustable flash tubes encircle the lens and produce shadowless lighting of small subjects, and two on-board incandescent focusing lamps help facilitate sharp images.

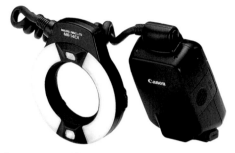

Image courtesy of Canon, Inc.

1.23 The Canon Macro Ring Lite MR-14EX

Two features are included to make focusing and illuminating your subject easy with the Macro ring lite. On-board focusing lamps between the flashtubes light up for twenty seconds or until you depress the Shutter button. Modeling flash releases a short burst of flashes, allowing you to see what the light falling on your subject looks like.

Long a staple in the medical and dental industries for producing detailed before-and-after images of procedures, the ring lite creates the most uniform lighting of small subjects. Because the light is emitted from all around the lens, shadows are eliminated and any reflective surfaces on your subject, such as an insect's covering or eyes, may reveal a round highlight similar to a lifesaver, an easy indicator of ring lite use.

With an identical hot shoe-mounted control unit and similar features to the MT-24EX, the MR-14EX incorporates

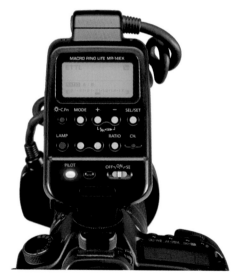

1.24 Control panel of the MR-14EX

many of the functions of the top-of-the-line Canon flashes, such as Flash Exposure Compensation, Flash Exposure Bracketing, high-speed sync, and adjustable output ratios between the two flash tubes by a 3-stop range in 1/2-stop increments.

Like the ST-E2 and the MT-24EX, the MR-14EX can be used to trigger off-camera slave flashes, such as the 580EX II or the 430EX II, in multiple channels and groups. This is a great feature if you need to illuminate the background separately from the subject to prevent the background from going completely black.

The Canon Speedlite System offers a variety of solutions for simple to complex lighting situations. Next, you set up your Speedlites and fire in some common applications, and learn several techniques to take your flash photography beyond the ordinary.

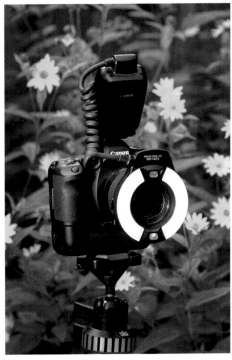

1.25 Photographing flowers and insects in the field with the Canon Macro Ring Lite MR-14EX

Setting Up the 580EX II and 430EX II Speedlites

This chapter aims to provide more information about getting your Speedlites set up for on-camera use and off-camera wireless operation. I discuss some finer details of the Speedlite's features and capabilities, briefly explain the optional flash exposure modes, and offer tables that list all the Custom Functions that are available with the 580EX II and 430EX II and suggestions when you might use them.

By the end of this chapter, you should feel more comfortable accessing the various menus of the flash modes and setting Custom Functions for your flash. This is key to making on-the-fly decisions and gaining some insight into reading certain shooting environments and situations where you may want to avoid using the fully automatic settings. Creative lighting and intuitive use of your gear are your goals, so let's get started!

This portrait of business consultant Laura Schlafly was shot in the lobby of her office building with just two Speedlites, a 580EX II and the older 580EX, both triggered wirelessly by the ST-E2 transmitter. The main light is fired through a small white translucent umbrella camera-right, and the undiffused edge light, camera-left is dialed down –2 stops on the ST-E2 transmitter. Exposure: ISO 400, f/5, 1/50 second with an EF 70-200mm f/2.8L USM lens.

Power Requirements

The power requirements for the 580EX II and the 430EX II are the same: four AA-size batteries. Having fresh batteries for your Speedlite is very important. Take it from me: batteries will almost always die on you at the worst possible time. It's smart insurance to pack at least one extra set of batteries for each Speedlite that you take along.

With the current emphasis on the three R's (reduce, reuse, recycle), it makes sense to purchase rechargeable batteries. The initial investment is more than you would pay for standard AA batteries, but it will more than pay you back over time, not having to purchase one-time-use batteries over and over. I always recommend having two sets of freshly recharged batteries for each Speedlite. Five different types of AA-size batteries are available for use in Canon Speedlites, and they fall into two categories: non-rechargeable and rechargeable.

Non-rechargeable

Primary, disposable, or one-use batteries have the dual advantages of having both a higher initial voltage and a longer life than secondary or rechargeable batteries of the same size. If you decide not to invest in a set or two of rechargeable batteries for your Speedlites, let's consider your choices within the non-rechargeable variety before making additional battery purchases. The two types to choose from are:

▶ **Alkaline.** This is your everyday, standard type of battery; alkaline batteries are available nearly everywhere, from your local supermarket to high-end camera stores. There are differences in quality, depending on the manufacturer. When buying these types of batteries, I suggest purchasing the batteries that are specifically designed for use with digital cameras and flash units. These batteries usually last longer and perform better than less expensive brands.

▶ **Lithium.** Lithium batteries cost a little more than standard alkaline batteries, but they last a lot longer and you get more flashes per set before you have to replace them. Professional photographers say they are worth every penny if they get the shot. You can find lithium batteries at office supply stores and camera shops.

Rechargeable

Rechargeable, sometimes called secondary batteries, require a greater initial investment, but you easily get your money back by not having to buy primary batteries so often. The two types of rechargeable batteries to choose from for your Speedlites are:

▶ **NiCd.** Nickel–cadmium batteries are the most common type of rechargeable batteries and are widely available. While NiCd batteries are rechargeable, they do not last as long or fire as many flashes as the more expensive NiMH batteries. Another consideration is the so-called lazy battery effect, or battery memory effect. It has been noted that certain NiCd batteries gradually lose their maximum energy capacity if they are repeatedly recharged after being only partially discharged. The battery appears to "remember" the lower capacity. The effect is caused by changes in the characteristics of the underused active materials of the cell. The term is commonly misapplied to almost any case in which a battery appears to hold less charge than was expected.

▶ **NiMH.** Nickel–metal hydride batteries are more expensive, but they will last longer. AA NiMH batteries have two to three times the capacity of AA NiCd batteries, and therefore they last longer on a single charge than NiCd batteries do, and the battery memory problem is not as significant. You can find NiMH batteries in almost any office supply and photo store.

A few things to keep in mind about batteries. With every battery, there are environmental concerns. The NiCd, in particular, was highly controversial because the element cadmium is considered one of the most toxic elements in the world. If the battery leaked or exploded, it could cause serious damage and endanger the lives of anyone around them. The NiMH, on the other hand, has no known environmental concerns. When NiMH batteries came into the mainstream, people began to realize that the newer NiMH battery far exceeded that of the older NiCd. Furthermore, the NiMH was also much safer than the cadmium-based battery and did not fall victim to the memory effect that was such a staple of the NiCd batteries. In short, the NiMH battery is superior to the NiCd battery.

When purchasing rechargeable batteries for your Speedlite, always select batteries with the same mAh rating (milliamp hours) and be sure not to mix battery types. The higher the mAh rating, the longer it will last on a charge. Make sure all the batteries are fully charged, and don't mix weaker batteries with freshly charged ones. Batteries will slowly lose their charge if left in storage for a while, too, so be sure to fully charge before every shoot.

Cold temperatures will also affect battery life and performance. In cold weather shooting, I always keep a spare set inside my coat, close to my body to keep them warm.

Radio Shack markets a great battery charger that recharges batteries in two hours and includes a Refresh option. This single feature is highly desirable in a battery charger. In Refresh mode, batteries and those that have not been used for a long time can have

their charge depleted to zero to recover the optimum capacity of the rechargeable bat-teries. The charger then automatically switches back to charge mode to fully charge the batteries. It recharges eight AA batteries at the same time (enough for two Speedlites) and works with AAA, C, D, and 9-volt batteries as well.

Canon also offers the CP-E4 battery pack, which uses eight AA batteries, significantly reducing recycle time and doubling the working life of your Speedlite. Another option is the Canon Transistor Pack E, which holds six C-size batteries for extra-long battery life. These attach to the 580EX II, 430EX II, MT-24EX, and MR-14EX Speedlites via the external power source socket.

Flash Modes

The Canon Speedlites come equipped with several different flash modes for complete creative control. The availability of all modes varies slightly among the Speedlite mod-els. For instance, Multi-Stroboscopic mode cannot be set on the 430EX II, but it can be programmed that way by a master when it's being used as a slave. All currently mar-keted Speedlites offer backward-compatible flash modes for use with pre–2004 Canon EOS dSLRs and even EOS SLR film cameras.

E-TTL II

E-TTL II is the newest and most innovative flash mode from Canon. It was introduced in 2004 for use with the Canon EOS 1D Mark II, and it continues to be used with Canon's current lineup of EOS dSLR cameras. The camera gets most of the metering information from monitor preflashes that are emitted by the Speedlite. The camera also uses data from the lens, such as distance information and f-stop values.

The main improvement of E-TTL II over E-TTL is that it gives a more natural flash expo-sure, by being able to handle difficult scenes where normally the old E-TTL system would be thrown off. Such improvements are possible because E-TTL II now incorpo-rates lens-to-subject distance information in its calculation to assist in determining an approximate Guide Number for flash output.

The flash metering system is also no longer linked to the AF system, where in the old E-TTL, metering bias was given to the selected AF point. Rather, E-TTL II compares the ambient and the preflash light levels of the scene to determine where the subject lies. This gives a photographer flexibility to lock focus and recompose the scene with-out fooling the flash metering system. Hotspots that normally throw off the flash metering system are also ignored in the calculation. The results are more natural flash pictures, even under adverse lighting situations.

E-TTL

This is an older form of Canon's flash metering system. It functions very much like E-TTL II. This metering system was used on Canon camera bodies from 1995 to 2004, and it stopped being used with the introduction of E-TTL II.

The primary difference between E-TTL and E-TTL II is that E-TTL is strongly focus-point biased. E-TTL evaluates the flash exposure primarily at the active focus point. E-TTL II does not have this high focus-point biasing, and the flash exposure is calculated using more of an evaluative metering pattern.

E-TTL and E-TTL II appear as just "ETTL" on the Speedlite LCD because, although the Speedlite functions in both of these modes, a camera body only uses one type of metering system. Whether it is E-TTL or E-TTL II depends on the particular camera with which you are using the Speedlite.

2.1 The 580EX II LCD menu set to E-TTL

Canon's older film cameras used a flash metering system known as A-TTL. The 580EX II and 430EX II flashes are not compatible with this older technology; they may work with these cameras, but they are not recommended because they do not share all communications with the camera.

2.2 The 430EX II LCD menu set to E-TTL

Canon series EZ Speedlites are the ones to use with EOS film cameras and are readily available for a good price on eBay. In fact, I have two of these Speedlites in my lighting kit that I use remotely and set to manual output, and they are very dependable.

Manual

E-TTL and E-TTL II are great for any number of picture-taking situations or those times when you want to get the best results possible when shooting on the fly. Then you just set the camera on P, Av, or Tv mode and shoot away. The sophisticated camera/ flash communications take care of many lighting problems and produce well-lit images. In the old days, photographers had to figure out a Guide Number and do a few calculations that took their eye away from the viewfinder. Now, it's as easy as shooting a test shot, judging the results on your camera's LCD monitor, and making corrections and adjustments and shooting again.

Once you've begun using a few Speedlites in multiple-flash setups, the E-TTL II system, while still awesome, may begin to feel a little limiting and rigid, considering you are locked into only a 3-stop range among all Speedlites and groups. This is not an extremely large range. Working with the 580EX II and 430EX II Speedlites in full Manual mode may take some getting used to, but they offer you the greatest amount of creative control, especially in multiple-flash setups.

Many photographers consider it confusing to work with their flashes set to manual output, but nothing could be further from the truth for off-camera flash setups. Many products are available, such as the Honl Speed System from ExpoImaging, that you can use to mold, shape, and filter the light just the way you want it. Manual flash mode is not to be feared!

2.3 The 580EX II LCD menu set to Manual full power

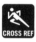 For more information on the many different light modifiers, see Chapters 5 and 6.

Multi-stroboscopic flash

In this mode, the flash fires repeatedly, similar to a strobe light, during a single exposure. You may have seen multiple images of dancers, tennis players, or gymnasts that are achieved by using this flash mode. You decide the frequency and the number of times you want the flash to fire by specifying the Hz numbers, which correspond to the number of flashes per second. The slower the shutter speed, the more flashes you are able to capture. This mode works best in low-light situations or locations where the background is predominantly very dark or black.

To set this mode:

1. **Set the camera to Manual exposure mode.**

2. **Press the Mode button on the Speedlite until the Multi menu appears in the upper-left corner of the Speedlite's LCD.**

3. **Use the 580EX II's Select/Set button in the middle of the dial to highlight the frequency setting.** The frequency is set in hertz (Hz). Use the dial to change the frequency from 1 to 199 Hz. Hertz is simply a measurement of cycles per second. 1 Hz is one cycle per second.

4. **Press the center Select/Set button again to confirm your selection.** This sets the frequency level and highlights the number of flashes per frame. Set this to how many times you want the flash to fire during the exposure.

5. **Press the center Select/Set button again.** This sets the last option and allows you to set the flash exposure level.

6. **Set your shutter speed.** Your shutter speed depends on the firing frequency of the flash per second (measured in Hz) and the number of flashes (also called the repeat rate). Your shutter speed is equal to the number of flashes divided by the firing frequency. For example, say you set the frequency to 5 Hz, and you want the flash to fire 20 times in a single frame; in this case, you divide 20 by 5. This tells you that you'll need at least a 4-second exposure to accomplish this.

7. **Check the pilot lamp for ready status and shoot the photo.**

After ten multi-stroboscopic frames, allow the flash tube to rest and cool down for at least fifteen minutes, or, if you continue to shoot, it may automatically do so for fifteen minutes.

> Zoom 70 mm
> $1/4$ $2-$ 8Hz
> MULTI
>
> 1.7 2.3 4 5 7 10 15 20 30 40 60 ft

2.4 The 580EX II LCD menu set to multi-stroboscopic flash

Zoom position

The zooming feature of the Speedlite focuses the light from the flash in order to match the angle of coverage of your lens. To facilitate the wider coverage that wide-angle lenses require, the flash tube is zoomed forward, diffusing the light through the Speedlite's Fresnel lens and dispersing it to a wider area. When a longer lens is used, the flash tube is pulled back, and coverage is diminished, but intensity picks up and output is focused through the Fresnel to allow a further distance to be lit.

By default, the 580EX II and 430EX II automatically set the zoom to match the lens. When shooting quickly or in E-TTL mode, 90 percent of the time I'm in flash auto zoom mode. However, during photo shoots when I am setting up multiple wireless

off-camera flashes, I am nearly always working the manual zoom settings to contain light spill for creative control.

580EX II

To set the zoom manually:

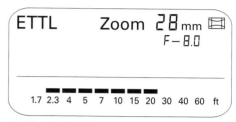

1. **Press the Zoom button on the back of the flash.** The Zoom setting flashes when it is ready to be changed.

2. **Scroll the dial left or right to change the Zoom setting.**

2.5 The 580EX II LCD menu zoom setting at 28mm

3. **When finished, press the Zoom button again to save the setting.** You can also just tap the Shutter button to resume shooting.

430EX II

To set the zoom manually:

1. **Press the Zoom button on the back of the flash.** The Zoom setting flashes when it is ready to be changed.

2. **Use the + or – buttons to change the Zoom setting.**

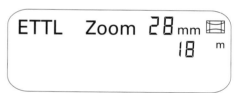

3. **When finished, press the Zoom button again to save the setting.** You can also just tap the Shutter button to resume shooting.

2.6 The 430EX II LCD menu zoom setting at 28mm

Auto Zoom Adjustment for APS-C Sensors

Certain Canon camera bodies, such as the 5D, 5D Mark II, and 1Ds Mark III, have a full-frame sensor. This means the digital sensor is exactly the same size as a frame of 35mm film. Canon currently makes three dSLR sensor sizes and utilizes them in many different dSLR camera models.

Canon's professional- and consumer-level dSLRs are equipped with an APS-H and APS-C size sensor, respectively, which are a bit smaller than a 35mm frame of film by certain percentages. With this smaller sensor, the actual coverage area of the lens is

larger than the sensor because it doesn't cover the same area as it would on a full-frame sensor or a piece of 35mm film. This brings up the lens conversion factor.

Simply stated, you take the actual focal length of the lens and multiply this number by the sensor's conversion factor to find the equivalent focal length of the lens in terms of 35mm film. For example, on a full-frame 5D Mark II camera, a 28mm lens is considered wide angle and yields the standard image that a 28mm lens produces. However, when you multiply it by the lens conversion factor for your particular camera's sensor, you get a different angle of view. For APS-C cameras, the conversion factor is 1.6x and for APS-H cameras, it is 1.3x. Doing the math, it would yield the same coverage as a 44.8mm lens when using the same 28mm lens on a camera with an APS-C size sensor, and the equivalent of a 36.4mm lens with an APS-H sensor.

Canon Speedlites automatically recognize the EOS digital camera's sensor size, and adjust the flash head zoom automatically and set the flash coverage for the converted lens focal lengths from 24mm to 105mm. When the Speedlite is connected, an icon appears in the upper-right corner of the Speedlite's LCD monitor.

Adjusting Flash Exposure Compensation

E-TTL and E-TTL II are great for producing well-lit images in difficult lighting scenarios, and I use them all the time. But when you know certain things about how the camera will see certain areas of your photo, it helps to take a little creative control. Flash exposure compensation involves setting the flash to a lower or higher output than the camera's chosen setting. Take away flash power by specifying a minus FEC setting and the flash becomes weaker, less dominant, but possibly more natural in the scene. Specify more FEC with a positive number, and the flash will dominate the ambient light. FEC can be adjusted in 1/3-stop increments over a 6-stop range (3 under, 3 over normal).

You can adjust the output of your Speedlite in a number of ways. When the Speedlite is mounted on your camera, you can adjust the output on the camera body itself. Most Canon dSLRs have a button for setting flash exposure compensation that works with Speedlites as well as the on-board pop-up flash. Some of the newer Canon cameras, such as the 5D Mark II, also have an External Speedlite Control menu where you adjust the flash settings using the camera's buttons and dials.

Finally, you can also adjust the flash output on the Speedlite itself. To set exposure compensation on the 580EX II in E-TTL mode, follow these steps:

1. **Press the Select/Set button for about one-half second.** The Flash Exposure Compensation (FEC) icon begins to blink.

2. **Scroll the Select dial left or right to make the adjustments.**

3. **After your adjustments are made, press the Select/Set button again to save the setting.**

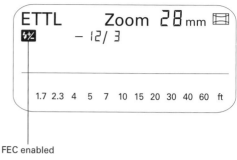

FEC enabled

2.7 The 580EX II LCD menu FEC-enabled by −1 2/3 stop

Follow these steps to set the flash output on the 430EX II in E-TTL mode:

1. **Press the Select/Set button for about one-half second.** The Flash Exposure Compensation (FEC) icon begins to blink.

2. **Use the + or – buttons to adjust the settings accordingly.**

3. **Press the Select/Set button to save the setting.**

2.8 The 430EX II LCD menu FEC-enabled by −2/3 stop

When exposure compensation is selected, the settings appear on the Speedlite's LCD. When the FEC is returned to normal, the FEC icon does not appear.

Red-Eye Reduction

Red-eye. Everybody's seen it in a picture at one time or another: that red glow in the eyes of people and pets that ruins an otherwise perfect picture. This anomaly is caused by the reflection of the light from the flash off of the eye's retina. Most cameras that have flash compatibility have a red-eye reduction function, which consists of a preflash or an LED that produces a light bright enough to constrict the pupils, therefore reducing the amount of light reflecting off of the retina.

Red-eye reduction cannot be set on the 580EX II or 430EX II. The camera bodies control this function. Most, if not all, Canon dSLR camera bodies have some sort of red-eye reduction function. Consult the owner's manual for your camera for instructions on how to set it up.

To return the FEC to normal, follow the same procedure as in the previous set of steps, and set the Speedlite accordingly.

AF-Assist Beam

When photographing in a dark environment, it can be very hard for your camera's autofocus sensor to find something to lock on to. When using a 580EX II or 430EX II in a low-light situation, the flash emits an LED pattern to give your camera sensor a red grid to focus on. For this feature to operate correctly, you must be using an AF lens and the camera's focus mode must be set to Single shot or AI Focus.

580EX II

To turn the AF-assist illuminator on and off on the 580EX II:

1. **Press the C.Fn button for two seconds to enter the Custom Functions menu.**

2. **Scroll the dial left or right to select the C.Fn number.** The C.Fn number for AF-assist beam OFF is F12. After you select C.Fn F12, press the Set button in the middle of the dial; the setting digit blinks.

3. **Scroll the dial left or right to change the setting to either 0 or 1.** The 0 indicates that AF-assist beam OFF is disabled, which means the beam is ON. The 1 setting indicates that the AF-assist beam will not illuminate.

4. **Press the Set button to save the setting.**

5. **Press the Mode button to return to the main menu.**

On newer Canon EOS cameras like the 5D Mark II and 7D, all of the latest Speedlites controls and Custom Functions can be set from the camera's External Speedlite control menu.

430EX II

To turn the AF-assist illuminator on and off on the 430EX II:

1. **Press the C.Fn button for two seconds to enter the Custom Functions menu.**

2. **Use the + and – buttons to select the C.Fn number.** The C.Fn number for AF-assist beam OFF is F08. After you select C.Fn F08, press the Select/Set button; the setting digit blinks.

3. **Use the + or − button to change the setting to either 0 or 1.** The 0 setting indicates that AF-assist beam OFF is disabled; this means the beam is ON. The 1 setting indicates that the AF-assist beam is disabled and will not illuminate.

4. **Press the Select/Set button to save the setting.**

5. **Press the Mode button to return to the main menu.**

LCD Panel Illumination

The LCD panels of both the 580EX II and 430EX II have an LCD backlight built in to help viewing in low-light situations. To turn on this backlight, simply press the Custom Functions (C.Fn) button. This LCD backlight turns off when you press the button a second time, or it will automatically turn off after approximately 10 seconds. This is a very useful feature that you will find invaluable when shooting performance and back-stage activities or you need to change a setting quickly in a dark environment.

Custom Functions

Similar to your Canon EOS camera, the 580EX II and 430EX II both come with user-adjustable Custom Functions to offer you greater flexibility and control over the performance of your Speedlites. The 580EX II has 14 Custom Functions, and the 430EX II has 9. They are accessed using the same instructions as for the AF-assist beam.

Setting Custom Functions on the flash

Setting the Custom Functions (C.Fn) on the flash is as easy as pushing the Backlight/C.Fn button, turning a dial, and pushing some buttons to make adjustments. The hard part is remembering what all the C.Fn numbers correspond to, and what each of the settings means in terms of performance. Most users set up their Custom Functions when they first get their flashes, and leave them set that way. Occasionally, a situation will arise where you need to move off of your standard way of shooting, and that will often involve changing one of your preset Custom Functions.

2.9 Anytime a Custom Function has been changed from the default settings, an icon alerts you to this in the Speedlite's LCD.

The Speedlites C.Fn. menu doesn't give you much information, only the function number and the setting number. I prefer to use the camera's External Speedlite control menu that includes the functions description whenever possible. The following tables list the C.Fn number of the respective Speedlites, what the settings are, and why you'd want to use them.

580EX II Custom Functions

Custom Function Number	Function	Settings and Description
C.Fn-00	Distance indicator display	0-meters/1-feet. Depending upon where you live, set this to the most common distance designation.
C.Fn-01	Auto power off	0-Enabled/1-Disabled. Auto power off turns the flash off automatically after a certain amount of inactivity (1.5 minutes to 15 minutes) to save battery power. Press the Shutter button or Pilot Lamp button to reactivate the Speedlite.
C.Fn-02	Modeling flash	0-Enabled (DOF preview button)/1-Enabled (Test firing button)/2-Enabled (both buttons)/3-Disabled. You can choose which buttons you want to use to fire the modeling flash.
C.Fn-03	Flash exposure bracketing (FEB) auto cancel	0-Enabled/1-Disabled. This controls the FEB auto cancel feature. After three shots are taken, FEB is automatically canceled. Set to 1 to continue taking FEB photos in sets of three.
C.Fn-04	Flash exposure bracketing (FEB) sequence	0, minus exposure, plus exposure/1-minus exposure, on stop, plus exposure. I set this to 1 because on my computer, I like to see the pictures in exposure order sequence to pick the best one.
C.Fn-05	Flash metering mode	0-ETTL II & ETTL/1-TTL/2-External metering: Auto/3-External metering: Manual. This allows the user to choose between several advanced metering systems of the Speedlite along with two modes of external metering, Auto and Manual, similar to older Thyristor-type flashes. In External Auto mode, the camera's ISO and aperture are set automatically by the Speedlite In External Manual mode, this information must be entered into the Speedlite for the function to operate properly.
C.Fn-06	Quick flash with continuous shooting	0-Disabled/1-Enabled. In situations where you don't need a lot of flash power output, by choosing 1, Quick flash can be employed for continuous shooting but operates only in camera single-shot mode. This allows you to shoot flash photos faster in Quick mode and not to have to wait for the Speedlite to fully power up.

continued

580EX II Custom Functions *(continued)*

Custom Function Number	Function	Settings and Description
C.Fn-07	Test firing with autoflash	0-1/32 power/1-full power. This allows the user to set the power level of the test flash. I use 0 to save battery life when I just want to check if the flash is working, and 1 when I'm metering the flash output with a hand-held light meter.
C.Fn-08	AF-assist beam firing	0-Enabled/1-Disabled. Use this setting when you don't need the AF-assist beam to focus the camera or in situations such as performance photography, where the beam would be distracting to others.
C.Fn-09	Auto zoom for sensor size	0-Enabled/1-Disabled. EOS digital cameras have one of three different sensor sizes. The Speedlite automatically recognizes the sensor size and adjusts the flash zoom for proper coverage.
C.Fn-10	Slave auto power off timer	0-60 minutes/1-10 minutes. This allows the user to set the time interval the Speedlite stays active when used as a slave. I prefer the longer setting to make adjustments to the set, model, or lighting without having the slave flash power down and have to be reset.
C.Fn-11	Slave auto power off cancel	0-Within 8 hours/1-Within 1 hour. You can specify the time range in which the slave unit's auto power off feature can be cancelled by the master. Again, I prefer the longer time setting.
C.Fn-12	Flash recycle with external power source	0-Flash and external power source/1-External power source. When the Canon Compact Battery Pack CP-E4 is used, the flash's recycling is powered by both the external battery pack and the internal batteries. When the Speedlite is in its default mode, it will draw power from both sets of batteries. When I'm using the CP-E4, I prefer to set Custom Function 12 for the Speedlite to the "1" setting to draw power from the battery pack only. That way I still have a fully-charged set of internal batteries available if the pack runs low on power. If the internal batteries become exhausted, shooting might not be possible. Switching to 1 allows the flash to be recycled only by the external power source; therefore the internal batteries will last longer. Even with the flash set to 1, the Speedlite will still require internal batteries to operate.
C.Fn-13	Flash exposure meter setting	0-Speedlite button and dial/1-Speedlite dial only. Setting 1 saves you a step and time by not having to press the Select/Set button on the Speedlite to access FEC settings. You simply turn the dial to the desired FEC setting and shoot.

430EX II Custom Functions

Custom Function Number	Function	Settings and Description
C.Fn-00	Distance indicator display	0-meters/1-feet. Depending upon where you live, set this to the most common distance designation.
C.Fn-01	Auto power off	0-Enabled/1-Disabled. Auto power off turns the flash off automatically after a certain amount of inactivity (1.5 minutes to 15 minutes) to save battery power. Press the Shutter button or Pilot Lamp button to reactivate the Speedlite.
C.Fn-02	Modeling flash	0-Enabled (DOF preview button)/1-Enabled (Test firing button)/2-Enabled (both buttons)/3-Disabled. You can choose which buttons you want to use to fire the modeling flash.
C.Fn-07	Test firing with autoflash	0-1/32 power/1-full power. This allows the user to set the power level of the test flash. I use 0 to save battery life when I just want to check if the flash is working, and 1 when I'm metering the flash output with a hand-held light meter.
C.Fn-08	AF-assist beam firing	0-Enabled/1-Disabled. Use this setting when you don't need the AF-assist beam to focus the camera or in situations such as performance photography, where the beam would be distracting to others.
C.Fn-09	Auto zoom for sensor size	0-Enabled/1-Disabled. EOS digital cameras have one of three different sensor sizes. The Speedlite automatically recognizes the sensor size and adjusts the flash zoom for proper coverage.
C.Fn-10	Slave auto power off timer	0-60 minutes/1-10 minutes. This allows the user to set the time interval during which the Speedlite stays active when used as a slave. I prefer the longer setting to make adjustments to the set, model, or lighting without having the slave flash power down and have to be reset.
C.Fn-11	Slave auto power off cancel	0-Within 8 hours/1-Within 1 hour. You can specify the time range during which the slave unit's auto power off feature can be cancelled by the master. Again, I prefer the longer time setting.
C.Fn-14	Flash range/ Aperture info.	0-Maximum distance/1-Aperture display. This allows the LCD display of the Speedlite to give you different information. When you press the Shutter button down halfway, the maximum effective range (distance) of the flash will be displayed with setting 0, and the aperture range will be displayed with setting 1.

Note that Custom Functions 03, 04, 05, 06, 12, and 13 from the 580EX II are missing from the list for the 430EX II. They are not available on the 430EX II. The MT-24EX and MR-14EX Speedlites also include slightly limited Custom Function menus.

Setting Custom Functions via the camera

Several Canon camera models now allow you to control the Speedlites' exposure modes, settings, and Custom Functions right from the camera's LCD monitor. This is much more intuitive, and I enjoy seeing the large menu telling me what settings I have chosen. It's also a huge time-saver when I can make all the settings for both pieces of gear on only one of them and not have to use another gadget's menu, buttons, and dials. I have enough to do just trying to get the shot!

Currently, the 1Ds Mark III, 1D Mark III, 5D Mark II, 40D, 50D, the latest Rebels, and the new 7D support this feature and offer External Speedlite control. Canon plans to offer this feature with all future dSLR cameras.

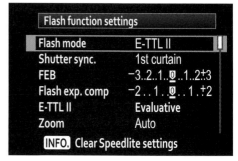

2.10 The External Speedlite menu of the Canon 5D Mark II with a 580EX II attached

Auto Off mode

Both the 580EX II and 430EX II have an Auto off or standby mode. The Auto off function puts the flash to sleep when not in use, which helps conserve battery power. When the Speedlite goes into standby mode, tap the Shutter button or switch the Speedlite off and then on. When using the ST-E2 Speedlite transmitter, simply push the Test fire button on your camera to wake up the slaves.

The Speedlite defaults have the standby set to automatic. This is fine if most of your shooting involves having the Speedlite connected to the camera. However, when using the Speedlites remotely, especially with third-party remotes such as PocketWizards or Radio Poppers, they can sometimes power down when you are making set, model, or lighting adjustments. In these situations, I turn the standby function off by selecting it in the C.Fn menu; this is C.Fn 10 on both the 580EX II and 430EX II. Change its status using the same methods used to change the settings for the AF-assist beam, described earlier in this chapter.

As you get more comfortable with small-flash lighting, you'll be moving the flashes off camera and using many of the adjustments described in this chapter to create images you've only imagined before.

Flash Photography Basics

Early in my photography career, I felt that flashes caused about as many problems as they solved. Even with the latest flash technology, which was auto-thyristor circuitry at the time, my results were less than stellar and often inconsistent. While attending a Dean Collins workshop about light in general and studio flash in particular, I began to see light in a new way. Photography became less about the gear, and more about the light. It was an epiphany, and it made a lasting impression on me.

Taking the time to learn about using flashes to light your photos will also benefit your natural-light outdoor photography. You'll be sensitive to the nuances and quantities of light in a brand new way, and you'll now be positioning the camera to take advantage of it. You'll literally begin to "see the light."

Lit by two Canon Speedlites, this 580EX II using the included tabletop stand and a Sto-Fen diffuser is set to trigger remotely.

Studio Strobes or Speedlites?

While studio lighting systems fall into two main categories — continuous lighting or "hot lights," and flash lighting — I will only discuss flash lighting in this chapter. Flash lighting, whether Speedlites or studio strobes, are convenient to use because you can vary the light output and they pack a lot of power. Hot lights are, well, hot and that heat can have a negative effect on your subject. They may be more appropriate for larger scenes or subjects that can't tolerate the bursts of light from a flash.

There are three main types of flash lighting systems that you should consider before you start to outfit your studio and purchase equipment. The first and most powerful group is a pack-and-head type system, which includes individual flash heads connected by cables to a power pack. These systems are usually supported by a large number of light modifiers, such as softboxes, grids, and snoots, and are well suited to everyday studio use. However, they tend to be rather large, not easily transported, and require AC power to operate.

The second group consists of monolights, and their design combines the power supply and flash head into one convenient unit. They are fairly easy to transport and have a good range of output adjustments, yet they still require AC power or a portable battery to operate.

The last group is, of course, small dedicated flashes, or in this case, Speedlites. While lower in power output than the previous two systems, their portability, E-TTL capabilities, and ease of use make them great candidates for travel and location work.

In order to make an informed decision concerning what type of flash lighting system to purchase, you also need to address a few other considerations. Let's consider some of the pros and cons of the three different lighting systems.

- ▶ **Cost.** Without a doubt, Speedlites and monolights are the most economical of the three systems I mentioned. Many times, the cost of studio flash systems is beyond the reach of a casual photographer's budget. Speedlites are more financially feasible in the long run and can last for years of regular use.

- ▶ **Portability.** Speedlites win in this category. You still need stands and light modifiers for many types of shooting, but the Speedlites themselves are small and very portable, and offer a good range of power outputs. You can also use gorilla pods or small clamps to easily mount Speedlites -- not something you can do with monolights or studio flash heads.

▶ **Power supply.** Speedlites run on AA batteries. You don't have to rely on AC current and long extension cords to power these small flashes. For location work, you can power studio flashes with auxiliary batteries, but the battery can sometimes weigh more than the actual flash heads. That's one more piece of equipment that you have to purchase, carry, and maintain.

When getting ready for a photo shoot, I always put a freshly charged set of rechargeable batteries in the Speedlites I intend to use. One set of batteries can last for hundreds of photos, and often last for the entire assignment or event. You should always have at least one set of extra batteries along for each Speedlite you plan on using.

▶ **Ease of use.** After you arrange and configure your Speedlites, you're ready to shoot, and are able to control flash output from a central location. With studio flash systems, you make all of your adjustments either at the flash head (if using monolights) or at the power pack. Tricky lighting setups can involve a lot of walking back and forth from the camera, changing the flash output settings.

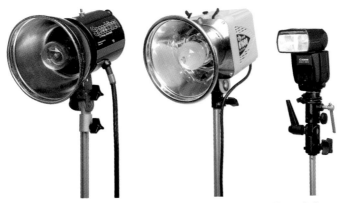

3.1 Three different types of flash lighting equipment. From left to right, a Speedotron 102 flash head that connects to a 2403B power pack, an AlienBees B1600 monolight, and a Canon 580EX II Speedlite.

▶ **TTL.** With studio flash systems, you don't have the advantage of Through-the-Lens (TTL) metering. When using Canon's version of TTL metering, E-TTL (E-TTL II), the camera automatically adjusts the flash output according to the desired exposure, and measures the distance to the subject as calculated from the lens distance reading. This automatic adjustment is a huge advantage of using Speedlites — you can just set up your Speedlites for E-TTL, set the groups and channels, and start shooting. The Canon Speedlite System and your camera do all the rest.

 For information on setting groups and channels, see Chapter 4.

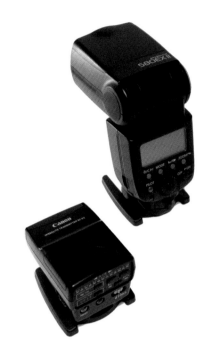

3.2 A 580EX II or an ST-E2 (or one of the macro Speedlites) is all you need to control lighting output of multiple Speedlites right from your camera.

Many times, your budget will determine what you purchase for location lighting, but it's likely that a set of Speedlites is the most convenient option, especially if you like to shoot quickly and need the advantage of portability. Studio units have cords that people can trip over, and they contain high voltage that can be dangerous if you don't maintain your equipment. However, studio flash systems offer several advantages over Speedlites in many shooting situations. A few of them are:

▶ **Power.** For sheer raw light output, pack-and-head and monolight systems can't be beat. They offer stable light sources as long as there is a receptacle to plug in to. They also allow you to shoot in controlled environments at higher f-stops, resulting in greater depth of field. There is, however, a price to pay for all that flash power, usually in the form of portability and cost.

▶ **Recycling time.** Recycling time refers to the amount of time it takes the flash to be powered up fully to make another exposure. Speedlites typically take .1 to 6 seconds between shots, and as batteries lose power, they take longer to recharge the flash. Power packs connected to wall outlets don't have this issue but still need time to recycle.

▶ **Modeling lights.** Studio flashes usually have the capability to illuminate a subject using a modeling light. A modeling light is a secondary light element in the flash head that when turned on, simulates the light output of the flash, allowing the photographer to model highlights and shadows and adjust the lighting output and placement. Although the 580EX II and 430EX II have a modeling light feature, the modeling light isn't continuous (only 2.5 seconds) and is of limited use to help you preview the lighting effect on the subject.

> **NOTE** The modeling light from a Speedlite fires a quick 2.5-second series of flashes. It doesn't provide constant lighting so that you can see where the highlights and shadows fall. It also depletes your battery power fairly quickly and can overheat your flash tube if you keep on using it, requiring a costly repair.

▶ **Accessories.** Studio flash systems have long offered a wide array of light modifiers and accessories. Diffusion panels, grids, snoots, barn doors, gobos, gel holders, umbrellas, octabanks, beauty dishes, and softboxes are common accessories for all commercial studio systems. It used to be that small flash users often had to create their own accessories, but with the recent popularity of small flash use, many vendors now market these items, such as the Honl Speed System from Expolmaging.

3.3 Your first light modifier should be this Sto-Fen diffusion dome. This custom-made, frosted-plastic dome scatters the light emitted from a Speedlite to soften it, and it protects the flash face. Sto-Fen manufactures a large assortment of these diffusion domes — make sure you get the right one for your Speedlite model.

Only you can decide which system best meets your shooting needs. Much less expensive than the other two types of lighting gear, Speedlites offer the photographer a powerful, lightweight alternative that provides beautiful light in a wide array of shooting situations.

Concepts of Lighting

When most people think of studio photography, they tend to think of products and portraits, and in truth, these are the main activities of my photography studio. Speedlites allow the photographer to take quality studio lighting out of the studio for

location work on a variety of subjects, such as weddings and special events. In those situations, you will often use your Speedlites with natural light (possibly from a window or skylight), ambient incandescent light, or fluorescent light, or some combination of the three. Location lighting can be tricky outdoors, fooling the camera's metering system, but at some point in the creative process, the ambient light must be dealt with. Having different Speedlites to light the subject, create fill, and illuminate the background can help solve this problem.

You can find additional information on using Speedlites for the specific scenarios within various categories of photography in Chapter 6.

Using multiple Canon Speedlites wirelessly as your main lighting system is extremely convenient. The wireless E-TTL system, while superb on its own most of the time, allows you creative input to control the lighting by offering ratio controls and exposure compensation in shooting situations that demand fine-tuning of the light.

Studio lighting

If you are fortunate enough to be able to set up a dedicated space for indoor photography or want to establish a studio of your own, Speedlites can help you create looks and styles of lighting like no other. If you're just starting out and experimenting with studio lighting, a living room, basement, or garage will do just fine. Taking notes or jotting down lighting diagrams, exposure notes, flash ratios, and power levels in a small book offers the advantage of repeatable results. The more you work with your equipment, the more intuitive it will become, and you'll be able to produce flash-lit setups much more quickly.

Placement

As you set up your shooting space, you need to plan how you want to light your subject, and what sort of feeling and how much mood and drama you want to create. Previsualizing how you want the image to appear is a concept Ansel Adams felt very strongly about and used judiciously to create his most powerful photographs. This approach can also benefit you and ensure that you achieve the results you seek.

When planning out your photographs, keep these ideas in mind:

▶ **Visual impact.** The first thing to consider is how to create a photograph of your subject that has strong visual impact. You have several tools at your disposal to achieve this, such as composition, color, background, f-stop and shutter speed selection, and lighting intensity and placement. If you break down the shot in

terms of the individual problems that need to be solved, reverse-engineering it will expose several creative solutions.

▶ **Direction.** Especially when shooting with a mix of ambient and flash lighting, the direction of the lighting is very important. You must take into account where the light is coming from and where the shadows fall, and try to mimic that in your lighting placement. You can use reflectors and fill flash to brighten problem areas, but the thing you want to avoid is crossed, overlapping shadows. Because we live in a world with only one sun, your lighting pattern should look that way, and so overlapping shadows is a dead giveaway of poor flash use. The indoor studio relieves you of that burden and gives you complete control over the lighting so that this consideration becomes less significant.

▶ **Amount.** The terms *high-key* and *low-key* are designations that photographers use to describe bright and dark lighting setups. High-key lighting is bright and evenly lit, usually having a bright background, as illustrated by figure 3.5. Conversely, low-key lighting is dramatic lighting, often featuring dark, shadowy areas, as demonstrated in figure 3.6.

3.4 Lights, modifiers, and reflectors are positioned for maximum impact when setting up studio still-life images. This product shoot also involves adding a projected background image into the lighting mix.

3.5 This glassware shot is an example of a high-key image.

By comparing the images in figures 3.5 and 3.6, you can see how using high- or low-key lighting can completely change the feeling of an image.

Having several Speedlites to work with is great, but don't fall into the trap of thinking that's the only way to light your subjects. You can create stunning photographs with just one Speedlite, as many photographers do on a regular basis. When I'm on location and want to travel light, I look for natural reflective elements to open up the shadowed side of my subject, and position the subject in such a way as to take advantage of these elements. Another approach, if I'm using just one Speedlite, is to use the Canon Off-Camera Shoe Cord OC-E3. Moving the Speedlite off-camera results in greater control over the lighting angle, and connecting the Speedlite with this accessory still gives you all the flash-to-camera E-TTL communication capabilities.

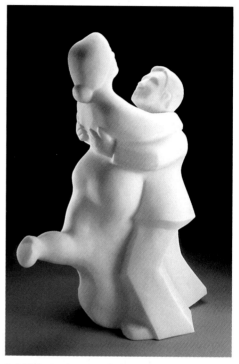

3.6 This sculpture of two dancers is an example of a low-key image.

Portrait lighting types

When speaking about studio lighting patterns, it's best to keep a few definitions in mind. Photographers speak of lighting by using terms like *key*, *fill*, and *bounce* to describe the lighting placement, the intensity of the light source, and how large or small the light source is.

▶ **Key.** The key or main light is the light that illuminates the subject and tells the story. It can be a shaft of sunlight, a reflected light source, cloudy sunlight, or a flash.

▶ **Fill.** This is added light that is reflected back into the shadow areas of an image.

▶ **Bounce.** Anytime the light source is aimed away from the subject toward another surface to reflect light back onto the subject, this is referred to as bounce flash. The light bounces off the surface, picking up whatever color it is, and scatters the light in the direction of the subject, producing subtle gradations of softer light.

The two basic types of studio lighting techniques for making portraits are called *broad* and *short* lighting. You have probably already shot some portraits using these styles and not even thought about it. I try to include different types of portrait lighting patterns during shoots, which is a plus for editors and art directors who need a lot of layout choices.

Broad (or wide) lighting refers to a key (main) light illuminating the side of a subject's face as they are turned toward the camera (see figure 3.7). Short lighting is created when the key light is positioned to illuminate the side of the subject's face that is turned away from the camera (figure 3.8), emphasizing facial contours.

3.7 Broad lighting illuminates the side of the subject that is turned toward the camera.

Broad and short lighting techniques apply when shooting outdoors as well. When shooting portraits outdoors, and using the sun as your main light and the Speedlite as a fill, the same techniques can be applied. Using sunlight as your main light source, positioning your subject to take advantage of these principals can produce flattering results for your outdoor portraits.

Lighting ratios represent the difference in light intensity between the shadow and highlight areas of your subject. Lighting ratios are expressed numerically, for example, 2:1, which means one side of the subject is twice as bright as the other. You use ratios when you are planning how much contrast you want in a portrait or studio setup. Lighting ratios determine the amount of highlight and shadow detail in your images. You can get very accurate measurements for lighting ratios using Speedlites in E-TTL mode. You can adjust ratios by making adjustments on the master unit for each flash. Here, the figure shows a portrait taken with a 2:1 lighting ratio.

3.8 Short lighting illuminates the side of the subject that is turned away from the camera.

Other lighting styles to consider include:

▶ **Hard lighting.** Hard light is also called specular light and can be used effectively in photographs to show texture and highlight form. It can be described as light emitted from an undiffused source and is considered harsh, especially for portraits where the flash is used in fairly close proximity to the subject. Harsh light is strong, contains a lot of contrast, and when used for portraits, brings out skin texture and highlights flaws.

▶ **Diffused/soft lighting.** Much more desirable when shooting portraits, soft lighting produced by firing your Speedlite through a translucent umbrella or using a diffusion dome over your flash head can help soften the lighting in a portrait, as shown in figure 3.9. This technique provides much more natural lighting effects and produces realistic-looking skin.

▶ **Bounced/angled lighting.** Bounced or angled lighting involves aiming your Speedlite into a reflective umbrella or toward the ceiling, or moving the flash off of the camera to fire remotely or by using the previously mentioned Off-Camera Shoe Cord 3. Bouncing the light off of these surfaces scatters the light rays to strike the subject from many different angles, producing a softer, more diffused look to the image.

▶ **Front lighting.** From a camera-mounted Speedlite or onboard pop-up flash, this type of lighting is often the least flattering, compressing the subject and exacerbating any surface skin shine. But when used in the studio with diffused lighting

sources such as a beauty dish, octabank, or softbox, this type of lighting is very forgiving and provides a beautiful, glamorous look.

3.9 This portrait of naturopath Reba Akin depicts a 2:1 lighting ratio between the main and fill Speedlites. A third Speedlite fitted with a green gel was used on black background paper.

▶ **Mixing ambient or natural lighting.** While slightly more difficult to manage, you are often faced with mixing available light sources in a scene, whether from existing indoor ambient lighting or the natural light streaming from a window. You may even want to preserve the tone of the existing light, and only use a flash to complement the metered reading of the ambient room light as fill. Or, you may want to omit the ambient light altogether and only rely on your Speedlites.

Mood and drama

The subject can be strong and visually interesting but you create the most mood and drama in your images with creative use of lighting where it's all about the feel of the photograph. Hard lighting can be useful in this instance, where you may want a harder look, stronger shadows, and chiseled features. It can mimic the lighting of an urban street scene at night or full-on direct sun.

Mood and drama combine with your subject to establish a sense of time, place, or location in your given scene. I always strive to photograph my subjects in lighting that looks natural and speaks to who they are, what they do, and where they live. Mood and drama are the keystones of successful photojournalism and are driven by creative use of composition and lighting. Be sensitive to the role of lighting to create these qualities that can lift your photos above the everyday photographs of less-talented photographers.

3.10 Undiffused flash, whether on-camera or off, can produce less-than-flattering results and increases the likelihood of surface skin shine. But it can also be a hard light source and can work well when positioned to only highlight what you want it to, as in this image of fashion maven Jacqueline Joseph in a film noir style.

3.11 Diffusing the flash with a light modifier such as an umbrella, softbox, or octabank produces a softer, much smoother look for portraits.

Lighting patterns

Most portrait photography utilizes some interpretation of five time-tested lighting patterns: butterfly/Paramount, loop, Rembrandt/45, split lighting, and modified split/rim lighting. You have probably used these patterns already and just didn't know what they were called. When setting up to create portraits, these five lighting patterns, each with their own strengths and weaknesses, should be considered as you begin. I also include shadowless lighting information for when a lighting pattern is not desired.

Butterfly/Paramount

Also referred to as Hollywood glamour style, this type of lighting is often used in model and celebrity photography. It gets its butterfly designation from the shape of the shadow that the nose casts on the upper lip. You achieve this type of lighting by positioning the main light directly above and in front of your model. Studio photographers usually use a softbox, octabank, umbrella, or beauty dish to create this look.

This lighting style is also referred to as Paramount in some circles. It was used so extensively by Paramount Studios in Hollywood's golden age, that this lighting pattern became synonymous with the studio's name.

3.12 Tessa Duncan poses for an example of butterfly-style portrait lighting.

Loop

Probably the most commonly used lighting technique for portraits today, A minor variation of Paramount lighting, loop lighting is achieved by lowering the key light and moving it more to one side of the subject, making sure to keep the light high enough so that the shadow cast by the nose — the loop — is at a downward angle on the shadowed side of the face, yet low enough to create catch lights in the eyes.

In loop lighting the fill light is positioned on the camera-subject axis. The fill light's intensity is lower than the main so that it does not cast a shadow of its own to maintain the

3.13 Loop-style portrait lighting

3.14 Rembrandt-style portrait lighting

one-light look of the portrait. To be considered true loop lighting, the loop shadow from the nose area should not touch the shadow area on the side of the face. This is a very flattering lighting pattern I use all the time.

Rembrandt/45

Rembrandt lighting is a name given to the lighting effect that the old master used for the lighting effects in many of his paintings. It's basically broad lighting where the shadow from the nose connects with the shadow on the short side of the face, thus creating a triangle of light on that side of the face. If the nose shadow doesn't connect with the cheek shadow, it's not considered to be Rembrandt lighting, just broad light-ing. The Rembrandt style is created by placing the light at a 45-degree angle position, higher than the subject but still low enough to produce a catch light in the eyes.

Split lighting

Placing the main light at a 90-degree angle to the subject throws the other side of the face into deep shadow and creates mood, drama, and a bit of mystery in your portrait. This technique gives the photographer less of a canvas to work with, as half the face

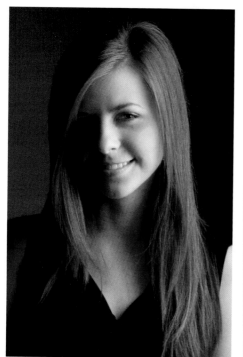

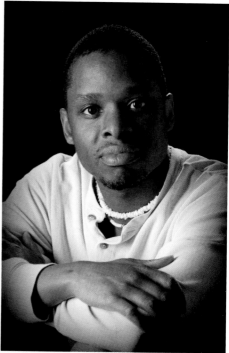

3.15 Split-style portrait lighting

3.16 A portrait of photographer Roland Simmons using the modified split/rim lighting style. Two Speedlites were used for this image: one is placed in a portable softbox for the main and the second, undiffused, is used for the rim light.

is in shadow, but it can add great power to a portrait. Having a little concealer make-up or powder on hand to help your subject look their best can reduce the probability of skin texture. This type of lighting from the side shows off any texture in the light's path and highlights any skin imperfections.

Modified split/rim lighting

This style of lighting involves adding a secondary light source to the split-lighting mix, often undiffused, to create a rim of light around the subject that separates them from the background. In figure 3.16, a rim light is used to create separation of Roland's black hair from the black background. This establishes boundaries for his head shape and provides a more three-dimensional look to the portrait. This rim light can also be fitted with a colored gel to add some contrasting or complementary color to the image, while retaining all the separating qualities afforded by the lights' positions.

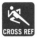 For more information on colored gels, see Chapter 5.

Shadowless

Several configurations of equipment will get you into the realm of shadowless light-ing. Ring lights that encircle the lens are often used, as well as positioning light sources above and below or to the left and right of the subject's face. Combined with setting the light output to equal ratios, shadowless lighting is very forgiving to skin tones and delivers a very clean, stylized look. Fine make-up and attention to skin detail are good to be aware of when using this lighting setup.

3.17 Shadowless-style portrait lighting

Using Speedlites for outdoor locations

Using Speedlites to light up your outdoor scenes is fun and convenient. The units provide quite a solid punch of light for their small size. They are also small enough that you can stick them in places you wouldn't expect to be able to put a light in and

create light with dramatic results. Unlike in the studio, ambient light becomes more of a consideration and major player in your lighting mix, and you'll first have to decide which way you want to go with it.

The first approach is to use E-TTL with fully automatic camera settings and hope for the best. In some fast-breaking shooting situations, this is all you can do. The next method involves using E-TTL but changing up the white balance settings to accurately match the natural lighting conditions and adding a colored gel to the flash to match. A third approach that is a little more creative is to shoot with manual settings, forget accurate white balance for a moment, pick a totally inappropriate color temperature for the ambient light, and add a gel to the flash to push it back to neutral or even warmer. I discuss color temperature, white balance, and balancing for ambient light in the next section.

Whatever you decide, taking a Speedlite along on location shooting is smart insurance that you will get the shot, even under the worst of conditions. Because of their small size, you can quickly make many of the light-shaping tools you may need on the fly from some paper and cardboard. More professional third-party accessories are now available for a variety of hot shoe-mounted flashes.

3.18 Two Speedlites, one with a blue gel, were used for this dramatic nighttime portrait of video producer Vernon Vinciguerra.

Light diffusers or reflectors are important tools to use for any type of portraits or macro work, but using a Speedlite outdoors for those shooting situations is just as easy. The camera's LCD rapidly displays your work for review, allowing you to quickly make adjustments to your camera setting and lighting mix and keep shooting. This way, you can see if you are getting the lighting quality you wish for or need to add diffusion or reflectors to the lighting set up.

Advantages of using flash when taking shots outdoors include the following:

▶ **Creates a fill light.** Using a Speedlite as a fill light complements the ambient light and opens up shadowed areas, providing more information and less contrast to the viewer. It also adds nice catch lights to the eyes that add a little sparkle and pizzazz to the images. By reducing the flash with Flash Exposure Compensation (FEC) or power output when in Manual mode to just under the ambient light levels, the flash's contribution to the scene will look natural and not readily apparent.

▶ **Reducing contrast.** Speedlites can also improve the tonal range of an outdoor portrait in high-contrast situations. Mostly, I try to avoid direct sun for shooting portraits but when I can't, such as during a wedding ceremony, using a Speedlite can help reduce the difference between the brightest and darkest values of the image by raising the values of the darker areas to be more in line with the darker middle tones.

▶ **Creating light in the dark.** You can create extremely dramatic portrait images by using the changing colors of an evening sky as a background, with your Speedlite as the main light, and keep right on shooting as night falls. City lights come on, and a whole new background palette is offered up as shadows grow long, colors intensify, and daylight fades away. As long as there's enough light to focus by, having a Speedlite along can extend your shooting time and provide much enjoyment for the process.

Remembering light theory

Without getting into a dissertation on photons and Sir Isaac Newton, the light theory I'm suggesting you remember here is simply that light goes in one direction unless diffused or broken up. Oh sure, you can bend light and shape it with modifiers, but the original intent of the light should look consistent with the scene. Opposing lights can be used as rim lights or fill, but should remain low enough in value so as not to confuse the viewer and create crossed shadows. You can get away with a little more rule-breaking in advertising and product photography than you can in documentary or photojournalist work. Keep the light as simple or dramatic as you want, but remember to pay attention to the shadows to see where they fall.

The most important aspects of using flash to keep in mind are that aperture selection controls the amount of light from the flash on the subject and shutter speed controls the light value of the ambient light in the photograph. It is critical to understand this distinction. This is how photographers control flash output and ambient light levels and select settings that make the combination look natural.

Setting power output

With location photography, the ambient light must be carefully evaluated to determine if it is adequate to use as the main light source. The ambient light can provide a sense of the subject's environment that helps set the prevailing scene, particularly in indoor locations. I try to make the most of ambient light and use it as the main or fill light source when possible. As a result, I use Speedlites to boost ambient light and to help define areas in the scene that are poorly lit or to create edgier light.

To this end, I use the Speedlite's E-TTL ratio settings or manual power output controls to choose and fine-tune my light for the look I want. Adding light modifiers may absorb some of the power output, but this is no problem for E-TTL to adjust for automatically and is noted and figured into the exposure calculation. Manual flash mode may require you to boost the flash power, which is diminished slightly by the accessory. Make sure that any light modifier or gel does not cover the flash sensors.

Color Temperature and White Balance

Light, whether it is sunlight, moonlight, fluorescent light, or light from a Speedlite, has a color that can be measured using the Kelvin scale. This measurement is also known as color temperature. While our vision system can automatically adjust for changes in the color temperature, a digital camera has to measure and approximate it in any number of lighting situations through white balance adjustments. If your Canon digital camera is set to an automatic white balance, it automatically adjusts the white point for the shot you are taking because white is most dramatically affected by the color of the light source. The result of using a correct white balance setting with your digital camera is correct color in all of your photographs.

If you shoot JPEG images, the white balance is set in the camera by the preset you choose. If you shoot RAW images, the white balance setting is only "noted," and you can set or adjust the white balance in a RAW conversion program after the image is captured.

What is Kelvin temperature?

Similar to Fahrenheit and Celsius, Kelvin (K) is a temperature scale, normally used in the fields of physics and astronomy, where absolute zero (0K) denotes the absence of all heat energy and molecular movement.

Kelvin is a scale for measuring temperature. Zero degrees Kelvin corresponds to –459.67 degrees Fahrenheit. The relationship between color and Kelvin temperature is derived from heating a "black body radiator" (a piece of black metal) until it glows. The particular color seen at a specific temperature is the color temperature. When the black body is hot enough and begins to glow, it is dull red. As more heat is applied, it glows yellow, and then white, and ultimately blue.

For most people, Kelvin and color temperature are opposite to what you generally think of as "warm" and "cool" colors. We respond to colors and light on an emotional level that does not correspond to the Kelvin temperatures. On the Kelvin scale, what we think of as "hot" or "warm" colors represents the lowest temperatures. Blues and greens which we perceive to be "cool" or "cold" colors actually represents the highest temperatures.

Choosing the white balance

Canon dSLRs offer four methods to setting white balance. This gives you flexibility to use different approaches in different shooting scenarios. Here are some examples that provide a starting point for using each of the three methods:

▶ **Use Auto white balance.** For shooting quickly in situations where there is no time to perform a custom white balance, choose Auto white balance. The camera takes into account the various ambient light sources and makes its best assumption on providing neutral colors.

▶ **Set a custom white balance.** Setting a custom white balance is an option that produces very accurate color because the white balance is set precisely for the light temperature of the scene. To use this option, you shoot a white or gray card and select the image, and the camera imports the color data and uses it to set the image color.

 See Appendix D for more information on how to use the gray card and color checker included in this book.

You can use the custom white balance as long as you're shooting in the same light, but if the light changes or you add a Speedlite, you have to repeat the process to set a new custom white balance.

▶ **Use a preset white balance setting.** For outdoor shooting, especially in clearly defined lighting conditions such as bright daylight, an overcast sky, or fluorescent light, using a preset white balance setting produces accurate color in most cases. The exception is shooting in tungsten light and using the Auto White Balance (AWB) option, which I feel produces less-than-ideal color reproduction. Otherwise, the preset white balance settings have very good color and hue accuracy, and acceptable color saturation.

▶ **Select a specific Kelvin temperature.** If you happen to know the specific Kelvin temperature to the lighting equipment you're using, go ahead and choose the Kelvin (K) setting and select the temperature to match them.

The file format you choose determines whether the images are stored on the CF card in JPEG or in RAW format, and the quality level you choose determines the number of images you can store on the card, as well as the overall image quality and the sizes at which you can enlarge and print images. RAW format also allows you to set the white balance after the fact, when you are processing the images. With JPEG you are locked in to the white balance settings you chose so choose wisely.

Your choice of file format and quality will also be situation- and/or output-specific. For example, I shoot RAW images during portrait sessions, industrial location shoots with mixed lighting, etc. but then I might switch to Large/Fine JPEG format for a wedding or luncheon reception because I know that these images will likely be printed no larger than 5 × 7 inches. But for most other assignments, such as studio portraits and artwork, I shoot only RAW images to get the highest image quality and to have the widest latitude for converting and editing images.

For RAW capture, there are easier techniques. For my work, I alternate between shooting a gray card and setting a custom white balance, or I shoot a Calibration Target from PhotoVision, which has three sections of black, gray, and white, and then color-balance a batch of images during RAW conversion in Adobe Photoshop Lightroom. Both techniques work in the same general way; they only differ in when you set the white balance.

With one, you set the white balance before shooting, and with the other, the click-balance technique, you set the white balance during RAW image

3.19 PhotoVision's 14-inch Calibration Target

3.20 Tungsten white balance, 2850K

3.21 Auto white balance, 3750K

3.22 Fluorescent white balance, 3800K

3.23 Custom white balance from a calibration target, 5050K

3.24 Daylight/Flash white balance, 5500K **3.25** Cloudy white balance, 6500K

conversion. However, if you are shooting a wedding and showing JPEG images onsite during the event as a slide show, then setting a custom white balance as you go along is a good approach because the color is correct as you shoot.

It's always a good practice to try and get an accurate white balance when shooting so that you are not distracted by off colors while shooting or while making selections before image processing.

White balance presets

White balance options give you a variety of ways to ensure color that accurately reflects the light in the scene. You can set the white balance by choosing one of the preset options, by setting a specific Kelvin color temperature, by setting a custom white balance that is specific to the scene, or by selecting Auto white balance. These settings may not be possible on all EOS cameras. The next series of images shows the difference in white balance settings from a photo shot with multiple Speedlites. This photo was shot in RAW format after performing a custom white balance off of a target, then exported as shot in each of the color presets. Each photo represents a different white balance setting, with color temperatures ranging from 2850K to 6500K.

The lower the color temperature, the more blue appears in the image. The higher the color temperature, the more red and yellow appear in the image.

> **TIP** Don't fall into the habit of always relying on the automatic white balance settings, because AWB can't always solve mixed light situations, especially when adding Speedlites. Once your camera and flash are set up, it takes less than a minute to perform and set a custom color balance.

3.26 Color balance nightmare. Setting the white balance preset to tungsten, adding two full orange gels to the Speedlite, and then performing a custom color balance for that value, pushes the blue to an extreme level and yields otherworldly, surreal colors.

Consider these approaches regarding white balance and the use of Speedlites:

▶ **Speedlites are set to 5500K.** Speedlites produce light with a color temperature of 5500K, which is also the same color temperature as the daylight white balance setting. It's your decision when shooting subjects with a lot of ambient light and Speedlites, so try the different white balance presets on your digital camera to see which ones you like, gel the flashes to match the ambient light, or just keep your camera on the AWB or the Flash preset.

▶ **Cooler color temperatures appear blue.** If your digital camera is set to a white balance setting that represents lower color temperatures (below 5000K), your images appear bluer, or cooler.

▶ **Warmer color temperatures appear orange.** Setting your digital camera to a white balance setting that represents higher color temperatures (above 5000K) makes your images appear more orange, giving a much warmer appearance to skin tones.

▶ **Automatic white balance settings can be very accurate.** Today's digital cameras perform a very accurate job of measuring a subject's white balance. Setting your digital camera to an automatic white balance setting often results in a correctly color temperature-balanced image. When using Auto white balance and a Speedlite with an E-TTL II-compatible digital camera, the Speedlite sends color temperature information to the camera, usually resulting in a more accurate white balance than when it is set to flash white balance.

By keeping your digital camera set to the automatic white balance setting, you can shoot quickly in RAW mode and not worry about incorrect color temperatures. You'll probably want to get it as close as possible, but you don't need to be as accurate as you do when shooting JPEGs. You may find that your camera's ability to evaluate and produce a pleasing white balance is more accurate than adjusting white balance settings manually.

▶ **Shoot in RAW format for ultimate control of white balance.** All Canon dSLR models offer you the ability to shoot your images in RAW mode. When shooting your images in RAW format instead of JPEG, you have the ability to adjust the white balance of your images while or after you transfer the files to your computer. By using the RAW conversion software that is included with your digital camera or using Adobe Camera Raw or Adobe Photoshop Lightroom 2.0, you can adjust the white balance of an image after you've imported it into the computer.

Balancing for the ambient light

The Speedlite's small size and high flash output make it ideal for professional location lighting when your scene is of a manageable size. Speedlites can be placed almost anywhere and set to produce just the right amount of light that you need to create a dramatic portrait or interior shot. The exposure controls of the camera in tandem with the settings of the compatible Speedlite make it simple to balance ambient and flash light.

Sometimes you'll find yourself shooting in locations or situations where you need all the ambient light you can get, but still need your Speedlite to add some snap to the colors. In these situations, I set my camera to the white balance preset, and add a colored gel to my flash to match the ambient light. Personally, I like the Honl Color Correction gels from InfoImaging for their easy application, but you can buy larger sheets of the same gels from any theatrical supply house and cut your own.

The three main color-correcting gels that I use on my flash are:

▶ **CTO.** Color Temperature Orange gels are used to color-match the flash to tungsten light, resulting in a more realistic look. These are the gels I use most, as I often shoot in indoor locations and need to match the Speedlite color temperature to the ambient light. CTOs come in 1/8, 1/4, 1/2, and full strength. One full-strength CTO will usually get you back to neutral, but I often add another full- or half-strength CTO to warm up my subject.

▶ **CTB.** Color Temperature Blue gels are used less frequently, but I use them in situations where I need to balance tungsten to daylight, such as when there is a window in the scene. CTBs come in the same strengths as CTOs.

▶ **Green.** For fluorescent conversion, green gels color-match the flash to fluorescent light and are great when you are shooting in office situations. There are so many flavors of fluorescent light out there now, this has become more difficult to get an exact match with gels.

More gel options are discussed in Chapter 5.

Using Bounce Flash

When shooting photos with a Speedlite attached to your camera, you can create softer light by bouncing the light from your flash off of the ceiling (or a reflector) onto your subject. Bounce flash provides softer light and more evenly lit images.

Bounce flash is a technique used indoors in many situations and can be accomplished in a couple of different ways. Most commonly, your flash head needs to be positioned so the light is pointed away from the subject but toward a ceiling or wall, thus bouncing the light from that surface onto your subject. If a ceiling or wall isn't close by, you can use attachable bounce reflectors such as those by LumiQuest, Honl, Westcott and others. LumiQuest (www.lumiquest.com) makes an entire line of bounce flash reflectors and accessories.

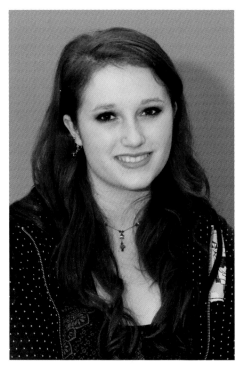 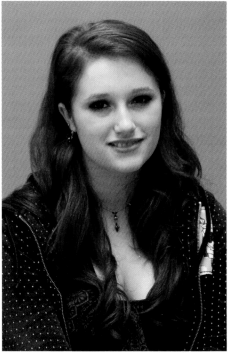

3.27 Portrait using the flash in the normal position

3.28 Portrait using the flash in the bounced position

Why and when to use bounce flash

Bounce flash is useful when you need to soften the light falling on the subject, spread out the light to cover a larger area, or just want to produce a more natural lighting effect. These situations can include the following:

▶ **When the camera is close to the subject.** If you're positioned close to your subject when taking photos, having your Speedlite pointed directly at the subject can result in a blown-out or over-lit photo. Bouncing the flash off the ceiling (or even a wall) can help soften the light.

▶ **When even illumination is desired.** If you're taking a photo of a scene where you want more even lighting throughout the frame, bounce flash helps you more evenly illuminate the entire area. Examples are when taking photos where you want both the foreground and background evenly lit. Using a bounced flash results in more balanced lighting in both the foreground and background.

3.29 Design students check out green-design competition submissions at a gala event. Bouncing the flash into a curved beige wall just outside the frame at camera right, provided wide coverage of soft, warm light.

▶ **When shooting portraits.** Directly lit portrait subjects can result in harsh skin tones and heavy shadows. Straight-on flash can create the undesirable effect of making skin look like plastic, increasing skin shine, and blowing out highlights. To soften the light, bounce your Speedlite off of a ceiling, wall, bounce accessory attachment, or opaque umbrella. My current style is to shoot the flash through a translucent white umbrella, which produces the same effect.

Camera and Speedlite settings

When you have the 580EX II or 430EX II mounted securely on your camera, you can tilt the flash head up to bounce the light off the ceiling or even the walls. For a solo portrait, use a longer lens somewhere in the 85-150mm range to keep you a nice distance away from the subject so that the bounced light doesn't create shadows in the eye sockets. When bouncing light off the ceiling, adjust the flash head position and find the best angle. Shoot. Review. Adjust. Depending on the height of the ceiling or distance from the wall, angles play a major role in the direction of the light.

When using bounce flash, you need to position your Speedlite flash head, make camera settings, and make some adjustments to your Speedlite. Follow these steps:

1. **Set your camera's exposure mode to the desired setting.** Whether you prefer using Aperture-priority, Program, Automatic, or Shutter-priority mode, make sure you have your desired exposure mode set in your camera.

2. **Set the white balance.** Set your digital camera's white balance setting to Custom, Flash, or Auto. If you are using a custom white balance, remember to create the target by also using bounced flash. There are many different whites out there, and the bounce surface will also influence the color.

3. **Set the flash mode.** Make sure that the flash mode on your Speedlite is set to E-TTL. You can toggle to the desired flash mode by pressing the Mode button on your 580EX II or 430EX II Speedlite.

4. **Position the flash head.** Tilt or rotate the Speedlite's head by pressing the lock release button and moving the flash head to the desired position. The 580EX II Speedlite can tilt up 90 degrees (straight up) and rotate horizontally 180 degrees to the left and right. The 430EX II can tilt up 90 degrees and rotate horizontally 180 degrees to the left and 90 degrees to the right.

5. **Take a test shot.** Take a photo and review the results on your digital camera's LCD. If the image appears under- or overexposed, you can adjust the output of the flash by adjusting the FEC or by adjusting the aperture setting on your camera. FEC only applies to the light output of the flash. Exposure compensation plus or minus set on the camera affects the ambient light values. When using bounce flash, you usually lose two to three stops of light because bouncing light results in less illumination on the subject as opposed to using normal, straight-on flash.

To compensate for the light loss and the subsequent loss of exposure, you can increase your camera's exposure compensation to increase the amount of light entering your camera. Alternatively, you could switch to your camera's manual exposure mode and then adjust the aperture setting to stop down a few clicks until you get the desired exposure and look you want. The E-TTL system will continue to operate when the camera is set to manual exposure mode.

Explaining Flash Exposure and Specifications

If you want to go "old-school" style and figure out the flash exposure yourself, it's really not that difficult once you know how. After you know what the numbers mean and where to apply them, it becomes quite easy. This can be a huge time-saver if you've been keeping a lighting diagram booklet, as I recommended earlier, and need to create repeatable lighting setups.

If you are using your Speedlite in the E-TTL mode, all of these calculations are done for you, but it's always good to know how to achieve the same results in manual shooting mode. When you know this information, you can use any flash and get solid, repeatable results.

In the following sections, I discuss how to use the Guide Number, the distance from the Speedlite to the subject, and the aperture to determine the proper flash exposure.

Guide number

The guide number (GN) for a Speedlite measures its ability to illuminate the subject to be photographed at a specific ISO and angle of view. A higher GN indicates a more powerful flash. You can find the GN for your specific Speedlite in the owner's manual, and I've also included tables of GNs for the 580EX II and 430EX II. The GN changes with the ISO sensitivity, so that the GN at ISO 400 is greater than the GN of the same Speedlite when set to ISO 100. The GN also differs, depending on the zoom setting of the Speedlite. Tables 3.1 and 3.2 break down the guide numbers according to the flash output setting and the zoom range selected on the Speedlites.

If you have access to a flash meter, you can determine the GN of your Speedlite at any setting by placing the light meter 10 feet away and firing the flash. Then, take the aperture reading from the flash meter and multiply by ten. This is the correct GN for your flash.

Table 3.1 580EX II Guide Numbers (at ISO 100)

Flash Coverage (meters/feet)								
Flash Output	14	24	28	35	50	70	80	105
1/1	15/ 49.2	28/ 91.9	30/ 98.4	36/ 118.1	42/ 137.8	50/ 164	53/ 173.9	58/ 190.3
1/2	10.6/ 34.8	19.8/ 65	21.2/ 69.6	25.5/ 83.7	29.7/ 97.4	35.4/ 116.1	37.5/ 123	41/ 134.5
1/4	7.5/ 24.6	14/ 45.9	15/ 49.2	18/ 59.1	21/ 68.9	25/ 82	26.5/ 86.9	29/ 95.1

Flash Coverage (meters/feet)								
Flash Output	14	24	28	35	50	70	80	105
1/8	5.3/ 17.4	9.9/ 32.5	10.6/ 34.8	12.7/ 41.7	14.8/ 48.6	17.7/ 58.1	18.7/ 61.4	20.5/ 67.3
1/16	3.8/ 12.5	7/ 23	7.5/ 24.6	9/ 29.5	10.5/ 34.4	12.5/ 41	13.3/ 43.6	14.5/ 47.6
1/32	2.7/ 8.9	4.9/ 16.1	5.8/ 17.4	6.4/ 21	7.4/ 24.3	8.8/ 29.9	9.4/ 30.8	10.3/ 33.8
1/64	1.9/ 6.2	3.5/ 11.5	3.8/ 12.5	4.5/ 14.8	5.3/ 17.4	6.3/ 20.7	6.6/ 21.7	7.3/ 24
1/128	1.3/ 4.3	2.5/ 8.2	2.7/ 8.9	3.2/ 10.5	3.7/ 12.1	4.4/ 14.4	4.7/ 15.4	5.1/ 16.7

Table 3.2 430EX II Guide Numbers (at ISO 100)

Flash Coverage (meters/feet)								
Flash Output	14	24	28	35	50	70	80	105
1/1	11/ 36.1	25/ 82	27/ 88.6	31/ 101.7	34/ 111.5	37/ 121.4	40/ 131.2	43/ 141.1
1/2	7.8/ 25.6	17.7/ 58.1	19.1/ 62.7	21.9/ 71.9	24/ 78.7	26.2/ 86	28.3/ 92.8	30.4/ 99.7
1/4	5.5/ 18	12.5/ 41	13.5/ 44.3	15.5/ 50.9	17/ 55.8	18.5/ 60.7	20/ 65.6	21.5/ 70.5

continued

Table 3.2 430EX II Guide Numbers (at ISO 100) *(continued)*

Flash Coverage (meters/feet)								
Flash Output	**14**	**24**	**28**	**35**	**50**	**70**	**80**	**105**
1/8	3.9/ 12.8	8.8/ 28.9	9.5/ 31.2	11/ 36.1	12/ 39.4	13.1/ 43	14.1/ 46.3	15.2/ 49.9
1/16	2.8/ 9.2	6.3/ 20.7	6.8/ 22.3	7.8/ 25.6	8.5/ 27.9	9.3/ 30.5	10/ 32.8	10.8/ 35.4
1/32	1.9/ 6.2	4.4/ 14.4	4.8/ 15.7	5.5/ 18	6/ 19.7	6.5/ 21.3	7.1/ 23.3	7.6/ 24.9
1/64	1.4/ 4.6	3.1/ 10.2	3.4/ 11.2	3.9/ 12.8	4.3/ 14.1	4.6/ 15.1	5/ 16.4	5.4/ 17.7

Aperture

Another factor that determines the proper flash exposure is the aperture setting. The wider the aperture (smaller f-stop number), the more light hits the sensor. The aperture or f-stop number is actually a ratio showing the fractional equivalent of the opening of the lens compared to the focal length. Confusing? It's not all that bad; read on.

All math aside, all you really need to know is this: if your Speedlite output is going to remain the same, in order to lessen the exposure, you need to stop down the lens to a smaller aperture or move the Speedlite farther away from the subject. Remember, the aperture controls the light intensity from the flash on your subject while the shutter speed controls the intensity of the ambient light.

Distance

The third factor that determines the proper flash exposure is the distance from the light source to the subject. The closer the light is to your subject, the more flash exposure you have. Conversely, the farther away the light source is, the less illumination your subject receives. The amount of light fall-off is due to the Inverse Square Law, which states that the quantity or strength of the light (coming from the Speedlite)

landing on your subject is inversely proportional to the square of the distance from the subject to the Speedlite.

In simpler terms, this means that you divide 1 by the distance and then square the result. So if you double the distance, you get 1/2 squared, or 1/4 of the total light; if you quadruple the distance, you get 1/4 squared or 1/16 of the total light. This factor is important because if you set your Speedlite to a certain output, you can still accurately determine the exposure by moving the Speedlite closer or farther as needed.

Guide number ÷ Distance = Aperture

Here's where it all makes sense. Take the GN of your flash, divide by the distance the flash is away from the subject, and you get the aperture at which you need to shoot. Because you can express an equation in a few different ways, you can change this equation based on the information you already have to find out what you want to know specifically.

▶ **Aperture × Distance = GN**

▶ **Distance = GN ÷ Aperture**

The guide number represents an exposure constant for the flash unit. A guide number of 80 feet at ISO 100 means that a subject 20 feet away will be correctly illuminated with an aperture of f/4 (80 = 20 × 4) using ISO 100. For the same guide number and an aperture of f/8, the flash should be 10 feet from the subject (80 = 10 × 8).

Sync speed

The recommended sync speed of your camera is the fastest shutter speed you can shoot with and still get the full exposure of the flash. The sync speed is based on the limitations of the shutter mechanism, usually around 1/200 to 1/250 second. The sync speed on different camera bodies differs with the type of shutter mechanism used.

When using Canon Speedlites, the camera body prevents you from selecting a shutter speed faster than the rated sync speed, but you can select any of the slower ones. This is important when you need to bring up the value of the ambient light, and is often referred to by wedding professionals and others as "dragging the shutter." When a non-dedicated flash or an external flash is used via the PC terminal, there is no mechanism to make the camera aware of this, so it is possible to set a shutter speed higher than the rated sync speed. The disappointing result of this is usually a partially exposed image due to the shutter already closing while the flash is reaching its peak output.

Second-curtain sync

All Canon EOS cameras have two moving "curtains" in the shutter mechanism. One curtain of the shutter opens, and the other closes after the correct exposure time. The normal operation of the shutter and flash causes the flash to fire immediately when the first curtain opens. This is called first-curtain sync and it is fine for most general flash applications. So what's wrong with that? Let's say your subject is moving and you are tracking the subject using a slow shutter speed to pick up some ambient light. You press the Shutter button, the shutter opens, the flash fires, and then the shutter remains open to complete its exposure. When you review the image, you see motion trails out in front of the subject you tracked and it looks like it's moving backwards. The proper technique is to get the flash to fire right before the shutter closes, thereby showing the motion trails behind the subject, and this is exactly what second-curtain sync does. You can set this feature either on the camera or on the Speedlite, but the Speedlite will take precedence over the camera settings.

3.30 This is an example of second-curtain sync with a stationary camera and a moving subject. Notice the shadow behind her head and the black in her outfit overtaken by the lights in the background. A different look for this image would be produced by panning with the subject as she moved.

Fill flash

When shooting outdoors on a sunny day using the sun as your main light source, you usually get images that are very high in contrast. As a result, the shadows are invariably much darker than they should be. In order to overcome this, a technique called *fill*

flash is used. When your camera is set to Shutter-priority or Aperture-priority, the camera meter exposes for the ambient light and the Speedlite is used as a fill. When using the Manual setting on your Speedlite, you can also use fill flash but will want to reduce the power output to something below the ambient levels.

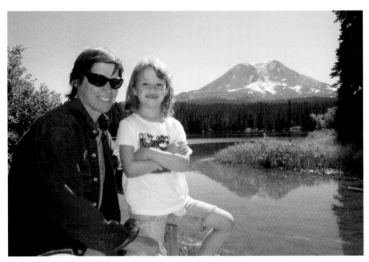

3.31 Gayle and Brenna at Takalak Lake in Washington with Mt. Adams in the background. Because the sun was behind them, their bodies were in shadow, but Speedlite fill flash solved the problem.

For realistic-looking fill flash, I decide what ISO setting I want to use based on the time of day and ambient lighting conditions, taking into consideration whether my subjects are going to be moving. I then set my Speedlite to expose just under the ambient level, somewhere between −1 and −2 stops. Exactly matching the ambient level with the Speedlite creates flat and artificial results in my opinion, and often my goal is to try and mask the fact that I used flash at all.

To use fill flash in E-TTL mode with the camera set to Manual:

1. **Position your subject so that the background looks just right.** Avoid having the sun shine directly in your subject's eyes, as this will probably cause them to squint.

2. **Use your camera's light meter to determine the correct exposure.** A typical exposure for a sunny day at ISO 100 is f/16 at 1/100 second.

3. **Determine the proper exposure for your Speedlite, using the GN ÷ Distance = Aperture formula.** Remember to take into account the focal length of the lens and the flash's zoom head position. You can also determine the approximate

distance to your subject by looking at the distance scale on the lens if your lens has one, or simply using a tape measure to determine the distance.

4. **Once you have determined the exposure, set the flash to expose at 1/3 to 2/3 stop under the proper exposure.** The actual amount of underexposure needed depends on the brightness of the sun and the relative darkness of the scenes.

5. **On the 580EX II and 430EX II in E-TTL mode, press the Select/Set button.** Turn the select dial on the 580EX II or the minus button on the 430EX II to reduce the flash output.

6. **Take the picture and review it on the LCD.** This helps you to decide if you need more or less flash exposure to render the scene properly. Change the exposure compensation value and reshoot.

When shooting manual fill flash, be sure the flash head is zoomed to the same focal length as the lens in use.

Wireless Flash Photography with the Speedlite System

The simple beauty of the Canon Speedlite System is that you can trigger any number of Speedlite flashes without any cords linking them together or to the camera, and automatically control many difficult lighting scenarios. The Speedlite's E-TTL II preflash, working together with the camera, does all the work for you; all you have to do after that is make some minor adjustments and you're ready to shoot. You make all of your adjustments behind the camera on the 580EX II flash LCD monitor or the back panel of the ST-E2 Speedlite transmitter or the External Speedlite control menu on some of the newer Canon cameras.

The Canon Speedlite System allows you the flexibility to set up your flashes in groups, and to individually

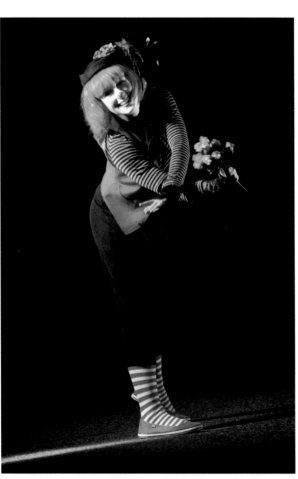

Two Speedlites were used wirelessly for this portrait of professional clown, Mimi.

control flash exposure on your subject and background, as well as add a hair light or backlight that you also control.

This chapter provides an overview of how the Canon Speedlite System uses the camera and master units to communicate with the remote units, and opens up a whole new world of creative possibilities for your photography.

How the Speedlite System Works Wirelessly with Your Camera

The Canon Speedlite System is actually a collection of communication devices that carry on a conversation with each other in real time, wirelessly. That alone is an amazing technological feat. When the flashes are set to E-TTL, the Speedlite relays information to the camera, and the camera body relays information back to the Speedlite. You begin the conversation by pressing the Shutter button and making the exposure. In a millisecond, the Speedlite fires a preflash and along with the ambient light metering, determines the flash output using the metering zones. Zones that differ greatly in brightness are given less weight in the equation, as they are most likely to be reflections from small, highly reflective objects.

Modern lenses that return distance information to the camera also figure in to the equation. It becomes even more complex (but easier for you) when you add remote flashes to the mix. The Speedlite, set to Master, sends out a signal to the remotes to fire a series of preflashes to determine the exposure level. These preflashes are read by the camera's TTL metering sensors, which combine readings from all of the separate groups of Speedlites along with a reading of the ambient light.

The camera then tells the master unit what the proper exposure needs to be. The master unit then relays specific information to each group about how much exposure to give the subject. The camera then tells the master unit when the shutter is opened, and the master unit instructs the remote flashes to fire at the specified output.

All this is done in a millisecond, and for the most part, the results are superb. All these calculations go on behind the scenes so quickly that you don't even notice they are happening. Swing your camera around to frame a different scene, and the whole process begins again — rapidly, wirelessly, and with stunning results.

Wireless controls set as Master communicate to the flashes through an arrangement of channels, groups, and ratios. It uses these controls to organize and set the light output for multiple Speedlites.

Overview of Flash Setup with the Canon Speedlite System

I assume you will probably be starting wireless flash photography with only one Speedlite and the ST-E2 transmitter and possibly including your pop-up flash (if your

camera has one) for fill light. The pop-up flash can be used as a master on the latest EOS cameras that include them. Working this way, you will soon see the advantages of adding more Speedlites to your arsenal. That would give you a few independent light sources for a background, hair light, or rim lighting from the side. The more lights you add, the more you'll think of creative ways to use them.

In the past, when photographers worked with studio strobe units, four heads were considered a standard kit and could handle most commercial assignments. Heavy, and time-consuming to set up and tear down, they were the price photographers had to pay for all that awesome location power. Granted they were capturing images on large pieces of low-ISO film at f/32 and f/64, and needed all that raw power. Nowadays, with digital technology and the ability to get great results with higher ISOs, that power is no longer needed.

Step 1: Choose a flash mode

Begin by deciding which flash mode you want to use. The main flash modes available when using the Speedlite System are E-TTL automatic flash and M (or manual). I usually just go with the E-TTL unless I need a lot of control. A Speedlite set to manual at 1/1 power delivers all the output that the Speedlite has to offer. E-TTL can sometimes be fooled by what the camera is seeing and vary the flash output. Keep in mind that the system is making all sorts of adjustments and computations based on the information it is receiving in real time, and every once in a while, all that incoming data just doesn't add up.

For more information on using the flash modes, see Chapter 2.

Step 2: Choose a channel

Once you select a flash shooting mode, the next step is to decide which channel to use. I usually just pick channel 1. In the rare times you are working near other photographers using Canon Speedlites wirelessly, find out which channel they're using and just switch to a different one. Although it makes no difference what channel you use, I have sometimes received interference problems in commercial settings and simply switched to another channel to solve the problem.

Be sure all your Speedlites are set to the same channel or they won't function properly.

Step 3: Set up groups or slave IDs

For more complex lighting scenarios, the next step is setting up groups, also known as slave IDs. Generally, I set my main lights to group A; the fill lights to group B; and any peripheral lights, such as hair and background lights, to group C. You want to do it this way so that you can adjust the output of the specific lights. The fill lights could be a little under what the E-TTL reading is, so by setting them to group B, you can adjust the ratios without altering the exposure of your main light. The background lights may or may not need to be adjusted, depending on the darkness or lightness of the background, and whether you're shooting high key or low key, and so on. I set these lights to group C so that I can make the necessary adjustments without affecting the other two exposures.

Step 4: Adjust the flash ratio levels

Lastly, I adjust the flash ratio levels. Once the Speedlites are set up, and the channels and groups are set, it's time to take some test shots. If I have everything set to E-TTL flash mode right from the start, I'm pretty close to the proper exposure. I might just need to make some minor adjustments to the flash ratios, make any zoom head adjustments to tailor the light coverage and color of the light, and then I can start shooting. All these adjustments can be made right on the flash on the camera, or on the ST-E2 transmitter, and so there's no need to visit each flash to make minor changes, a huge time-saver when you are working by yourself.

In the following sections, I'll go step-by-step through setting up your flashes for master and remote use, choosing a flash mode, setting channels and groups, and adjusting the output ratios for your specific needs.

Setting Up Master and Slave Flashes

This next part is a little technical, but don't be dismayed. The really technical stuff goes on behind the scenes with algorithms and such, so all you need to do is follow the action through your viewfinder and shoot pictures. I'll cover how to set up the Speedlite as a master flash or a wireless remote flash (slave), how to adjust the exposure, how to set up groups of lights, and I'll give you a few bits of advice from the field. By now you are beginning to see just how multitalented and powerful the Canon Speedlite System can be.

You can control an infinite number of flashes, all from your camera. You don't even need to have a light meter; the camera meters for you. If you don't like the way the lighting looks, you can change the flash output between the groups right from the

camera or Speedlite transmitter. This is very convenient when you need to work quickly, such as when it's getting dark out and you're rapidly losing your ambient light or, as I said before, working by yourself.

Masters

Let's begin by setting up a Speedlite to act as command central, also known as a master flash. The master flash is what controls all of the wireless slaves and instructs them what to do. The master can be a 580EX II, 580EX, 550EX, either of the Macro Speedlite flashes, or the ST-E2 Speedlite transmitter. The 430EX II and older 430EX cannot be used as masters, only as slaves during wireless remote operation.

 The MR-14EX and the MT-24EX macro flashes can also be used as masters to control off-camera remote slaves.

Setting up the 580EX II

To use the 580EX II as a master flash:

1. **Turn on the Speedlite.** Flip the On/Off switch to the On position.

2. **Press and hold the Zoom/ Wireless button to enter the Wireless setup menu.** Both Off and the wireless icon blink on the Speedlite's LCD.

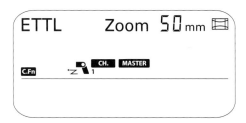

4.1 The 580EX II set to Master

3. **Turn the Select dial so that On, Master, and the wireless icon blink on the Speedlite's LCD.** The auto zoom icon switches to manual. If you do nothing, after five seconds the display stops blinking.

 When your Speedlite is set for wireless master/slave functions, the flash remembers where you are in the sequence of choices, and cycles to the next one every time you push the Zoom button. If you make a selection, then do nothing, after five seconds the display stops blinking, and the settings are confirmed. The next time you push the Zoom button, the next item starts to blink, allowing you to change it. The sequence order is: Zoom head setting, ratio on/off setting, channel setting, flash firing on/off, and, if ratio was turned on, the settings for that.

4. **Press the Zoom button once.** The zoom designation blinks. If the Speedlite is connected to the camera's hot shoe, you can reset the auto zoom feature using the Select dial. If the flash is used off-camera, depending on the look you wish to create with flash, set the zoom designation to match the focal length of the lens you're using or use different zoom settings to cover larger areas of the scene or for creative effect. If shooting with a zoom lens, you may want to set it as close as possible to the zoom range you'll be shooting in. Either way, the zoom head feature allows you to set how much of the scene you want to cover with the flash.

 When in wireless mode, the auto zoom function of any Speedlites not connected to the camera's hot shoe is disabled.

5. **Press the Zoom button so that both Off and the Ratio icon blink.** Set your desired ratio. Use the Select dial to change the setting. Choose from ratio off, ratio A:B, or ratio A:B C. Again, you can press the Select/Set button to confirm, or do nothing and the Speedlite will confirm your ratio selection after five seconds.

 When using only one group of Speedlites, or if you want all of the Speedlites to fire at the same power output, just use one group and choose the ratio off setting. The master flash is always A. When using two groups, choose ratio A:B. When using three groups of different Speedlites, the C group won't fire unless you choose ratio A:B C.

6. **Press the Zoom button until the channel settings blink.** Use the Selector dial to change the setting from channels 1 through 4.

7. **Press the Zoom button until the master flash output setting blinks.** Use the Selector dial to turn the flash output On or Off. If you only want to use the camera mounted 580EX II as a master controller and don't want it to fire and add additional illumination to the scene, select the Off position.

4.2 The 580EX II channel, master, and ratio settings. Ratio settings are shown using an A:B combination in the first image and an A:B C combination in the second image.

Understanding Flash Ratios in the Canon Speedlite System

When setting the ratios for your wireless Speedlites, you are given quite a few options. The ratios are adjustable in increments of 1/2 stop, allowing you 13 different settings. This allows you a total of +/–3 stops of light, a fair amount in most situations.

In the center position is the ratio 1:1. This means that the Speedlites in group A and the Speedlites in group B both fire at the same output. Adjusting the ratio to 2:1 means that the Speedlites in group A fire at twice the output as group B. Conversely, adjusting the ratio to 1:2 means that group A fires at half the power of group B.

Group C fires at the same output as group B when used in ratio A:B C. Use FEC to adjust group C to fit your specific lighting requirements.

8. **Press the Zoom button to finish, or if ratio was selected, to set the A:B ratio numbers.** Scroll the dial left or right to set the flash ratio. You can set the flash ratio from 8:1 to 1:1 to 1:8. To set the output level for group C when using three groups of Speedlites, set the ratio to A:B C. When everything else is set, press the Select/Set button in the center of the Selector dial until ratio C is blinking, and then scroll the dial left or right to adjust the Flash Exposure Compensation (FEC). This can be adjusted in 1/3 stops to +/–3 stops of light. With no exposure compensation, group C fires at the same output as group B.

9. **If desired, press and hold the Zoom/Wireless button again to turn off the wireless system by selecting Off with the Select dial.**

The first number in each ratio always refers to Speedlites in group A, and the second number of the ratio always refers to Speedlites in group B.

Setting up the ST-E2

The ST-E2 Speedlite transmitter is a joy to work with. Lightweight, compact, and very balanced when it's connected to the camera's hot shoe, it becomes command central for your wireless shooting. All of the necessary changes can be made right from the back panel. Keep in mind that while the ST-E2 can trigger three groups of flashes, only the A:B groups will fire if ratios are set.

Here are some of the features of the ST-E2:

▶ **Control of three groups of Speedlites with the ability to control the slave's light output.**

▶ **An AF-assist beam that is compatible with 28mm and longer lens focal lengths.** The AF-assist beam has an effective range of approximately 0.6 to 10 m/ 2.0 to 16.5 ft. along the periphery (in total darkness). I recommend using the ST-E2 as an AF-assist light in difficult low light situations even if you aren't using flash.

▶ **Flash ratio control and adjustment and channel control.** The flash ratio control for the A:B ratio is 1:8 to 8:1, in 1/2-step increments or 13 steps.

▶ **FE Lock, Flash Exposure Bracketing, Flash Exposure Compensation, Stroboscopic flash, and high-speed sync (FP flash) in high-speed sync mode for flash synchronization at all shutter speeds.** Flash Exposure Confirmation during FE Lock is indicated when the flash exposure level icon is lit in the viewfinder. If the flash exposure is insufficient, the icon blinks. After the flash fires, the ST-E2's flash confirmation lamp lights in green for 3 seconds.

▶ **Infrared pulse transmission system with a range of approximately 12 to 15 m/ 39.4 to 49.2 ft. indoors, and approximately 8 to 10 m/26.2 to 32.8 ft. outdoors.** The flash transmission coverage is +/–40 degrees horizontal and +/–30 degrees vertical.

For multiple off-camera Speedlite shooting, the ST-E2 is invaluable because it gives you cable-free operation and precise flash ratio control. The unit is powered by CR5 lithium batteries. I prefer to use rechargeable CR5s for the ST-E2, which provide approximately 1,000 to 1,500 transmissions per charge.

To set up the ST-E2 Speedlite transmitter:

1. **Attach the ST-E2 to your camera's hot shoe and lock with the switch on the lower-left side of the transmitter.**

2. **Turn the ST-E2 on using the power switch.**

3. **Select the proper channel using the Channel button.** The channel number is illuminated when selected. Keep pressing the Channel button to select different channels.

4. **To turn on the ratio feature, press the Ratio button.** The Ratio On lamp lights up when activated.

5. **Adjust the flash ratio settings using the left and right arrow buttons.** The lamps under the ratio designations are illuminated when selected.

6. **Press the High-Speed Sync button to turn this feature on or off.**

 To lock the settings on the ST-E2 and prevent them from being changed, slide the Power button to the Hold position.

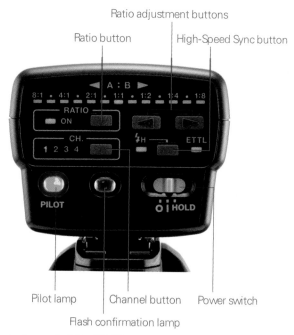

4.3 Control panel of the ST-E2

Slaves

There is perhaps no more fun in flash photography than when you use multiple wireless Speedlites to create colorful, stunning photographs. I use the 580EX II or the ST-E2 Speedlite transmitter with Speedlites, and add light modifiers depending on the subject and the mood I'm trying to create. With outdoor wireless shooting, you have to ensure that the signal between the Speedlites is direct, but in an interior setting, you have a bit more flexibility in setting up the flashes.

Setting up the 580EX II

To set up the 580EX II for use as a wireless remote slave flash:

1. **Turn on and set the master unit to E-TTL.** The master can be a 580EX II, 580EX, 550EX, either of the Macro Speedlite flashes, the ST-E2 Speedlite Transmitter or the pop-up flash on the newest EOS cameras.

2. **Press and hold the Zoom/Wireless button to enter the Wireless setup menu.** Both Off and the wireless icon blink on the Speedlite's LCD. These settings include the flash head zoom range (24mm–105mm), the communication channel (1–4), and the slave group (A, B, or C). When the specific setting is ready to be changed, it blinks.

3. **Set the flash status to Slave.** Press and hold the Zoom/Wireless button until the display blinks, then turn the Select dial until Slave blinks, then press the Select/Set button to confirm.

4. **Set the zoom.** Scroll the dial left or right to set the flash head zoom to match the focal length of the lens you're using or use different zoom settings for creative effect. If shooting with a zoom lens, you may want to set it as close as possible to the zoom range you're using. Either way, the zoom head feature allows you to set how much of the scene you want to cover with the flash.

5. **Set the channel.** Scroll the dial left or right to set the channel on which the flashes communicate with each other.

 Both the master and the slave must be set to the same channel number for wireless flash to work.

6. **Set the slave ID or group.** You can set up to three different groups of Speedlites, A, B, or C.

 The slave ID only needs to be set when using two or more groups of flashes.

Setting up the 430EX II

To set up the 430EX II for use as a wireless remote slave flash:

1. **Turn on and set the master unit to E-TTL, either another Speedlite or ST-E2 transmitter.**

2. **Press and hold the Zoom button for two seconds or more to set the flash for wireless slave operation and additional settings.** These settings include the flash head zoom range (24mm–105mm), the communication channel (1–4), and the slave ID (A, B, or C). When the specific setting is ready to be changed, it starts blinking.

3. **Set the zoom.** Use the + or – buttons to set the flash head zoom to match the focal length of the lens you're using or use different zoom settings for creative effect. If shooting with a zoom lens, you may want to set it as close as possible to the zoom range you're using. Either way, the zoom head feature allows you to set how much of the scene you want to cover with the flash.

4. **Set the channel.** Use the + or – buttons to set the channel on which the flashes communicate with each other.

 Both the master and the slave must be set to the same channel for wireless flash to work.

5. **Set the slave ID or group.** You can set up to three different groups of Speedlites, A, B, or C.

Setting Up a Wireless Manual Flash

Changing from E-TTL mode to Manual mode is not as scary as it sounds. Sure, photographers in the old days had to figure out some Guide Numbers charts that used to be on flashes and set their flashes accordingly. They also had to wait a few days to get their results back from the lab. In that amount of time, camera settings and flash-to-subject distances could be forgotten, replaced by other details in life unless they were written down. However, today, with digital cameras and the ability to review your results on the camera's LCD monitor immediately (chimping), more time is spent shooting than figuring out manual flash output settings.

Getting a handle on manual flash output is as easy as turning on a water faucet when you consider the similarities. If you need a lot of water in a hurry, you turn it on full blast. If you only need a tiny bit of moisture to seal an envelope, you release only a drop or two.

Manual flash output works in a similar fashion. I rarely use the two extremes — 1/1 – full power or 1/128 for 580EX II or 1/64 for 430EX II — and I find myself nearly always in the middle of the range, 1/16, 1/8 power settings, and so on. In fact, that's where I start, somewhere in the middle of the range, and much like a chef, I add a little bit of power here and take away some there. It's all about molding and shaping the light to perform the way you want it to.

Another consideration that may enter into my lighting setup is the fact that the full power setting uses up batteries faster, which produces slower recycle times. Conversely, low power or adding more Speedlites so that you can adjust them to lower power settings individually speeds up recycle time and extends battery life. You can also adjust the effect of the Speedlites contribution to the scene by physically moving the flash closer or farther away from the subject to control the amount of light hitting the scene.

580EX II in Manual mode

To set up for manual wireless flash on the 580EX II in Master mode, follow these steps:

1. **Turn on the Speedlite.** Slide the On/Off switch to the On position. Press the Mode button to change the flash from E-TTL to Manual (M). Confirm that the flash is set to Master mode.

2. **Set the 580EX II to Master.** Press and hold the Zoom/Wireless button until the display blinks then turn the Select dial until Master blinks. Press the Select/Set button to confirm your selection.

3. **Press the Select/Set button.** The manual flash output setting will blink. Use the Select dial to set the flash's desired output. You have 21 different power levels available in 1/3-stop increments.

4. **Press the Zoom button.** This selects the flash head zoom range so it can be changed. When the 580EX II is ready to change, it blinks. Set the flash head zoom to match the focal length of the lens you are using.

5. **Press the Zoom button again.** This sets the zoom and highlights the ratio setting so it can be changed. Use the Selector dial to choose from ratio off, ratio A:B, or ratio A:B C.

 When using only one group of Speedlites, set the ratio to ratio off. When using two groups, set the ratio to ratio A:B. When using three groups, set the ratio to ratio A:B C.

6. **Press the Zoom button to highlight the channel settings.** Use the Selector dial to choose from channels 1 through 4.

7. **Press the Select/Set button in the center of the dial to choose the group.** When the group letter is blinking, use the dial to set the desired output level. Press the Select/Set button to cycle through the groups.

8. **Turn the Select dial to set the desired light output.** Then press the Select/Set button to confirm or do nothing, and after a few seconds the display will stop blinking.

Setting slaves for manual flash

You can also set your slave units to function entirely manually. Changes need to be made on the slave unit itself; any changes made on the master unit do not affect the power output of the slaves. This takes a little more effort, granted, but remember, you're making pictures, not just taking them.

My workflow setup regarding remote flash units involves setting all my Speedlites, masters, and slaves to the same power output settings, placing them where I want, and working from there. I know other photographers may do things differently, but that's what works for me. Once I have a clearer idea of what I want the image to look like, I go to work creating it. That may involve light modifiers such as diffusers, snoots, gobos, grids, and colored gels. These will also affect power output in some significant way, and so if I start with all Speedlites set the same in manual, I know how far from that baseline they are once they receive their final settings.

580EX II

To set the 580EX II as a manual slave:

1. **Turn on the Speedlite.**

2. **Set the 580EX II to Slave.** Press the Zoom/Wireless button for two seconds or longer until the display blinks. Turn the Select dial until Slave blinks and press the Select/Set button to confirm,

3. **Press the Mode button for two seconds.** This sets the flash to manual slave mode. You see a blinking M on the LCD and the power level indicated.

4. **Press and hold the Select/Set button.** The M and the power level blink.

5. **Set the power level output using the Select dial.** The power level can be set to 1/1 or full power, all the way down to 1/128 power.

6. **Press the Select/Set button to save the power setting.**

430EX II

To set the 430EX II as a manual slave:

1. **Turn on the Speedlite.**

2. **Set the 430EX II to Slave, by holding down the Zoom/Wireless button for two seconds or longer.**

3. **Press and hold the Mode button for two seconds.** This sets the flash to manual slave mode. You see a blinking M on the LCD.

4. **Press and hold the Select/Set button for one second.** The M and the power level blink.

5. **Set the power level output using the + or – buttons.** The power level can be set to 1/1 or full power, all the way down to 1/64 power.

6. **Press the Select/Set button to save the power setting.**

Using Wireless Multi-Stroboscopic Flash

You can use your 580EX II to fire a slave using the Multi-Stroboscopic Flash mode. Although the 430EX II does not have the ability to do multi-stroboscopic flash on its own, when used as a slave with the 580EX II as a master, this function does become available to you.

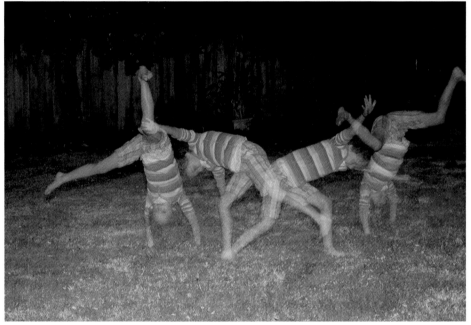

4.4 Multi-Stroboscopic mode produces multiple images with a moving subject. It is a fun mode, very often overlooked by many photographers.

Setting Up Channels and Groups or Slave IDs

In this section you look at how to set channels and slave IDs to be used with wireless flash.

Channels

When using a Speedlite in the wireless mode, you can decide which channel your master unit uses to communicate with the slave. You have four channels, numbered 1 through 4 to choose from, and it doesn't really matter which one you use. This feature is included because professional photographers sometimes shoot alongside each other using similar equipment, such as at a sporting event or stage performance. In order to prevent another photographer's Speedlites from setting off your own (and vice-versa), you can set your master flash or transmitter to a different channel.

As previously described, channels are different than groups. All the Speedlites you wish to use can be set to different groups but must all be set to the same channel.

Groups

When using more than one Speedlite, you'll want to set up your Speedlite's slave IDs in separate groups in order to adjust the lighting for each group to produce different quantities of light, unless you are shooting in manual power mode. Setting each group to different output levels enables you to creatively control the light that falls on your subject. For many shooting situations, I like to vary the light output in order to show texture, some color, and contouring.

Your subject in relation to the background determines the lighting setup. In an ideal world, there would be excellent backgrounds everywhere, but in much of the location portrait work I do, there aren't. You still have to come back with results, and so I often use different groups to light stubborn areas of my shot that are going too dark. Size of the light source, distance to subject, diffusers, grids, light modifiers, and gels are the tools I use to fine-tune the light and get the shot.

 The channel and slave ID setting must be set on each individual Speedlite in order for them to function properly.

580EX II

To set channels and slave IDs using the 580EX II:

1. **Set the 580EX II to Slave.** Press the Zoom/Wireless button for two seconds or longer until the display blinks. Turn the Select dial to select Slave, then press the Select/Set button to choose.

2. **Press the Zoom button.** This selects the flash head zoom range so it can be changed. When it is ready to change, it blinks. Set the flash head zoom to match the focal length of the lens you are using.

3. **Press the Zoom button again.** This sets the zoom and highlights the channel setting so it can be changed. Use the Selector dial to choose from channel 1, 2, 3, or 4.

4. **Press the Zoom button again.** This highlights the slave ID setting so it can be changed. Use the Selector dial to choose from slave ID A, B, or C.

5. **Press the Select/Set button to save the settings.**

430EX II

To set up channels and slave IDs using the 430EX II:

1. **Set the 430EX II to Slave.** Press and hold the Zoom/Wireless button down for two seconds or longer.

2. **Press the Zoom button.** This selects the flash head zoom range so it can be changed.

3. **Press the Zoom button again.** This sets the zoom and highlights the channel setting so it can be changed. Use the +/– buttons to choose from channels 1, 2, 3, or 4.

4. **Press the Zoom button again.** This highlights the slave ID setting so it can be changed. Use the +/– buttons to choose from slave ID A, B, or C.

5. **Press the Select/Set button in the middle of the Selector dial to save the settings.**

Setting Flash Exposure Compensation

Occasionally, you may find yourself in interesting lighting situations where you read the scene and just know it's going to trick the camera. For example, you may be shooting strongly backlit scenes, or you may have reduced the ambient exposure on the camera by Exposure compensation and now want to boost the flash a little.

Photographers use the terms *plus* or *minus EV* (exposure value) to describe any time they purposely override the camera's E-TTL shutter speed/aperture combinations that would yield the same exposures. Taking away EV reduces the exposure while adding EV increases it.

You use Flash Exposure Compensation (FEC) to fine-tune the settings to achieve the desired brightness of the overall image, much like adjusting the manual settings, although you have less range to choose from. The FEC can be adjusted in 1/3-increment stops, up to +3 and down to –3 stops of light.

4.5 The 580EX II with Flash Exposure Compensation set to underexpose by –1 2/3 f-stops

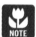 When the FEC is set on the master flash, the exposure compensation affects all slave Speedlites in all groups.

Setting FEC with the 580EX II set to Master

To set Flash Exposure Compensation, follow these steps:

1. **Turn on the Speedlite.**

2. **Be sure the 580EX II is set to Master.**

3. **Press the Select/Set button in the middle of the Selector dial.** This brings up the FEC compensation factor. It blinks when it is ready to change.

 When the FEC is set to 0, the FEC icon does not appear on the LCD unless it is selected for change.

4. **Scroll the Selector dial left or right to adjust the amount of FEC.**

5. **Press the Select/Set button in the middle of the Selector dial to confirm the settings.**

Setting FEC slave flashes

When using a 580EX II Speedlite as the master, this technique works well. But when triggering wirelessly with the ST-E2 wireless transmitter, the FEC must be set on the slave flash.

580EX II

To change FEC on the 580EX II in Slave mode, follow these steps:

1. **Press the Select/Set button.** The FEC icon flashes when changes are ready to be made.

2. **Scroll the Selector dial left or right to make the adjustments.**

3. **After your adjustments are made, press the Select/Set button again to set them.**

430EX II

To change FEC on the 430EX II in Slave mode, follow these steps:

1. **Press the Select/Set button.** The FEC icon begins to blink.

2. **Use the + or – buttons to adjust the settings accordingly.**

3. **Press the Select/Set button again to save the setting.**

Using Your Speedlites with PocketWizards

While there are any number of remote triggers you can use with your Speedlites, PocketWizards have earned a reputation for reliability and outstanding range. The PocketWizard Remote triggering system was developed in a secret electronics lab in Burlington, Vermont, in the late '80s and has attracted a growing legion of loyal professional photographers ever since. For the Speedlite System, PocketWizard radio systems enable greater working distances and more reliability outdoors than Speedlites do but complement them perfectly. Unlike Speedlites, PocketWizards use radio frequencies to communicate with flashes instead of infrared (IR), as the Speedlites and ST-E2 transmitter do.

The Canon Speedlite System uses infrared light (IR) to trigger the flashes to fire. This works well indoors because there are lots of surfaces for the IR signal to bounce off of to be picked up by the Speedlite's sensor. Outdoors there usually are not readily available surfaces for this to happen and the IR has to compete with higher ambient light levels to operate properly. PocketWizards solve this wireless problem. Early PocketWizards had no E-TTL capability, but new models for Canon camera flash systems, the MiniTT1 and FlexTT5, were introduced while this book was being written.

PocketWizards have a very generous 1600-foot range of use, fast sync speeds, locking shoe mount, and a fast FPS rating (up to 12 FPS on capable cameras), and they run on 2 AA batteries. They also include status-ready and connect LEDs that let you know they are communicating successfully.

In the late 1990s, the PocketWizard line of precision wireless-control devices introduced the Plus and the MultiMAX products. These two products have evolved significantly since then, and I can say from experience that they are extremely reliable and easy to use. The trade-off with this generation of PocketWizards was the lack of TTL or E-TTL capabilities, something photographers came to rely on when using the Speedlite System indoors. PocketWizard addressed this issue with the latest versions the MiniTT1 and FlexTT5, which do include full E-TTL II capability.

Setting channels

Because of their popularity, PocketWizards also come with different channel settings to prevent triggering the flashes of other photographers who might be using the same system. These channel settings have no relation to the same numbered Canon channels.

4.6 PocketWizards afford the photographer unlimited possibilities of flash units to use manually, as is the case of this older EZ series Speedlite being triggered remotely.

Plus II transceivers and MultiMAXes

PocketWizard Plus II transceivers are the easiest to use and the least expensive. They are called transceivers because they both transmit and receive radio signals so that you can use them attached to the camera and at the remote flash. Plus IIs also include a Mode switch that allows you to fire locally (flash connected to the PocketWizard), remotely (PocketWizard connected to a remote flash), or both.

MultiMAX transceivers are far more sophisticated. They offer a range of 32 different frequency channels and much more timing and firing control. They also offer a Quad-Triggering mode setting that allows you to fire four different flashes separately, together, or in any combination of the four.

During the time this digital field guide was being conceived, PocketWizard launched a new era of PocketWizard triggering devices featuring the MiniTT1 Transmitter and the FlexTT5 Transceiver for Canon. With the new ControlTL software platform, these new E-TTL II-capable radio slaves make using off-camera flash as effortless as sliding the unit in, turning it on, and shooting. I have not had time to test them prior to completing this book, but look forward to doing so in the near future.

Setting Up a Wireless Studio

When you find your Speedlite gear outgrowing its share of space in your camera bag, it may be time to start building a portable studio kit of your own and devoting a separate bag or case for your lighting equipment. Because of their small size, you can easily pack in a few Speedlites and still have room for stands, remote triggers, gels, extra rechargeable batteries, umbrellas, and other light modifiers.

This chapter addresses some of the concerns of setting up a small studio in your home for portraits and products, and offers some ideas for building a traveling, small-flash studio lighting kit. I created just such a kit for my location work after years of lugging around several cases of studio flash and monolight equipment, and it amazes me to this day that I can nearly replicate all that gear in just one bag.

With one Speedlite and some household items such as a paint tray, sandwich baggie, and some colored paper, you can easily create dynamic images right in your own home studio.

Introduction to the Portable Studio

As you become more adept at setting up and lighting your subjects, you may also want to start building a lighting kit that will be ready to go at a moment's notice. Instead of having to sort through several gear bags to find the equipment you need every time you shoot outside of your home studio, a traveling, portable studio lighting kit is the way to go. You'll have peace of mind knowing that everything is already in the bag.

Your portable studio lighting kit should include at least one Speedlite, one or two reflectors to fill in shadows created by the flash, an umbrella or small softbox to soften the light, and one or more light stands. As you build your kit, you may want to add more Speedlites, gels, grids, lighting modifiers, and wireless transceivers for triggering remote flashes.

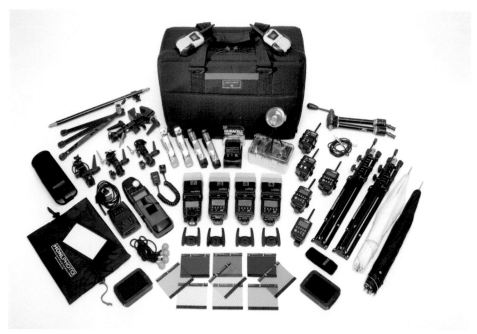

5.1 Everything I need to create beautiful location lighting fits into one 22 × 16 × 8-inch Lightware MF 1420 Multi-Format Case. For many assignments, this and my camera bag are all I need to take.

Let's take a closer look at some of the extra gear you may want to consider in your pursuit of awesome location lighting.

Light Modifiers

Light modifiers refer to anything you add to the light source to mold, bend, shape, diffuse, color, or reflect light. Studio professionals and film crews have been using these tools forever to make light do what they want, when they want. When filming a movie, you can't wait for a sunny day, you have to create it. Light modifiers do just that.

With the current groundswell revolution in small flash use championed by David Hobby at Strobist.com, the Internet abounds with videos and tutorials that show you how to make your own light modifiers for your specific flash. This is fine, if you have the time and inclination, but for the rest of us, Honl Photo has created the Professional Speed System, a collection of lightweight, durable, and affordable light modifiers for shoe-mount flash.

Designed to universally fit all shoe-mount flashes, the versatile light modifiers from Honl Photo provide photographers with an assortment of practical tools to shape light.

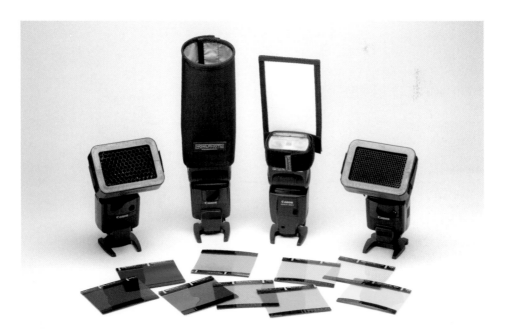

5.2 The Honl Professional Speed System includes gels, grids, a snoot, and a bounce card reflector, all based around the Speed Strap mounting design.

Devised by photojournalist David Honl, the Honl Speed System consists of an assortment of grids, snoots, bounce card reflectors, and gels that attach quickly and easily to any shoe-mount flash via the Speed Strap, a simple, non-slip Velcro strap that wraps around the flash head without the use of annoying adhesives. The Honl Photo Speed System allows you to bring studio-style lighting control with you into the field. You can find out more at www.expoimaging.net.

I discuss each of these items, what they do, and when to use them in the following sections.

Reflectors

Commercial-quality reflectors have been available for years, but you don't need a store-bought reflector to make good light. A reflector can be almost anything that is white, silver, gold, or colored that bounces light back into your photo with the intent of opening up the shadow areas and lowering contrast. For years, I used simple, white foam-core panels from an art supply store that were durable and lightweight. Over time, when these panels started looking shabby from use, I replaced them with commercial-quality ones.

Several versions are well suited to location work. Many suppliers manufacture systems that include a reflective material stretched around a shock-corded PVC pipe frame that folds up for easy transport. With a short trip to Home Depot and a fabric store, you can easily make your own with a hacksaw and a sewing machine. Common sizes are 4 × 4, 4 × 6, and 4 × 8 feet.

5.3 Shown here connected to a studio stand, commercial-grade collapsible reflectors, such as this one from F.J. Westcott, are easy to set up and transport and are a great complement to natural light or your Speedlites. They come in white, silver, and gold, and you can find out more at www.fjwestcott.com.

Another tool that is great for location work, portraits, and small products is a collapsible reflector. This consists of reflective material that's white, silver, or gold and is stretched around a spring steel frame that collapses to a quarter of its size. It may take a little wrestling around with to figure out how to get the reflector back in its case when you first open it up, but once you do, it's easy from then on. White produces the softest light, silver adds more specularity and a slightly harder edge, and gold adds warmth to the shadowed areas.

The opposite of a reflector is something that blocks light from hitting the sensor generated by lens flare. The sun or some other light source bounces stray or reflected light back into the camera that degrades image quality. In photography, these light blockers are called flags or incorrectly referred to as gobos (short for "Goes On Before Optics".) Common flags can include your hand, a clipboard, a simple piece of cardboard, or whatever's handy to shade the lens.

Gels

If you have been to any type of stage production, you have seen colored gels in action. A colored gel is a transparent, colored material that is used in theater, event production, photography, videography, and cinematography to color light either for effect or for color correction. Modern gels are thin sheets of polycarbonate or polyester, placed in front of a light source in the path of the beam.

You use gels in photography for two reasons: either you are color-correcting the light output of your flash to match the ambient light temperature, or you are adding colored gels to spice up the scene of your photo. Adding gels to the flash will cut light transmission, depending on their strength. This is no concern when shooting E-TTL because the camera/flash processor takes the loss of light into account and changes the exposure or outputs the light accordingly.

5.4 A Canon 580EX II with a Honl full Color Temperature Orange (CTO) gel mounted to the Speed Strap

You can find sheets of gel material in specific colors in most theatrical supply stores and professional camera shops. Top manufacturers include Lee (www.leefilters.com), Rosco (www.rosco.com), and Honl Photo (www.infoimaging.com).

Grids and snoots

Grids and snoots share a similar purpose, and that is to direct light to a specific spot and nowhere else. This adds a spotlight effect to your images that is easy to produce. Along with zooming your flash head to its longest focal length setting, adding a snoot to your flash concentrates the beam along the line of the flash head axis, and so aiming the flash is critical to get the light exactly where you want it to go.

5.5 A green gel is used to add a large area of color to the background in this business portrait of IT tech Keegan Mullaney of KM Authorized.

You can use snoots to make concentrated spots of light, which also enables you to keep light from falling where you don't want it. I use snoots when I want to illuminate specific areas of my photo and produce slightly softer light with more gradual fall-off.

Almost any material can be used to make a snoot — foam or cardboard are popular choices — and I have even seen some pretty good ones made from discarded Pringles cans and macaroni-and-cheese boxes. Let your imagination run wild!

Grids concentrate the light a little more, in a tighter circle or whatever shape the grid is made of, usually round or honeycombed openings. Grids condense the light, maintain the hardness if undiffused, and have very quick fall-off from where they are aimed. They add high drama to your lighting setup and create a very theatrical look to the images. I use grids and snoots to keep my viewers' attention on exactly what I want them to see first, and create moodiness in the images through the lighting setup.

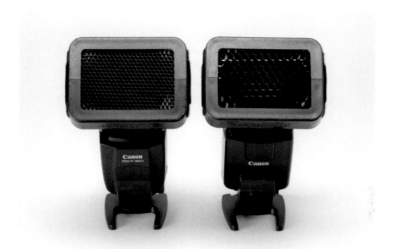

5.6 **Grids produce concentrated pools of light in whatever shape they are made of, usually round or honeycombed, and they fall off very quickly. Different-size openings produce different-size illumination areas.**

Diffusers

A diffuser can be anything that breaks up light rays and scatters them into different lengths and different directions, producing soft lighting effects, less contrast, and greater fall-off (which is the transition line between highlights, diffused highlights, and shadows). Clouds are natural diffusers when they float between you and the sun. On cloudy days, you'll notice softer light, weakly defined shadows, and far less contrast than on bright, sunny days. The wide panel on the 580EX II and 430EX II is also a type of diffuser, scattering light for coverage using wide-angle lenses.

The first diffuser you should consider is the Sto-Fen model for your particular flash. The Sto-Fen diffuser is a piece of custom-molded, frosted plastic that covers the flash head and extends beyond the lip of the flash by about 3/4 inch. I almost always have it on my flash to soften the light from the flash, scatter it, and provide better skin tones. It also works well in the bounced position, softening the light before it even hits the ceiling or bounce surface you're using.

Other types of diffusers can be the panel type or collapsible type, similar in construction to the reflectors described previously. When you have to use uncooperative natural light, a diffuser can be your best friend. I often use a collapsible, 42-inch diffuser from Photoflex to soften and even out the mottled light pattern that comes through trees when shooting outdoor portraits, or I set it up on a stand and fire my remote Speedlite through it when I need a broad light source.

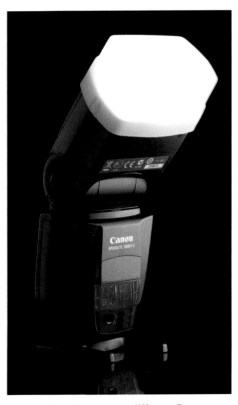

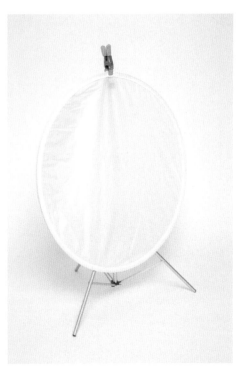

5.7 The Sto-Fen pop-on diffuser. Be sure to get the one that is specific to your model flash.

5.8 Stand-mounted, 42-inch, collapsible diffuser from Photoflex. These can do wonders outdoors in poor light and create beautiful, studio-quality light almost anywhere.

Umbrellas

Photographic umbrellas are probably the easiest light modifiers to use and are often the first choice for photographers looking to improve the quality of their light. In fact, umbrellas come with nearly every lighting kit assembled by manufacturers, unlike softboxes or other lighting modifiers. They come in many different sizes and operate just like their rain-shielding cousins. A photography umbrella is simply a regular umbrella with a reflective or translucent covering. You'll find any number of commercially available brackets to combine your Speedlite, umbrella, and stand together for a relatively affordable price.

Depending on the type of umbrella you're using, you typically set the umbrella to the left or right of the subject you are photographing, aim your Speedlite into it, and point the open side directly at the subject. Moving the umbrella closer amplifies the light source, while moving it away does the opposite. Multiple umbrellas can be used to provide broader lighting coverage for larger groups.

The three types of umbrellas to choose from are:

▶ **Standard.** The most common type of umbrella has a black outside covering to trap light from spilling through the fabric, with an inside surface coated with a reflective material that is usually white, silver, or gold. These are designed so that you point the Speedlite into the umbrella and bounce the light back onto the subject, resulting in a non-directional, soft light source.

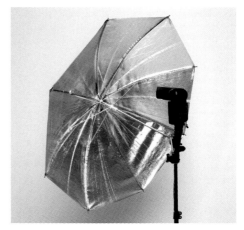

5.9 Stand-mounted, 30-inch, silver umbrella with Speedlite attached

▶ **Shoot-through.** These types of umbrellas are manufactured out of a translucent nylon material that enables you to fire your Speedlite through the umbrella, producing a quality of light much like that of a softbox. You can also use this type of umbrella to bounce the light back onto your subject, as mentioned previously, but if you use it this way, you'll also lose some light out the back of the umbrella.

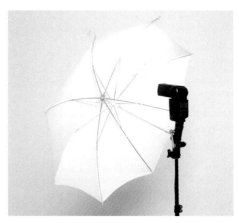

5.10 Stand-mounted 30-inch, white shoot-through umbrella with Speedlite attached

▶ **Convertible.** The convertible umbrella has a white, silver, or gold lining on the inside and a removable black cover on the outside. You can use these umbrellas to bounce light or the white version can be used as a shoot-through when the outside covering is removed. This is probably the most economical type to purchase when you consider it's like getting two umbrellas in one.

Photographic umbrellas come in various sizes, usually ranging from 25 inches all the way up to 12½ feet. The size you use depends on your taste, the size of the subject, and the degree of coverage you would like to obtain. For standard headshots, portraits, and small to medium products, umbrellas ranging from 25 inches to about

40 inches supply plenty of coverage. For full-length portraits and larger products, a 60- to 72-inch umbrella is generally recommended. If you're photographing groups of people or especially large products, you may need to go beyond the 72-inch umbrella or add a second light with an umbrella of the same size.

With the same umbrella-to-subject distance, the larger the umbrella, the softer the light falling on the subject will be. Generally, the small-to-medium umbrellas lose about 1½ to 2 stops of light over straight-on flash. Larger umbrellas generally lose 2 or more stops of light because the light is being spread out over a larger area.

Smaller umbrellas tend to have a much more directional light than do larger umbrellas. With all umbrellas, the closer you have the umbrella to the subject, the softer the light will be. By moving it closer, you are also making it larger in relation to your subject. The larger the light source, the softer the light will be. The smaller the light source in relation to the subject, the harder that light will be.

If you are just getting started with light modifiers, umbrellas are the way to go. They fold up to a compact size, are simple to use, are relatively inexpensive, and attach to the light stand with a small bracket, which is available at any photography store, usually for less than $15. These brackets usually include a hot-shoe mount for attaching your Speedlite flash unit. F.J. Westcott (www.fjwestcott.com) has a complete line of umbrellas, stands, and brackets, and they are the type found in my studio.

Choosing the right umbrella is a matter of personal preference. Some criteria to keep in mind when choosing your umbrella include its type, size, and ease of transport. Just remember that regular and convertible umbrellas return more light to the subject when bounced, which can be advantageous because a Speedlite has less power than a studio strobe. The less light energy your Speedlite has to output, the more battery power you save. On the other hand, shoot-through umbrellas, although they lose more light through the back when bouncing, are generally more affordable than convertible umbrellas and produce beautiful light.

Softboxes

As with umbrellas, softboxes are used to diffuse and soften light from a strobe to create a more natural rendering of faces, products, and still lifes. Softboxes range in size from small, 6-inch boxes that you mount directly onto the flash head, to large boxes that usually mount directly to a studio strobe. Softboxes also come in a variety of shapes — anywhere from large, rectangular softboxes to very skinny strip banks, which produce thin highlights and very directional light.

Flash-mounted softboxes

The small, flash-mounted softboxes are very economical and easy to use. You just attach the softbox directly to the flash head and use it with your flash mounted on the camera or on a flash bracket. This type of softbox is good to use while photographing an event, informal portraits, candid wedding shots, or anytime you'd like to increase the quality of your flash's light. You generally lose about one stop of light with a softbox when shooting with your flash set to manual power, but E-TTL takes this into account and compensates accordingly. For shooting small still-life subjects or simple portraits, this may be all you need to get started with your wireless or portable studio.

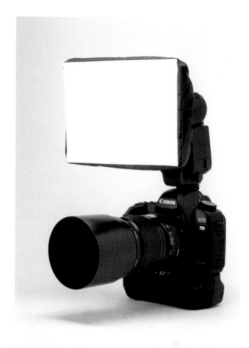

5.11 Flash-mounted softboxes, such as this Micro Apollo from F.J. Westcott, are small and collapsible, eliminate red-eye, and produce better light than just a straight flash.

Stand-mounted softboxes

Once you decide to get the flash off of your camera for better light, you'll need some place to put it and some way to modify the output quality. You might consider a medium-size softbox that is mounted, along with your Speedlite, onto a suitable light stand. For a medium-size softbox, you'll need a sturdier stand to prevent the lighting setup from tipping over, especially outside, where even the slightest breeze can send a softbox flying. F.J. Westcott and Manfrotto manufacture a range of stands that work well, set up easily, and are highly portable.

Softboxes provide a more directional and controllable light than umbrellas do. Softboxes are usually closed around the light source with Velcro tabs, thereby preventing unwanted light from being bounced back toward the camera. The diffusion material evens out the light and reduces the possibility of creating hotspots on your subject. A hotspot is an overly bright spot on your subject, usually caused by bright or uneven lighting.

Many softboxes also offer versatility in the way the front panel attaches to the softbox, and permit the photographer to control the spill rate from the light. A large Velcro strip on the front edge of the softbox allows you to mount the front panel either flush or recessed. Flush mounting creates a gradual fall-off to the light, while recessed mounting tightens up the edge of the light.

Softboxes are generally made for use with larger studio strobes. They attach to these strobes with a device called a speedring. A speedring is usually specific to the type of lights to which it is meant to attach. F.J. Westcott has solved this problem for Speedlite owners by manufacturing several sizes of softboxes and octabanks that open just like an umbrella and attach to the stand and Speedlite with a simple umbrella bracket, and they are very easy to use.

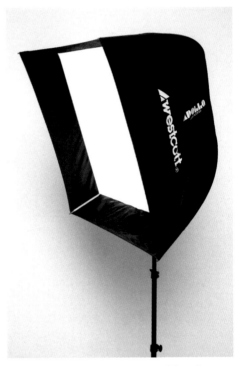

5.12 Stand-mounted Apollo softbox from F.J. Westcott

Most photographers use standard square or rectangular softboxes and, like any accessory, some perform better than others in certain shooting situations. As with umbrellas, the size of the softbox you need to use is dependent on the subjects you plan on photographing. Softboxes can be taken apart and folded up pretty conveniently, and many of them come with storage bags that you can use to transport them.

Octabanks

Gaining in popularity recently is another type of softbox called an octabank, named for its somewhat circular, eight-sided construction. Larger studio units often contain an elaborate mounting system, while the ones that work well for Speedlites look and operate very similar to umbrellas but include a closed back to contain the light and add to the efficiency of the flash unit.

They mount to the stand in the same way an umbrella does, and they generate a wrap-around, non-directional type of lighting. They usually come in sizes larger than softboxes to create soft light over very large areas.

Octabanks are considered by some photographers to be the most evenly lit, large light modifiers on the market today.

Softbox alternatives

A few other light modifiers that can be assembled relatively easily and that are cost-effective alternatives to commercial products deserve mentioning here. A homemade diffusion panel is basically a frame made out of PVC pipe with a reflective or translucent material stretched over it. You can run a 1/4-inch bungee cord through the pipe to keep all the pieces together, just like the professional ones. Because the PVC frame can be disassembled easily and packed away into a small bag for storage or for transportation to and from the location, it is a handy addition to the portable studio.

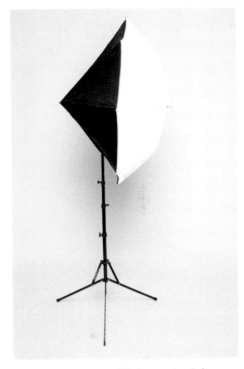

5.13 Stand-mounted Halo octabank from F.J. Westcott

Commercial diffusion panels are usually four, six, or eight feet tall and have a base that allows them to stand up without the need of a light stand. The diffusion panel is placed in front of your Speedlite, which is then mounted on a light stand. You can move the Speedlite closer to the diffusion panel for more directional light, or farther away for a softer and more even light. For a full-length portrait, you would place two Speedlites behind the panel, evenly spaced near the top and bottom of the panel.

A diffusion panel can also be used as a reflector when used in conjunction with another light source. Diffusion panels can be purchased at most major camera stores at a fraction of the price of a good softbox, but it's just as easy to make your own.

Another great idea for quick shots of small products and items is the studio-in-a-box used with a few Speedlites. Any size box works for this, but I prefer a 16 × 16 × 16-inch box for the size range of products it will handle.

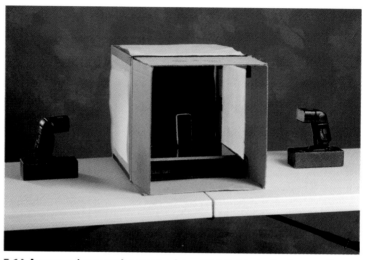

5.14 A square box can become a beautiful light studio for small products with this studio-in-a-box.

You simply cut the cardboard out of three sides of the box about 1 inch from the edge, and lay it on the one remaining side with the open box top facing you. Tape some tracing paper, velum, or tissue paper over the squares you just cut in the sides, add a piece of tile or Plexiglas to act as your shooting surface, and position your Speedlites to fire from either side, or from the top.

There are a number of other low-cost devices on the market that can be used directly on the flash to provide modification and diffusion to the light. My other favorites are Lumiquest's 80-20 light shaper and Gary Fong's Lightsphere, both of which attach to the flash head and soften the light to a very pleasing degree.

5.15 iPhone product shot using two Speedlites and the studio-in-a-box

Backgrounds and Background Stands

I always consider the background to be a very important element in the different kinds of photos I shoot, whether they are portraits, products, events, or macro work. Even in sports photography and photojournalism, the background can often make or break the shot.

Portrait and studio photographers have several different options open to them regarding backgrounds for their subjects. Obviously, you could use a room setting and just throw it way out of focus by using a large f-stop selection, but having a simple background to support your portrait is key to keeping the viewer's attention on your subject and making it stand out. Today, backgrounds come in a wide array of colors and materials, and you are only held back by your imagination. The following sections discuss some of the different types of available backgrounds and their applications.

Seamless paper backdrops

Seamless backgrounds got their name as a way to distinguish them from older canvas or muslin backgrounds that usually included a visible seam in their construction. The most common types of seamless backgrounds today are made of paper. Seamless paper backdrops are inexpensive and come in a broad range of colors. Standard rolls of background paper range in size from 3 feet to 12 feet wide in rolls that are 36 feet long. The great thing about using paper as a background is that if it develops footprints, or gets dirty or ripped, you can cut that piece off and throw it away. It's best to store your seamless paper backgrounds vertically instead of horizontally if you can, to avoid them developing a 'washboard' effect over time.

Starting out, it's a good idea to obtain a roll of the neutral gray paper. You can use this background for just about any subject without worrying about the color of your subject clashing with

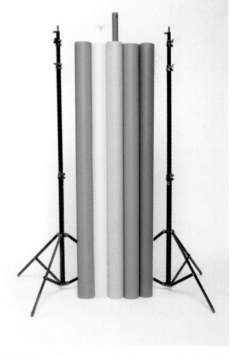

5.16 Seamless paper backgrounds, stands, and the crossbar that supports the paper are easily transported to and from portrait locations outside the studio.

the background. White paper is ideal for photographing subjects where you want a very clean or high-key look, just like many of the product shots used in this book. A black low-key background is good for making your subject pop where it appears to be the only thing in the shot, which is often desirable with lifestyle products and jewelry.

For more information on high-key and low-key images, see Chapter 3.

To keep your background kit to a manageable size when traveling, it's often more economical to buy larger-size backgrounds and cut them down to the size you need with a hacksaw — your photo store can probably do it for you. This way, you can cut down the background to fit a case or bag you're already using for your stands, as long as it provides adequate coverage for your portraits. Lately, I've noticed several photographers using snowboard bags to transport their backgrounds and stands with great success.

When using white, gray, or black seamless backgrounds, I often use gels on a Speedlite behind the subject, aimed at the backdrop to create a background color. As previously mentioned, gels are pieces of colored polyester that you place over the light source in order to change the color of the light. Theatrical supply stores and professional camera shops usually stock a wide assortment of gel colors.

Muslin backdrops

Muslin is a durable, inexpensive, lightweight cotton material that can be folded, rolled up, or crammed into a stuff sack and still perform well as a background. When used for backdrops, it is usually dyed a few different colors with a mottled pattern to give the background the appearance of an out-of-focus texture. You can

5.17 Muslin backgrounds compress to a very small size, making them ideal for location portraiture. This 10 × 20-foot muslin background easily fits into this 8 × 14-inch stuff sack.

purchase muslin at most well-stocked photography stores or online. If you have very specific needs, there are companies that dye muslin fabric to a custom color of your choice.

 The Internet abounds with sources and ideas for backgrounds, and a few top suppliers are EOS Lighting (www.eoslightingllc.com), Denny Manufacturing (www.dennymfg.com), and Owen's Originals (www.owens-originals.com).

You can drape muslin over your background cross-member or easily tack it to a wall. Muslin is very versatile, and although it's much more suited to portraits, it can sometimes be used successfully for product shots as well.

Canvas backdrops

Canvas backdrops are very heavy duty. They are usually painted with a scene or a mottled color that is lighter in the center and darkens around the edges, which helps the subject stand out from the background. These types of backdrops are almost exclusively used for portraits.

When considering a canvas backdrop, in addition to the weight factor, you should also consider the cost, as they are fairly expensive. Although you can get them in lighter-weight, smaller sizes, they cannot be folded and must be rolled up, and you must take care when transporting them. I have several that I purchased years ago from a local artist, but I typically only use them in the studio because of their size.

Background stands

Most background stand kits have three pieces: two identical stands and a convertible crossbar. The crossbar slides into a roll of paper or other backdrop material and is held up by the stands. The crossbar has two mounting holes, one at either end, which slide over a support pin on the top of the stands. The crossbar is usually adjustable from 3 to 12½ feet, to accommodate the various widths of backdrops. The stands are adjustable in height, up to about 10½ feet. Most kits also come with either a carrying case or a bag for maximum portability.

There are varying degrees of quality in background stands, and the sturdier the stand, the more expensive it is. For a portable studio, a decent medium-weight, background-stand kit suffices. Be careful when setting up stands and backgrounds that can become top-heavy and easily prone to tipping over. Having a couple of studio-set weights or bricks covered with black gaffer's tape secured to the stands helps to keep everything rock-solid.

5.18 Hand-painted canvas backgrounds create one-of-a-kind portrait looks.

Space Considerations

If you are fortunate enough to be able to dedicate a place in your home for your portable studio, you are that much more ahead of the game. Being able to test and retest lighting setups will allow you to work more smoothly and quickly once you have someone sitting in the chair, posing for you or have a lot of objects to shoot in a short time.

Depending on the type of photography you plan to do, space considerations often come up fairly quickly in the plan. If you intend to do full-body portraiture, including a hair light, you'll need a good ten feet from the image's background to the photographer's back at a minimum. Speedlites make it easy to do tabletop, macro, and still-life photography with a minimal amount of space and can also perform well with larger subjects, but remember that the larger your subject is, the larger the background needs to be. Everything expands from the camera's eye proportionally; a four-person rock band can easily require a 12-foot background.

Setting up for indoor shoots

One thing to consider when setting up indoors is finding a space wide enough to accommodate the background and stands. Remember that although your backdrop may only be six feet wide, the stands extend two or three feet beyond that. Next, you want to be sure that you have enough room in front of the background to be able to move back and forth, even with zoom lenses, to enable you to frame up your picture the way you want it.

Portraits

When photographing portraits, you want to use lenses with a longer to medium focal length. A lens in the 85-150mm focal length range is ideal because it compresses the scene slightly, and keeps you a comfortable working distance away from the subject but not so far away that they cannot hear you giving them posing suggestions. Unfortunately, with longer lenses comes the dreaded "minimum focusing distance," which becomes greater as the lens focal length increases.

I also like to select an aperture between f/8 and wide open, depending on the intent of the image, in order to throw any distracting details in the subject or the background out-of-focus.

If you use a long focal-length lens to photograph a standard head-and-shoulders portrait, you need at least ten feet between the camera and the subject, two or three feet behind the camera for you, and anywhere from three to six feet between the model and the background to be sure the model isn't casting shadows on the backdrop because of your lighting placement.

Be sure the area is wide enough to accommodate both the model and the lights comfortably. You want to have enough width to be able to move the lights closer or farther away from the model to fine-tune your light if need be.

Small products

Photographing small products requires a lot less room than photographing people. Using the previously mentioned studio-in-a-box technique, you can fit the entire production on a tabletop.

When shooting small objects, you only need a few feet between the camera and the subject. That's almost half the amount of space you need for portraits. Use the 12mm and 25mm Canon extension tubes if you need to get in closer to fill the frame.

The ideal way to start lighting a simple product shot is to place the main light above and a little behind the product, or on the sides. This simulates a natural light, and creates a slight rim light, which helps separate it from the background. The next step is to note where the shadows are and to fill them in if you want to. You can either use an additional Speedlite as a fill light, or you can bounce or reflect light from the main light into the shadow areas. Small, inexpensive, round, regular, and magnifying make-up mirrors work well in this capacity.

Remember, pay attention to details when you are working with small subjects. Dust can take on gargantuan size, and scratches and imperfections in the surface of the object can be highly noticeable. Canned, non-aerosol air is great for removing dust from your setup right before you shoot. This also works well on bugs when they sneak on to the set!

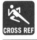

For more information on small product lighting, see Chapter 6.

Setting up for outdoor shoots

Putting a portable studio together ensures that you will have beautiful light wherever you go. With the Canon Speedlite System, you can bring your lighting gear just about anywhere and never have to worry about plugging in for power. Shooting outdoors offers its share of advantages — for example, you have none of the space restrictions that you have inside — but it also includes obstacles that must be overcome.

Using your 580EX II or 430EX II on-camera, you'd likely use the sun as your main light, set the flash to E-TTL, and shoot. If you use your flash off-camera with stands and modifiers such as umbrellas, softboxes, and octabanks, you need to set them up as level as you can whenever possible and use weights or stakes to hold them down. Many photographers purchase used fitness weights at yard sales, wrap them in bubble wrap, run a loop of rope through them, and hook them on the light stands' adjustment knobs, a solution that works well.

Also, when using a softbox or umbrella, it's a good idea to be very conscious of the wind. Wind can take the entire assembly and send it flying into the next county. Protect the people working with you and your gear at all costs and take the necessary precautions. I speak from experience!

When shooting outdoors, the same lighting styles and looks I covered previously can be applied, but you still need to pay extra attention to the sun's position — where it is now, where it's going, and where it's going to set — and planning accordingly. Different types of sunlight have different qualities and different color temperatures:

▶ **Bright sunlight.** Bright sunlight can cause serious problems with exposure when using flash. When in bright sunlight, your camera may not be able to select a shutter speed that's higher than your camera's rated flash sync speed if it detects a Speedlite is attached. You may need a higher shutter speed to achieve a proper fill flash exposure even at your smallest aperture.

The way to solve this problem is to move your subject into a more shaded area or to use Canon's high-speed sync on your Speedlite; this enables you to shoot at speeds higher than the actual sync speed of the camera when using the 580EX II, 430EX II, or macro Speedlites. This is very convenient if you're shooting an outdoor portrait and need to use a wider aperture for less depth of field, which will then require a fast shutter speed. The High-speed sync mode causes the Speedlite to emit a series of lower-power flashes that coincide with the movement of the shutter across the digital sensor. The drawback to high-speed sync is that it diminishes the distance range of the Speedlite. To compensate you could increase the ISO or aperture settings or switch the Speedlite to manual output settings. High-speed sync mode can be used all the way up to the maximum shutter speed of the camera.

▶ **Cloudy sunlight.** This lighting occurs when it is overcast, but when you still have slight shadows. This is wonderful light to photograph in, and is comparable to the light from a good softbox. All you may need to do is use your Speedlite to add a little fill-flash and some warmth.

▶ **Open shade.** Open shade happens when your subject is in shade but there is clear light and blue sky overhead. In harsh sunlight, I try to make any shady area work, but the light may be so soft that it has gone dead, with poor contrast and bluer light. You now can set your Speedlites much closer to the range they were designed for.

When using light stands outdoors, having sandbags or weights on hand to prevent the wind from blowing them over is highly recommended. Sandbags are commercially available through photography stores, or you can easily make your own. And you can always find weights at yard sales, right?

Traveling with Your Wireless Studio

Once you decide to start traveling with your wireless studio, your first consideration will be getting a durable case for your equipment that protects everything and is still easy to carry. Your Canon Speedlites are compact and built for years of service, but they still need to be properly cared for when packed and transported.

A myriad of styles, colors, and sizes await you when you begin to search for the perfect case or bag to store and transport your precious gear. From the simple Domke camera bag, which was the staple of photojournalists for many years, gear containers have morphed into fanny packs, backpacks, and gear belts to store every last bit of equipment that you need to produce quality photos. You want the container to be sturdy and well padded, and to look good.

Camera cases and bags

Here are a few good resources for quality protection for your gear.

▶ **Lightware.** These folks have been making professional photo gear cases for decades, using a variety of lightweight, shock-absorbing materials to produce extremely protective gear bags that protect equipment that is many times their weight. They look clean and professional, much better than a cobbled-together set of odd camera bags. You can find them at www.lightwareinc.com.

▶ **Think Tank Photo.** A relatively new company started by photographers, Think Tank Photo offers a huge array of smart gear packs, airline cases, bags, and photo accessories for the travelling photojournalist, and they are always coming up with new products. Their "Be Ready Before the Moment" philosophy inspires airport cases and bags that are especially well-received by photographers who need to know their gear is safe, even on extended trips. The Think Tank Photo Web site is located at www.thinktankphoto.com.

▶ **Pelican cases.** You've seen some version of these cases in nearly every James Bond movie. Pelican cases are watertight, airtight, dustproof, chemical-resistant, and corrosion-proof. They are built to military specifications and are unconditionally guaranteed forever. That's right, forever. Pelican cases even float in salt water with a fifty-five pound load inside. A standard Pelican case holds two camera bodies, a wide-angle to medium zoom, a telephoto zoom, and two Speedlites and all the attachments.

Cases are great for long term storage or airport shipping, but sometimes you have to carry all the gear to the location. Here are a couple of solutions for getting that gear where you need it to be:

▶ **Shoulder bags.** These are the standard, time-tested camera bags that you can find at any camera shop. Materials have changed significantly, and the new bags are sturdier than ever and come with user-configurable Velcro dividers and pads. Bags come in a multitude of sizes to fit almost any amount of equipment you can carry. I use Tenba, Tamrac, and Lowepro bags, all of which are easily found on the Internet.

▶ **Backpacks.** Backpack camera bags have grown in popularity, as a new wave of participatory photography has attracted today's image-makers, and backpack bags make it that much easier. Many offer laptop-carrying capabilities that make it effortless to have everything in one case. The Tenba DB17C backpack that I use can hold two camera bodies, a wide-angle and medium zoom, a 70-200mm telephoto, two Speedlites, a battery pack, a twelve-inch laptop, and all of the plugs, batteries, gels, sync cords, slaves, and other small accessories that go along with my gear.

Backgrounds and light stands

There is no way around it. You want the most stable stand you can find, that won't blow away in the wind, but you have to be able to move it around quickly. Plus, it has to fit in your case, alongside the umbrellas, and be lightweight. This is no small order.

Enter the Manfrotto 5001B Nano Retractable Compact Light Stand, which is perfect for supporting Speedlites on location. Surprisingly strong for such a small size, the stands extend to 6.2 feet and fold down to 19 inches, which makes them easy to fit into a location case like the one I use.

I might never attach a monolight to one of these stands in the studio, but their light weight makes them perfect for small flash support on location. F.J. Westcott has a Speedlite kit that contains a slightly sturdier stand that permits the use of a larger soft-box or octabank. Whichever one you decide to use, just remember to stake or weigh them down; that light weight also has a downside.

Everyday Applications of Your Speedlites

The first five chapters of this book dealt with introducing you to the operational modes of your Speedlites, choosing Custom Functions, firing them wirelessly, and setting them up for different shooting situations. I discussed the principles of flash photography, how to set up channels and groups for wireless flash work, and some ideas on building a portable, wireless flash studio-lighting kit.

This final chapter applies those techniques to situations you'll often find in the real world. These are locations and situations you need to make work in terms of lighting to get the shot you've conceived in your mind's eye. I discuss some of the common problems encountered in each of these shooting genres and some practical advice for solving them and going beyond the ordinary in your flash photography.

Damien Wiggins takes a break while tending his home garden in the early evening. The camera was set to a tungsten white balance, producing the deep blues of the background. Two Speedlites lit the scene, one for the subject, and one for the background. The main flash was gelled with two Color Temperature Orange (CTO) gels, one to match the flash to tungsten and one more to warm up the light. Exposure: ISO 500, f/2.8, 1/80 second with an EF 100mm f/2.8L USM lens.

Action and Sports Photography

Today's digital photographers are well poised to offer the world their version of a public event, epic moment, or memorable performance, with the possibility of creating iconic images for an adoring audience and a vast array of media outlets. With the added challenge of shooting in somewhat unfamiliar surroundings, sports, action, and event photographers grapple almost constantly with limited access, unflattering lighting, uncooperative venues and subjects, and a host of mechanical problems that studio photographers may never encounter.

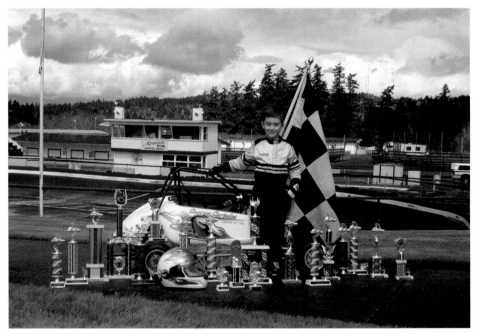

6.1 After a sudden shower shorted out my monolight and soaked down the location, having a Canon Speedlite along saved the day by adding just a little pop to the colors and reflections off the trophies won by George Cartales, Quarter Midget champion. The manual mode Speedlite replaced the monolight on a stand positioned camera-left. Exposure: ISO 100, f/8, 1/125 second with an EF 16-35mm f/2.8L USM lens.

On the plus side, low-light focusing speeds of today's cameras have become faster along with processor speed, and higher-resolution LCD screens have grown larger, allowing photographers to view images quickly with stunning clarity. Highly personal satisfaction awaits the sports and action photographers who continuously hone their craft on the sidelines, in the pits, or at the ballpark.

When shooting events with a Speedlite, remember that you're limited to using the top sync speed that your camera allows, usually around 1/250 second, which sometimes may not be fast enough to freeze the motion. If you are close enough to the subject, the flash duration will usually be quick enough to freeze the motion regardless of the shutter speed. If there is too much ambient light for this to happen, you can switch your Speedlite to High-Speed Sync mode and shoot at much faster shutter speeds — all the way up to the top speed of 1/8000 second.

You can also utilize a number of other techniques to further decrease motion blur with your subject. A very common technique is panning. Panning refers to tracking the moving subject with your camera lens as the subject moves horizontally across your field of view. When done correctly, the subject should be in sharp focus while the motion of the camera blurs the background. This effect is great for showing the illusion of motion in a still photograph. While panning, you can also use a slower shutter speed to exaggerate the effect of the background blur. With panning, it can be a little difficult to get tack-sharp images, so shoot a lot of images. With practice, your number of "keepers" will rise substantially.

6.2 Working the sidelines or the pits with Canon Speedlites allows you many creative opportunities. Shooting in E-TTL mode using an OC-E3 Off Camera shoe cord and zooming the flash head manually to its longest setting of 105mm created a small pool of light, framing this crewman as he glued lug nuts to the wheels before a NASCAR race. Exposure: ISO 100, f/8, 1/125 second with an EF 16-35mm f/2.8L USM lens.

Using flash for action/sports photography is usually neither necessary nor advisable. Sometimes you are so far away from the action that your flash won't be effective, or you may be in a situation where flash is not allowed. In these cases, just make sure you have a fast enough shutter speed to maintain handheld sharpness. Remember to use a shutter speed comparable to the focal length of the lens. You can also use a lens with a wide aperture or increase your ISO setting to be sure you get a workable shutter speed.

Preparations and considerations

For many photographers, the need to shoot at fast shutter speeds produces incredible images of moderately paced action. Today's cameras respond quickly to your touch, and autofocus (AF) is lightning fast to capture that shot at the peak of the action. In addition, when you shoot in Continuous drive mode, you'll be sure to capture the decisive moment of the play over several frames. Top-of-the-line professional cameras are renowned for their faster frames-per-second rates, but many prosumer cameras easily attain 3 to 7 frames per second, which is good for many sporting events. By including more images into that one-second time frame, the odds are just higher that you'll get many more great shots of the peak action.

For anyone who appreciates fast action, shooting sports can be one of the more exciting and rewarding genres of photography. Sports photography also comes with its own set of challenges and criteria that must be met if you are to produce images you'll be proud to share. You may have seen sports photos that make you stop and simply marvel at human achievement, or power, or grace. To be able to produce such arresting imagery requires some special gear to be sure, but also a certain sensitivity for the particular sport and an ability to think on your feet while using your peripheral vision, to see it all and capture it.

6.3 Leading lines of the track lanes frame distance runner Sarah Schaff in this sports portrait. An off-camera Speedlite set to E-TTL perfectly fills in the shadowed side. Exposure: ISO 500, f/2.8, 1/500 second with an EF 70-200mm f/2.8L USM lens.

Preparation is key to being able to capture the images you want to come away with, that define the sport, the players, or the moment. Getting close to the action requires access that you need to find out about beforehand. For your own safety, make sure you are in an allowable area, keep both eyes open when shooting, and stay out of the way of the participants, coaches, or officials. Sports are really no different than portraiture in the sense that you want to fill the frame with your subject, which isn't an easy task when that subject is engaged in competition or streaking toward the basket, goal, or finish line at top speed.

When deciding what equipment you're going to bring to a sporting event, your main consideration is mobility and what you can physically carry. You want to be able to quickly relocate to the other side of the court, field, or track when the action moves there.

Here are some general suggestions of gear to bring along for sports and event shooting, as well as a look at some of the gear you may want to consider for more involved events:

- ▶ **One or more camera bodies.** The best-case scenario is having two camera bodies, one with a wide-angle lens and one with a lens anywhere in the 200-400mm telephoto range, depending on the event.

- ▶ **One or more Speedlites.** For fast shooting situations where you are using flash, it's easier to swap out Speedlites when the recycle time slows down rather than change the batteries. An extra Speedlite comes in handy for sports portraits also, when you need to illuminate the background or rim the athlete to separate them from the background.

- ▶ **One or more wide-angle and telephoto zoom lenses.** I've found that the 24-70mm f/2.8L lens and the 70-200mm f/2.8L IS USM lens are very versatile. I also use the Extender EF 1.4x II and the Extender EF 2x II to increase the focal length of the L-series telephotos. For sports and other fast-action events, an EF 300mm f/2.8L IS USM or a similar lens is a good choice and can also be combined with the above extenders. For outdoor events, such as motorsports, beach volleyball, or surfing, be sure to also have lens cleaner and cleaning cloths handy.

- ▶ **Tripod and monopod.** Having a lightweight but sturdy tripod is indispensable, particularly when you're shooting with long lenses. In addition, a versatile ball head with a sturdy quick-release plate increases the steadiness of shooting with big telephoto lenses. A monopod is a necessity when shooting sideline sports because tripods are somewhat clumsy for shooting the fast nature of sports and do not allow you to change shooting positions quickly.

▶ **Memory cards sufficient for the duration.** The number of memory cards that you carry depends on how many images you typically shoot and the length of the shooting session. High-volume shooting justifies the larger-capacity CF and SD cards, as well as a portable storage device, such as a jump drive or mini hard drive, to offload images as time allows. Faster cards mean longer bursts of shooting before the camera's buffer fills up and delays further image-making.

▶ **Spare camera and flash batteries.** Live by the battery, die by the battery. If your battery gives out, you're in trouble. For each camera and Speedlite, I usually have one or more charged spare batteries in my gear bag as insurance. Also, if I know that I have access to electricity where I can plug in safely, I sometimes bring along the battery charger for multi-day events. For multiple events on the same day, I plug the battery charger into a 300-watt power inverter that I plug into my van's power outlet to charge up as I drive.

▶ **Portable mp3 player or iPod.** These come in a wide variety of styles with different storage capacities so you never have to hear the same song twice. You can't do the job well if you're really bored, and there are often periods of downtime when shooting events. Having a snack, bottle of water, and comfortable clothing and shoes also deserve a mention here as ways to stay loose and be ready to shoot at a moment's notice.

▶ **EX-series Speedlites, light stands, umbrellas, an ST-E2 Speedlite transmitter, and PocketWizards.** Bring your wireless portable studio along if you think there will be an opportunity to take sports portraits of some of the participants. Then set up your gear in a safe place and capture one-of-a-kind portraits of the competitors.

For more involved shoots, you may want to include the following:

▶ **Laptop computer or portable storage device.** Backing up images on-site, either to a laptop or a handheld hard drive, is an essential part of the workflow. A laptop is also convenient if you upload images to a client server, blog, or Web site, or print images on-site.

▶ **Silver and gold reflectors.** Without question, reflectors of various sizes are indispensable for filling shadow areas and adding catch lights to the eyes if part of the session involves shooting individual participant portraits. Reflectors are especially useful for getting some light up under baseball hats and filling in back-lit portraits.

▶ **Plastic sheets or drop cloths.** For outdoor shooting, large plastic sheets come in handy for a variety of unexpected situations, including offering protection from a rain shower or wet grass, protecting camera and lighting equipment, or serving as a backdrop for portrait sessions.

▶ **Multipurpose tool.** This tool can solve all kinds of unexpected problems, from fixing camera and lighting gear to fixing sports equipment. Don't laugh, it has happened!

On location, choosing what will be the background of my image is often my first consideration. For outdoor events, you want to avoid shooting angles that show cars in the parking lot, portable toilets, or those orange event cones. Indoors, watch out for illuminated exit signs, trash cans, and vast sections of empty grandstand. This is not as easy as it sounds for local sports. Start at this point, and your photography will immediately improve.

Try to choose angles where your background "holds" or at least complements your subject in a clean, non-obtrusive way. Shooting at your widest f-stop will blur your background as well as affording you the ability to shoot at the fastest possible shutter speed for your chosen ISO.

The closer you are to the action, the more choices you have regarding lens selection and composition. For this reason, depending on their assigned location, many professionals tend to shoot sports with two or more cameras — one outfitted with a telephoto lens appropriate for the sport event and another with a wide-angle zoom for when the action comes in close. Gaining access means more than just cool shooting angles. Often, photographers pre-position themselves and then test fire flash lighting equipment before the game, to be ready when the real action begins.

Learning all you can about your particular sport before you begin to shoot can pay huge dividends later. Think

6.4 Bicycle racers line up in the staging area for the Lance Armstrong Live Strong Challenge. The low early-morning sun necessitated using a 580EX II Speedlite in E-TTL mode to fill in the heavy shadows and a dome diffuser to spread and soften the light from the flash. Exposure: ISO 500, f/14, 1/250 second with an EF 16-35mm f/2.8L lens.

about it. You have a sport you love, and you know the intricacies of play and all the nuances of the rules. That special knowledge of the sport will become evident in your

photographs. All sports have down-times and peak moments and also many moments of unpredictability. Having the skill to predict these times helps keep you alert and focused on the action, or sends you off looking for unique compositions of the gear, players, location, or setting.

Successful sports photography is all about timing and anticipating the action before it happens. There's a saying among sports photographers that "if you saw the play, you missed the shot," meaning that if you saw that split-second action in your viewfinder, you probably missed getting a shot of it. Getting into the flow of the game helps to anticipate what may happen next. Keeping the camera near your face, ready to shoot, and your other eye open and watching the scene unfold speeds up your reaction time.

Because my subjects are usually human — and humans are vertical

6.5 Speedlites provided the only light in this ice cave, and three were used wirelessly for this shot of caver Liam Nagy. Exposure: ISO 640, f/8, 1/13 second with an EF 24-70mm f/2.8L USM lens.

subjects — I prefer to shoot with the optional battery grips on the 5D Mark II or with the EOS 1D Mark II, which has a higher burst rate (frames per second) and a built-in vertical grip. The comfort level of using these vertical grips can't be overstated. Most often, I'm shooting with a heavy telephoto lens and a monopod, and not having to position my arm over the top (side) of the camera to shoot verticals keeps my shoulder and neck relaxed and limber.

Practical pro advice

Keep these techniques in mind when shooting events:

▶ **Do your homework.** Know the key participants, know the rules of the game, know the schedule of events, know if the event is being videotaped and how that affects your ability to shoot with flash or to move around the stage or venue, know if any areas of the venue are off-limits to photographers, know where the best action might happen, and, of course, stake out a shooting area early.

▶ **Shoot both traditional shots and creative variations.** By and large, it's very hard for people to tell you what they like but easy to say what they don't like. Giving a lot of variety to your mix of shots and not a lot of images from the same point of view gives them something to "not like," and hopefully you will have satisfied your expectations with a large repertoire of camera angles.

▶ **Look for small stories within the larger one.** Many events produce lulls when it seems like nothing is going on. These are great times to look for the details of the sports or action setting you're covering. Close-ups of the gear, faces, or hands of the competitors all make great subjects that tell a smaller story.

▶ **A monopod can be your best friend.** Monopods help keep your camera steady for tack-sharp images even when panning. They are lightweight and easily attach to your camera bag or backpack. And they can significantly reduce back and neck strain when shooting long events.

▶ **Bring backup gear.** Just as with wedding photography, there are no retakes, and second chances are rare when shooting many types of events, so if the battery dies or if a flash suddenly refuses to fire, you need to be able to quickly switch to a backup camera and flash to continue shooting without missing a beat.

▶ **Know the Speedlite.** Before you begin shooting sports or action events, shoot some test images using the Speedlite exposure modes and settings. You don't want to be messing around with your equipment and miss the action. Practice taking pictures in similar light, surroundings, or conditions as the actual event, and work out strategies for covering the event using several different lenses, camera angles, flash settings, and backgrounds.

▶ **Scope out the area to find where the action is.** Getting a great action shot requires being at the right place at the right time. Before you break out your camera and start shooting, take some time to look around to see what's going on.

▶ **Stay out of the way.** Be sure you're not getting into anybody's way or the judge's sight line. It can be dangerous for you and the participants. Be aware of the field boundaries and know where you can and cannot go. Be very careful at track events where discus, shot put, and javelins are all flying through the air, and avoid ever walking across the finish line even during lulls between races.

▶ **Practice your technique.** Action photography requires a skill set that is different than that of a portrait photographer. Be prepared to shoot a lot of images. After you get comfortable with the type of event you're shooting, you'll learn to anticipate where the action will go as well as the peaks.

▶ **Experiment with different shutter speeds.** Sometimes slowing down the shutter speed and letting the flash freeze the action, known as "dragging" the shutter, can result in unique effects.

Obtaining Permission

When photographing people, it's generally a good idea to ask if they mind if you take their pictures. This is especially true when photographing children other than your own. You should always find a parent or guardian and ask permission before photographing kids.

Generally, I keep a pad and paper in my camera bag and ask for a mailing or e-mail address, and I offer to send them a copy of the photo, either in print form or as an electronic file.

If you're planning to publish your photographs, it's also mandatory to have secured a photo release, also known as a model release form. Depending on the language on the form, when signed by the person you photographed, this document allows you to use the image for publication and any other use that you want. If your subject is under the age of 18, you must have the parent or legal guardian sign the release form.

Many sample photo release forms are available on the Internet. Read them carefully or have an attorney do it for you, to choose the right one for your photography usage.

Concert and Event Photography

Concert photography can be an extremely rewarding photographic endeavor, especially if you are a music fan, but it's not without its own set of unique difficulties. If this particular area of photography appeals to you, a good start is to attend small concerts or music clubs where local bands perform to perfect your skills. It's here that you can experiment with mixed light sources, slower-than-normal shutter speeds, flash, zoom blur, or panning the camera. Providing images you shot of the performers may endear you to the band and provide more opportunities or other bands to shoot.

Preparations and considerations

As with sports, I try to find a clean background and shooting position. Many venues and even some bigger-name bands have a "three-song rule," where you're allowed to take photos during the first three songs of the show from the orchestra pit or special photographers' section. If this is the case, you'll have to shoot quickly and maybe have to pass up that "jumping-off-the-piano" shot for another concert.

For smaller venues, there may be no choice of background, so I try to shoot from both sides of the stage. Performers with guitars present the photographer with a nice triangular composition that looks good when shot in tight.

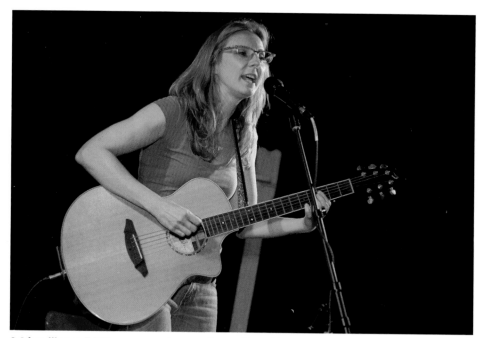

6.6 Intelligent E-TTL exposure from a Canon Speedlite bounced into a small reflector blends seamlessly with mixed, colored stage-lighting sources with surprisingly good results, as in this shot of singer-songwriter Connie Pazienza. Exposure: ISO 1000, f/2.8, 1/125 second with an EF 100mm f/2.8L USM lens.

NOTE Because some venues or performers do not allow flash photography at all, in these situations use the fastest lens you have and the lowest ISO possible while still maintaining a shutter speed that matches your focal length.

The biggest challenge I find is establishing a base exposure that still retains detail in the highlights of performers as they move in and out of the strong spotlights on the stage. To this end, I also experiment with white balance settings, even though I might be using flash. With Speedlites, I've had great results with Auto and Tungsten white balances, so alternate between the two as stage lighting changes to establish which is best. A lot of times, the stage lighting is warm and a tungsten white balance cools things off a bit, yet still produces pleasing skin tones.

6.7 Some clubs, concert halls, or bands don't allow flash photography. Such was the case in this photo of Timmy Jones from the band Tapwater. Exposure: ISO 6400, f/3.5, 1/80 seconds with an EF 70-200mm f/2.8L USM lens.

At concerts, I use the Auto Exposure (AE) Lock, setting the exposure on the hottest highlight area of the performer's skin. Alternately, you can use the Spot meter to determine the exposure of the face. For all indoor events on a stage, I shoot wide open at the lowest ISO that I can set, and still get 1/60 second at f/2.8 with my IS (image stabilizing) lenses. With the high ISO

6.8 Small venues are perfect for testing the performance of your Speedlite system. I photographed Chris Musolf at the Artichoke Café with the Honl bounce card connected to a Speed Strap instead of the dome diffuser on my 580EX II Speedlite to keep light from spilling back and distracting the audience. Exposure: ISO 800, f/2.8, 1/60 second with an EF 100mm f/2.8L USM lens.

range of some newer Canon cameras, I'm excited about shooting concerts now at exposure combinations that were not possible previously.

Practical pro advice

Depending on the band or type of show you expect to photograph, in order to be able to effectively capture definitive images, it's helpful to know the music, story line of the musical, or lighting changes so you're ready when the lights come up or go down. This is easy if you get to shoot the same show twice or follow the band to another venue the next day, but many times that's not feasible. You are pretty much at the mercy of the lighting or stage designer, but you can learn a lot about lighting for your photography by attending shows. Fog and theatrical smoke may set a mood and look great onstage, but it robs you of contrast if your subject or performers are enveloped in it. Behind them, it looks awesome.

6.9 A National Guard battalion fires off a cannon salute during the opening ceremonies of a NASCAR race. Exposure: ISO 200, f/5.6, 1/3200 second with an EF 70-200mm f/2.8L USM lens.

Try looking for angles where the performers look good and fit the rectangular frame, even if you have to turn the camera sideways. Musicians move around a lot into good and bad backgrounds, and lighting conditions change constantly. Similar to shooting pictures of kids, shoot a lot of pictures and avoid reviewing on the camera's LCD until after you have checked those first few exposures. Keep your eye to the viewfinder and keep shooting. A memorable image can happen in a fraction of a second.

Another consideration is file size. You may be generating hundreds of images from a single show. I shoot just about everything now in RAW mode. There was a time when I thought RAW meant "really awful workflow," but I was converted to RAW shooting once I saw the amount of detail and sharpness I gave up for convenience. Many photographers still prefer to shoot JPEG at events for the faster workflow that it offers, and this approach makes sense for high-volume shooting scenarios when you're displaying and printing images on-site. In other cases, it makes sense to shoot RAW + JPEG, particularly if you anticipate that you'll want to spend some time editing selected images after the event for your portfolio, Web site, or blog.

Using Second-Curtain Sync

Second-curtain sync, also known as rear-curtain sync, allows the flash to fire at the end of the exposure. When photographing moving subjects, if the flash fires at the beginning of the exposure, the ambient light being recorded causes a blur in front of the subject, which can look unnatural. Using second-curtain sync causes the motion blur to lead up to or follow the subject. Second-curtain sync is most effective when using a slow shutter speed with at least some ambient light and shooting against a dark background.

Here are some things to consider next time you plan on shooting a concert or event:

▶ **Experiment.** Don't be afraid to try different settings and long exposures. Long exposures enable you to capture much of the ambient light while freezing the subject with the short, bright flash.

▶ **Call the venue before you go.** Be sure to call the venue to ensure that you are allowed to bring your camera in. If they do allow photography, ask about using flash. Today, it's almost always up to the band. Know what time the concert starts, and whether there's a warm-up band, intermission for the main act, and so on. Details count, so make sure you have as many as you can.

▶ **Take the Speedlite off the camera.** Depending upon the intensity of the music being performed, some shows are easier on equipment than others. If I'm at all concerned about using flash for concert photos, I bring along the off-camera shoe cord, keep the flash in my jacket pocket, and use it when I need to. Not only is using the Speedlite off camera safer than mounting it on the hot shoe, but you also have more control over the quality of the light by holding it in your hand.

However, even in high-volume event shooting, I prefer to have the latitude that RAW offers in post-processing, particularly in changeable light, such as on a stage or outdoors, where participants move in and out of bright sunlight to overcast or shaded areas. I know that even if the images are slightly overexposed, I can pull back a minimum of one f-stop of highlight detail during RAW image conversion. And for assignment shooting such as music concerts, the RAW files offer more flexibility for providing files large enough for printing posters or small enough for CD jewel case inserts.

Landscape and Travel Photography

Photographers have no greater challenge than leaving their comfort zones behind, rising early in the morning, setting off looking for beautiful light in all its many moods, and submerging themselves in new surroundings, cultures, and climates in pursuit of meaningful images that tell a story. Such is the life of a landscape, nature, and travel photographer who relishes getting out there and returning with images that shape public opinion, focus the world's attention on an urgent issue, or simply convey the beauty of a foreign land.

People with a creative eye and a passion for travelling naturally gravitate toward landscape, nature, and travel photography. Starting at an early age, many were probably exposed to National Geographic magazine and the beautiful well-crafted images of foreign cultures and land formations. Nurtured further by family outings and camping trips, these hearty souls soon realized that beautiful vistas and breathtaking scenery often come with a fairly steep price paid by personal comfort, and have learned to adapt along the way.

At some point in the process, the financial burden of extended travel becomes evident, and so photographers seek ways to share and license their images with agencies, magazines, and book publishers as a way to cover their travel expenses and create careers for themselves. Often on this personal, spiritual, and creative journey, certain locations and cultures exert a strong pull on you, and you may find yourself drawn to specific genres of creative expression.

Preparations and considerations

Packing for nature, landscape, and travel shooting depends on where you're going, the length of the trip, and the weather conditions. For example, if you're shooting in an easily accessible location and can store extra gear in your vehicle, you can take more varied gear without worrying about being slowed down by a seriously heavy backpack.

If you're traveling, the selection of gear and the importance of portability increases, and for air travel, you have to be more selective in packing your camera bodies, lenses, filters, and accessories. The mix of gear most often changes if you're traveling domestically or internationally: Try to estimate the toll the travel might take on your gear and decide whether it makes more sense to rent the equipment you need on location. Because most of my shooting is in the United States, I keep a collection of different-size bags and pack them to suit the assignment with a focus on camera protection and how much I can physically carry.

Here's my list of recommendations for packing your shooting gear when airline travel isn't involved:

▶ **One or two EOS camera bodies.** Ideally, you should have a backup camera with you in case anything goes wrong. This is especially important in inclement weather and in locations where the camera is exposed to blowing dust, sand, rain, or heavy moisture.

▶ **One or more Speedlites.** For fast shooting situations where you are using flash, it's easier to swap out Speedlites when the recycle time slows down rather than change the batteries. An extra Speedlite comes in handy for sports portraits also, when you need to illuminate the background or rim the athlete to separate them from the background.

▶ **Weatherproof camera and lens sleeves.** Some camera bags, such as those from Lowepro and Think Tank Photo, include water-repellant bags or sleeves that fold compactly and attach to one of the camera bag's interior compartments. For severe weather, you can buy a variety of weatherproof camera protectors from ThinkTank (www.thinktankphoto.com), Storm Jacket (www.stormjacket.com), and Pelican (www.pelican-case.com).

▶ **One or more wide-angle, macro, and telephoto zoom lenses.** For general outdoor shooting, I carry the EF 16-35mm f/2.8L II USM or, alternately, the 24-70mm f/2.8L lens, the 100-400mm f/4.5L IS USM, or the 70-200mm f/2.8L IS USM. For macro nature images, I prefer the EF 100mm f/2.8 Macro USM and the EF 180mm f/3.5L Macro USM lenses.

▶ **Tripod and monopod.** A lightweight but sturdy tripod such as those from Manfrotto, Gitzo, and Cullman is indispensable. In addition, a versatile ball head with a sturdy quick-release plate increases the steadiness and speed of shooting, particularly with long lenses.

▶ **Spare camera and flash batteries and battery charger.** Live by the battery, die by the battery. Especially in cold weather that reduces the shooting time and lengthens the recycle time for the battery, it's important to have plenty of power

available in the form of one or multiple spare and charged camera and flash batteries. Protect the camera batteries with the supplied cover; there's even a neat little window in the cover to show whether the battery is charged or exhausted. In cold weather, place fresh batteries inside your jacket and near your body to keep them warm.

▶ **Memory cards.** The number of memory cards that you carry depends on how many images you typically shoot and the length of the shooting session. I usually carry a variety of 10 to 15 Lexar Professional cards in sizes ranging from 4GB to 16GB.

▶ **Extenders and extension tubes.** I typically carry both the EF 1.4x II and the EF 2x II tele-extenders to increase the focal range of my telephoto lenses. The tele-extenders can be used with fixed focal-length lenses 135mm and longer, as well as the EF 70-200mm f/2.8L, 70-200mm f/2.8L IS, 70-200mm f/4.0L, 70-200mm f/4.0L IS

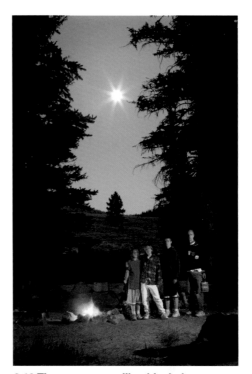

6.10 Time exposures like this drain a battery quickly. I created this family portrait of the Verellens by using an off-camera Speedlite connected to a PocketWizard MultiMAX under a full moon. This image also shows the optical phenomenon of star-points on spectral highlights, produced anytime you include them in a shot using your smallest aperture. Exposure: ISO 800, f/22, 6 seconds with an EF 16-35mm f/2.8 USM lens.

USM, and 100-400mm f/4.5–5.6L IS zoom lenses. The effective aperture is reduced by 1.5 f-stops for the 1.4x extender and 2 f-stops for the 2x extender. Autofocus is possible when combined with a lens having an f/4 or faster maximum aperture. Extension tubes, either the Canon 12mm or 24mm, allow you to get in close to capture the fine details of nature.

▶ **Polarizer and neutral density filters.** A circular polarizer can enhance the saturation and color of blue skies and create contrast separation between the sky and clouds, as well as reduce reflections on reflective surfaces. Neutral density filters come in varying densities and allow you to hold back the ambient light by 1 to 3 f-stops to facilitate longer exposures. Graduated neutral density filters allow you to balance exposure between bright skies and darker foreground elements.

▶ **TC-80 N3 Remote Controller.** This cable release connects to the camera via an 80 cm (2.6 ft.) cord. The mode button sets the mode, and the convenient Jog dial, which allows you to enter values using your thumb, sets the time or number of exposures. With this remote, you can set a self-timer, an intervalometer or interval timer, or a long-release or long-exposure timer (for Bulb exposure). The timer can be set for any time from one second to 99 hours, 59 minutes, 59 seconds. The LCD panel can also be illuminated for easy reading.

▶ **Laptop computer or portable storage device.** Backing up images on-site — either to a laptop or a handheld hard drive — is an essential part of the workflow throughout the day. Unless you have to, don't delete images from the memory cards after loading them onto the computer or handheld device until you have burned a disk so that you have at least two copies of the images at all times.

Your lens selection, of course, depends on your budget and shooting preferences. Canon offers a large selection of wide-angle, telephoto, and zoom lenses that perform extremely well in the field.

Additional items to pack include:

▶ **Cell phone and/or location device.** Whether you're near to or far from home, a cell phone is indispensable for normal and emergency communication. And if you're hiking in mountain areas, check in with the ranger station to see if it has GPS location devices or electronic signal devices that enable rescuers to more easily find you in case of an emergency.

▶ **Passport, driver's license, or other identification.** If you're staying in a hotel, also be sure to carry the hotel's phone number or business card with you.

▶ **Notebook and pen.** Write down your impressions of the area, especially first impressions that can help you define your creative inspiration of the place and, subsequently, your approach to shooting.

▶ **Plastic bags.** These are useful for storing anything and everything in inclement weather and keeping your sensitive electronic gear dry.

▶ **Gaffer's tape and florist's wire.** You can use these items to hold, secure, or repair almost anything.

▶ **Multipurpose tool.** This valuable tool can solve all kinds of unexpected problems in the field, from camera repair to clothing and camping gear malfunctions.

▶ **300-watt power inverter.** You can use this to recharge all your peripherals with power from your vehicle's accessory outlet.

Practical pro advice

Tips and techniques for nature, landscape, and travel images abound. Here are some of the techniques that you can use when shooting outdoor images:

▶ **Use a Speedlite to enhance or call attention to the subject or main element.** While we might easily think of using Speedlites for close-up macro work, they are very effective in nature, landcape, and travel work. Don't expect to light up an entire street scene or canyon with your Speedlite, but use it to selectively illuminate the subject or main element in your photos. Blending the flash into the ambient light can be a challenge but is very satisfying when you get it right.

▶ **Focus one-third of the way into the scene.** This technique approximates hyperfocal focusing, and although it's not as accurate, it works reasonably well. For sweeping landscapes where there's no obvious center of interest — such as a person, object, or animal — focus the lens approximately a third of the way into the scene. At close focusing distances, however, the point of focus falls approximately in the center of the depth of field.

▶ **Previsualize the image.** If you're shooting a sunset scene, decide if you want to capture foreground detail or show trees, hills, and buildings as silhouettes. If you want to show foreground detail, meter the foreground directly by excluding the sky and sun from the viewfinder and then use a graduated neutral density filter to tone down the sky so that it isn't over-exposed.

▶ **Research before you go.** Most travel photographers agree that you can never do too much research on the place you're traveling to. The more you know about an area, what its defining characteristics are, and what areas the locals frequent, the better the chances are that you can come away with distinctive images that capture the spirit of the locale.

▶ **Photographing rainbows.** To capture the strongest color of a rainbow, position the rainbow against a dark background, such as stormy clouds, a hill, or trees. You can underexpose the image by about 1/3 or 1/2 f-stop to increase the intensity of the colors.

▶ **Use side-, back-, or cross-lighting.** Frontal lighting is often chosen by inexperienced photographers and creates images that lack texture and depth because the shadows fall away from the camera and out of view. Instead, shoot so that the sun or your Speedlite is on one side of the camera, with light striking the scene at an angle. Side lighting provides the strongest effect for polarizing filters, given that maximum polarization occurs in areas of the sky at right angles to the sun.

▶ **Use the Self-timer mode or cable release.** For low-light and night scenes, you can use the Self-timer mode to ensure that there's no camera shake as a result of pressing the Shutter button with your finger.

6.11 It's all about mood with travel photography. Astoria/Megler Bridge, spanning the great Columbia River, is photographed with the camera set to a Tungsten white balance to add to the blue cast of this very long bridge. Exposure: ISO 800, f/22, 1/20 second with an EF 16-35mm f/2.8 USM lens.

▶ **Include people in travel images.** People define the locale, and the locale defines the people. As a result, it's difficult to capture the spirit of a place without including people in your images. I also make a point of using people in my landscape images to provide a sense of scale to natural land formations. Silhouetting people against a landscape or nature shot can add mood and drama. If you don't speak the language, use hand gestures to ask permission before you photograph people.

▶ **Find new ways to capture iconic landmarks.** Some landmarks, such as the Empire State Building, have been photographed at every angle, with every lens, and in every light possible. Spend some time thinking about how to get a fresh take on iconic landmarks to make your images distinctive.

▶ **Use a lens hood.** You can avoid lens flare by keeping lenses clean and by using a lens hood to prevent stray light from striking the front lens element. Alternatively, you can use your hand.

6.12 Guler Ice Cave in Washington was pitch black except for my Speedlites. Three were used in this time-exposure, with one on either side of the ice formation and the center one firing three times in one minute. Exposure: ISO 800, f/16, 1 minute 7 seconds using an EF 16-35mm f/2.8L USM lens.

▶ **Use selective focusing for creative effect.** The opposite of maximum depth of field is choosing to render only a small part of the scene in sharp focus by using limited depth of field. This technique is effective with any lens set to a wide aperture with a close subject as the point of focus while the rest of the scene is thrown well out of focus. The fall-off of sharpness is increased as the focal length increases and the aperture becomes wider.

▶ **Metering a bright sky.** To get a proper exposure for a bright sky, meter the light on the brightest part of the clouds by using the spot meter. If the sun is above the horizon, take the meter reading without the sun in the frame and from an area of the sky next to the sun.

▶ **Use silhouettes as design elements.** Be on the lookout for interesting silhouettes as graphic elements of your photograph. When creating silhouette images, it's often beneficial to underexpose the image slightly from 1/2 to 1½ stops.

Essential Filters

The most useful filters in landscape, nature, and travel — often referred to as outdoor photography — include UV filters, circular polarizers, neutral density or split-field neutral density filters, and warm-up filters. Here's a brief overview of each type of filter:

▶ **Skylight or UV (Ultraviolet) filter.** Skylight filters are colored glasses and usually have a touch of pink. In addition to absorbing UV light, the pinkish color of a Skylight filter can also counter the excessive blue color of the sky on a sunny day, and produce a warmish tone. UV filters absorb UV light and are clear glass.

▶ **Polarizer.** Polarizers deepen blue skies, reduce glare on nonmetallic surfaces to increase color saturation, and remove spectral reflections from water and other reflective surfaces. A circular polarizer attaches to the lens, and you rotate it to reduce reflected, polarized light. The polarizing filter, when rotated properly, yields deep-blue skies, reduces reflections from surface glare of foliage, and saturates landscape colors. Maximum polarization occurs when the lens is at a right angle (90 degrees) to the sun. With wide-angle lenses, uneven polarization can occur, causing part of the sky to be darker than other areas of the sky.

▶ **Graduated neutral density filters.** These filters allow you to hold back a bright sky from 1 to 3 f-stops to balance foreground exposure. With this filter, you can darken the sky without changing the color; the sky's brightness is similar to that of the landscape, and appears in the image as the sky appears to your eye.

▶ **Warm-up filters.** Originally designed to correct blue deficiencies in light or certain brands of film, warm-up filters correct the cool bias of the light, and you can use them to enhance the naturally warm light of early morning and late afternoon. For greatest effect, combine a warm-up filter with a polarizer. You can also apply the warm-up effect during image editing in Photoshop.

6.13 Remember to also look for the absence of light. Returning to camp dog-tired and hot after a long hike, I noticed these interesting shadows on the desert floor. Exposure: ISO 100, f/8, 1/400 second with an EF 28-70mm f/2.8L lens.

Macro and Close-Up Photography

The closer you look, the more there is to see. There is perhaps no area of photography with more potential for failure and surprise than macro photography; double the possibility when you add flash. Canon's E-TTL system is surprisingly adept at figuring out which objects are more important: the ones that are closer to the camera or that larger one at camera right? Although any of the Speedlites can be used for macro photography, Canon markets two specifically for that reason.

The MR-14EX Ring Lite is a common flash choice for taking stunning close-up images of small objects. The light-

Photo courtesy Dr. Ryan Mueller

6.14 Macro photography is an everyday occurrence at Dr. Ryan Mueller's dental office. The Canon MR-14 Ring Lite produces well-lit images of the before-and-after status of patients' teeth. Exposure: ISO 100, f/3.2. 1/250 second with an EF100 f/2.8 macro lens.

ing is soft and produces no shadows on the subject. This can work to the photographer's advantage, or look flat and lifeless because the lighting is so even. Dental offices have

used the Canon MR-14EX Ring Lite for years to produce visual records of work done on clients' teeth and gums.

The MT-24EX Macro Twin Lite is a compact and balanced unit. Two small flash heads connect to a mount ring that attaches directly to the front ring of the Canon EF 50mm f/2.5 Macro Lens, Canon EF 100mm f/2.8 Macro USM Lens, or Canon MP-E 65mm 1–5x f/2.8 Macro Lens. To mount the Canon Macro Twin Lite on the Canon EF 180mm f/3.5 L USM Macro Lens, you need the optional Canon Macro Lite Adapter 72C. These flash heads can be positioned, locked in place, turned off, or even removed from the mount ring and repositioned for greater creative control.

6.15 Using the MR-14EX Ring Lite on flowers produces stunning color and clarity but little depth and some surreal results, depending on the camera's proximity to the subject. Exposure: ISO 2000, f/32, 1/125 second with an EF 100mm f/2.8L lens.

Preparations and considerations

Because macro work is so dependent on small apertures to provide the much-needed depth-of-field, it is ideally suited for small flash photography. When moving the small flash head close to a small subject, it becomes, in effect, a soft light source. Anytime the light source is bigger than or as big as the subject, you have soft light and hard light when the light source is smaller or moved farther away.

The Canon macro Speedlites provide easy illumination for a wide range of close-up situations and produce ample light output for small subjects. However, a common problem in macro work is that the small apertures required for maximum depth-of-field yield black or nearly black backgrounds that receive no light from the flash. The way to solve this is to add another Speedlite to illuminate the background set as a slave. Either of the Canon macro Speedlites can be set as masters to trigger remote slave flashes.

Many photographers use a tripod for macro work and this is great in the studio but not always workable in the field. As long as the light is sufficient and there is no wind, a tripod keeps the camera rock solid for sharp images. However, even a slight breeze blurs certain elements if the shutter speed slows to compensate for the small f-stop selected. A not-so-obvious workaround for this is to use a small, handheld flash. This way, you can move around with the flower swaying in the breeze or follow that insect as it scurries about.

6.16 Tiger-striped lepterine feeding on a goldenrod branch. A common scenario with macro work is the black background produced by the use of small apertures. While this can be a good approach to isolate the macro subject, it can also create uninteresting backgrounds. This can easily be remedied by adding a second Speedlite or using one of the Macro Twin Lite flash heads to illuminate the background. Exposure: ISO 100, f/22, 1/60 second with an EF 100mm f/2.8L lens.

6.17 One Speedlite on a flash bracket created soft light for this macro image of an Arizona scorpion and her babies. Exposure: ISO 100, f/22, 1/60 second with an EF 100mm f/2.8L lens.

The MT-24EX incorporates many of the features of the top-of-the-line Canon flashes, such as Flash Exposure Compensation, Flash Exposure Bracketing, High-speed sync, and adjustable output ratios between the two flashes by a 3-stop range in 1/2-stop increments.

Both flash heads are fully positionable around the lens ring or can be removed from the ring and placed elsewhere, for example, to light up the background to keep it from going black. Because macro work requires such small apertures for maximum depth of field, the background will be out of focus by a considerable amount. Point one flash head at the subject and one on the background, and you totally change the feel of the photo. Look around for background elements and colors you can render as soft, out-of-focus shapes to add a sense of place to your image.

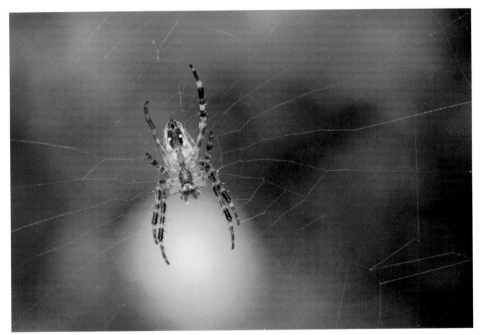

6.18 An MT-24EX Macro Twin Lite Speedlite provides soft light for this macro image of a common garden spider. An additional Speedlite set to –1 EV exposes the background. Exposure: ISO 100, f/22, 1/60 second with an EF 100mm f/2.8L lens.

Practical pro advice

While it is possible to use a Speedlite for macro photography while mounted on the camera, it's not the best way to go about it. The flash head of the camera can be tilted down to –7 degrees, but depending on how close you are to the subject, you may not get even coverage. When shooting extremely close, the lens may block the light from the flash, resulting in a dark cusp on the bottom of the images.

In order to get the flash off-axis and closer to the subject when shooting insects or other small live creatures, I use the flash with the ST-E3 cord, and handhold it next to the front of the lens. I can now position it where I want it and shoot handheld. You can position the flash near the top of the subject to achieve an overhead studio lighting effect.

When photographing small subjects, I set up multiple Speedlites on the little plastic stands that come with them. I might use my studio-in-a-box unit if I'm really concerned about producing large, smooth highlights on the object, and place two Speedlites angled at either side or on top. Depending on what looks better, I use both of the Speedlites at their E-TTL settings for even lighting or I use the ratio setting on the master flash or ST-E2 transmitter to get separate lighting output.

Besides using a Speedlite for macro work, you may find these other items to be very useful in the field:

▶ **Close-up filters and lenses.** Having a dedicated macro lens such as the EF100mm f/2.8 Macro or EF 50mm f/2.5 Compact Macro to use for your close-up work is great, but sometimes you need a little more reach than even these lenses can afford. Close-up filters and lenses screw directly on the front of your lens just like any other filter, and you don't lose any light when using them. I purchase them sized for the lens I'm going to use them on most often, and pick out step-up or step-down rings to adapt them to other lenses.

▶ **Extension tubes.** Extension tubes are close-up accessories that provide high magnification and provide close focusing, and can be used on many EF lenses, although there are a few exceptions. Extension tubes are placed between the camera body and lens, and communicate to the camera via electronic contact points. The function of the camera and lens is unchanged, and extension tubes can be combined for greater magnification.

▶ **Reversing rings.** When extreme macro work is needed, using reversing rings to attach a 50mm or 60mm lens to your macro lens can be just what you need. Because the reversed lens is attached by its filter mount, you are not restricted to using lenses designed for your camera system. You can even reverse enlarging lenses. This produces extreme close-up optics for images of the tiniest subjects.

6.19 The EF 25 and EF 12 II Extension Tubes showing the pin connections that the lenses need to communicate with the camera.

When using extension tubes a rough rule of thumb to use for the increased magnification is:

Additional Magnification = (Extension Tube Length) / (Lens Focal Length)

Based on this rough rule, the EF 25mm Extension Tube II put between the camera body and an EF 50mm f/1.4 USM lens will result in a .5 magnification gain (25mm divided by 50mm). If this is not enough magnification, you can move the camera closer to the subject or add another extension tube between the lens and camera.

At these close-focusing distances, I've found autofocus effectiveness is spotty when using extension tubes and not always where I want it when it does work, so I usually just focus manually whenever I'm using them. When combining tubes, it's especially important to focus manually due to the increased magnification.

6.20 The EF 12 II Extension Tube was used for this water droplet shot. In this instance the water is simply a reflector for the vertical card stock I positioned behind the water tray and lit with one Speedlite. A small red card placed in front of a larger white card created the interesting pattern in the ripples of the water. Exposure: ISO 500, f/11, 1/200 second with an EF 100mm f/2.8 macro lens.

Portrait Photography

Perhaps no other genre of photography can be quite as personally and spiritually rewarding to the caring photographer as the art and craft of portrait photography. The ability to take a slice of time, a fraction of a second, and create a memorable portrait of a person in a certain time and place can be a very powerful, motivating endeavor. Photographers approach portrait photography for any number of reasons, but the bottom line is almost always about capturing a spirit and vitality in an image that will stand the test of time and be remembered by loved ones for years to come.

People are probably the most photographed subjects in the world simply because the images of loved ones or strangers trigger so many emotions within us. Who among us hasn't been moved to pick up a camera and attempt to tap into that power after seeing pictures of crying babies, young people about to begin their adult lives, workers, or senior citizens whose lives have imbued their faces with a certain character? Photographers who decide to pursue portrait photography realize early on that the

best results of their work say something about them and their place in the world, and symbolize their own hopes and dreams. Using the time-honored tools of lighting, posing, and connection with the subject, photographers create lasting images that have the potential to convey these inner feelings.

Here are some basic recommendations for packing gear for portrait sessions, mostly the gear you'll want to have available when shooting sessions are local rather than long distance.

▶ **One or two EOS camera bodies.** The optimal solution is to have two camera bodies, one with a fixed, large aperture lens such as the EF 85mm f/1.2 lens, and one with a medium telephoto lens such as the EF 70-200mm f/2.8L IS.

▶ **One or more Speedlites.** Speedlites used off camera to light portraits provide exceptional light quality in a compact, affordable unit. Extra Speedlites come in handy for portrait situations when you need to illuminate the background or add rim or hair light to the subject to separate them from the background.

▶ **One or more wide-angle and medium telephoto zoom lenses.** I find that the EF 24-70mm f/2.8L, EF 100mm f/2.8 Macro, and EF 70-200mm f/2.8L USM lenses cover most portrait-shooting needs.

> Telephoto lenses are ideal to start a shooting session with because, depending upon your subject, they keep you a respectful distance away from the person you're photographing, who may feel uncomfortable with a closer approach. As you begin to build a rapport with your subject and make them feel more comfortable with you and your abilities, they'll loosen up and allow you to move in closer.

▶ **EX-series Speedlites, light stands, umbrellas, octabanks, lightboxes, and an ST-E2 Speedlite transmitter.** When part of the assignment involves shooting individual portraits, a handy portable studio might include a Lightware case with one to three EX-series Speedlites mounted on stands with light modifiers, such as an umbrella, softbox, or octabank connected to PocketWizards or the Canon ST-E2 transmitter. This completely wireless lighting setup, along with a couple of reflectors and a small roll of background material, is quick to set up and tear down, takes up minimal space, and provides professional results.

▶ **Tripod and monopod.** Having a lightweight but sturdy tripod is essential. In addition, a versatile ball head with a sturdy quick-release plate increases the steadiness of shooting stills and video, particularly with long lenses.

▶ **Memory cards sufficient for the duration.** The number of memory cards that you carry depends on how many images you typically shoot and the length of

the shooting session. I carry a variety of fast Lexar Professional cards in sizes ranging from 2GB to 8GB.

▶ **Silver and gold reflectors.** Collapsible reflectors of various sizes are great for filling shadow areas and adding a sparkle to the eyes when shooting individual portraits.

▶ **Spare camera and flash batteries.** Even with a good camera and rechargeable batteries, I still have a spare camera and one or more charged sets in my gear bag as insurance.

▶ **A laptop computer or portable storage device.** Backing up images on site either to a laptop or a handheld hard drive is an essential part of the workflow

Additional handy items include the following:

▶ **Brush, combs, cosmetic blotters, lip gloss, concealer, clothes pins, and safety pins.** Particularly for model or senior photo sessions, touch-ups of hair between shots are often necessary. Cosmetic blotters come in handy to reduce the shine from facial oil, and a neutral-tone lip gloss adds shine to the lips, while concealer hides blemishes and dark circles under the eyes. It's easier to apply a dab of concealer under each eye and rub it in than to spend time on the dark circle, retouching it in post-processing.

▶ **Portable background and stands.** Whether it's a roll of white, seamless paper or muslin, having a clean background that's easy to assemble and tear down for portraits is exceptionally handy.

▶ **Plastic bags or drop cloths.** For outdoor shooting, large plastic sheets come in handy for a variety of unexpected situations, including offering protection from a rain shower or wet grass, protecting camera and lighting equipment, or serving as a backdrop for portrait sessions.

▶ **Multipurpose tool.** This tool can solve all kinds of unexpected problems, from fixing camera and lighting gear to trimming back foliage in an outdoor portrait setting.

Studio portraits

Digital capture has changed the way photographers make images and approach shooting styles when they cover weddings, high-school senior portraits, business portraits, or any number of photographic applications, whether in studio or on location. These days, a studio portrait can be realized anywhere by taking along your portable wireless studio kit and Speedlites.

6.21 This studio portrait of a personal therapist for his Web site and brochure utilizes a classic three-point lighting setup. Exposure: ISO 100, f/5.6, 1/100 second using an EF 100mm f/2.8 Macro USM lens.

Today, a consistent trend in studio and location portraiture can be described as more of a lifestyle approach. Lifestyle shooting seeks to portray the subject in a natural setting that is typical for that particular subject, and when you are familiar with current cultural or musical trends you can use these styles to create unique and memorable portraits.

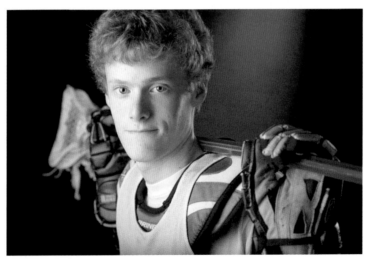

6.22 This studio portrait of high school lacrosse star Greg Stearns used colored gels to complement the purple in his lacrosse stick. Three Speedlites were used for this image. One flash was fired through a small Westcott softbox at camera-left, another at camera-right and behind him created the rim light, and a third flash outfitted with a purple gel created a shaft of color on the background. Exposure: ISO 100, f/5.6, 1/200 second using an EF 100mm f/2.8 Macro USM lens.

Outdoor portraits

My first concern with nearly any portrait is what the background is going to be, and from there, I build my shot forward to the camera. This is especially true in outdoor portraiture where I am using natural elements as the background. I create portraits for a wide range of final uses, and I am always mindful of what these uses will be before I even take the first frame. Your Speedlites can be used to mimic the sun or create lighting that looks entirely natural in an outdoor portrait.

For personality shots, I might try to capture a look or mannerisms that the subject's friends would say embodies their spirit, and then choose an uncluttered outdoor setting that complements that feeling. For a business portrait where I may want to imply strength, power, and control, I might opt for starker lighting and a street scene with an office building or more polished background.

Outdoor lighting presents many challenges similar to creating your light from scratch as in the studio. You must decide what the background will be, where the subject should be placed, where to position the Speedlites and how many to use. The lighting must provide beautiful facial illumination and be appropriate for the subject's face, skin tone, and personality. Midday, direct sunlight is harsh light to work in and is guaranteed to produce dark shadows under the eyes, nose, and chin. I use a 42-inch round diffusion panel to soften the light when I have no alternative but to shoot in bright sunlight because of location or scheduling, or I try to find an area where the subject is shaded from above, such as by the roof of a building, an awning, an alleyway, or a tree and use a Speedlite for fill or as the main light source. These locations soften the light on the face and keep the subject from having to squint into the bright sunlight. For fill light, I use a silver reflector to bounce a little edgier light back into the face or a white reflector for softer fill.

Backlighting is a look that I love, as the sunlight creates a fine rim of light that encompasses the subject and really separates him from the background. You can position the subject so the sun strikes him from behind, throwing his face into shadow, and then use a silver or white reflector to bounce soft light back up into the subject's face at an angle that's pleasing. For softer light in this situation, you can use a white reflector, which softens shadows and reduces contrast. If this isn't enough to balance the backlighting, add a small amount of on- or off-camera flash.

6.23 Photographer David Lutz, photographed at the dinner hour on the roof of his downtown studio. The ambient light was dropped –1 EV and the white balance was set to tungsten, allowing the sky to go a deep blue; one Color Temperature Orange (CTO) gel was then added to the off-camera flash. The setting sun created a slight rim light. Exposure: ISO 100, f/5.6, 1/100 second using an EF 100mm f/2.8 Macro USM lens.

Perhaps the ideal outdoor portrait light is the light of an overcast day. This gauzy light is diffused naturally by the clouds to provide a soft light source. While flattering for all types of subjects, I've found overcast light is especially flattering for portraits of senior citizens, women, and children. When it's too bright overhead, parts of the face fall into shadow and need to be perked up. A simple silver or white reflector in the right spot will both fill shadows and add important highlights to the eyes.

Alternately, open shade produced by large areas of sky on a sunlit day, where the light is blocked by an object such as a building or a tree, also provides soft light. When shooting in the open shade, be aware of how the shadows are falling, even though the light is soft. Then, to add a little bit of rim light to define shape and form and create separation from the background, a Speedlite or 42-inch silver or gold reflector off to one side of the subject really does an effective job.

> **TIP** If you're photographing a subject in open shade with a bright background, be sure to move in close to the subject's face and meter on the face (with the reflector in place), and then use the exposure from this reading to make the image.

6.24 I used two EX 580 II Speedlites, one shooting into a silver umbrella and another one fitted with an orange gel to subtly simulate the sun, for this outdoor portrait of naturopath Dr. Ariel Politano. Exposure: ISO 125, f/2.8, 1/6 second using an EF 24-70mm f/2.8L USM lens.

6.25 Overcast light, with a Speedlite shooting through a 25-inch white umbrella and a collapsible white reflector, set the scene for this outdoor portrait of writers David Jarecki and his wife Courtney. Exposure: ISO 100, f/5, 1/100 second using an EF 24-70mm f/2.8L USM lens.

Two beautiful times for outdoor portraits are sunrise and the golden hour before sunset. The low angle of the sun striking the subject's face provides dramatic and warm illumination. Use a 1/2 or 1/4 CTO gel on your Speedlite to match the warm light rays from the sun at these times. Watch your backgrounds and don't allow them to go too dark. Use reflectors, a piece of foamcore, a cooler lid — whatever's handy — to fill in the shadow side of the face, and enjoy those beautiful last rays of the sun.

Night portraits

Once the sun has gone down, you don't have to put your gear away and quit shooting portraits. The evening palette of colors is constantly changing, and as city lights come on, many different light sources come into play, affecting the color balance.

When photographing portraits at night, remember that while the Speedlite is used to illuminate your subject, it will not have enough power to illuminate the background. In order to get enough light to raise the background lighting value, you may need to use a slower shutter speed than normal — a technique called "dragging the shutter."

When using the Speedlite to shoot night portraits, using a tripod is a good idea but not really necessary to reduce the blur that may be caused by handholding the camera. The flash from the Speedlite has a short duration, around 1/1000 second, which effectively becomes your shutter speed for your subject. The background, which is probably soft anyway due to a larger aperture being used, won't suffer terribly from any motion blur.

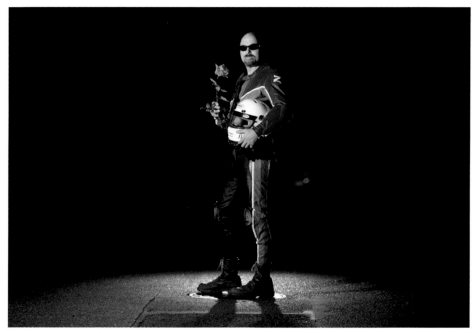

6.26 I used three Speedlites, one as the main, another one fitted with a green gel to light up the background, and one behind the subject to separate him from the street. Exposure: ISO 125, f/2.8, 1/6 second using an EF 24-70mm f/2.8L USM lens.

One technique I've used elsewhere in this book involves setting the camera to a tungsten (indoor) white balance and gelling the flash to match. The indoor white balance setting makes everything outside go deep blue, yet your portrait subject remains neutral. Adding another CTO gel to the flash warms the subject up considerably.

6.27 I used just two Speedlites, one as the main and another one with a Honl 1/4-inch grid fired into the background, for this portrait of artist and videographer Lyle Morgan. Exposure: ISO 125, f/2.8, 1/6 second using an EF 24-70mm f/2.8L USM lens.

Honl lighting modifiers are described and shown in Chapter 5.

Group portraits

Cheerleader, showman, and herder are all skill sets needed by the successful group photographer. Group photography can involve taking pictures of couples, families, or entire companies. With more subjects to arrange comes more responsibility to make everyone look good. Added to that is the challenge of getting everyone's attention, balancing the pose, and shooting quickly. Nobody likes to stand around for a group photo while the photographer messes around with her gear.

When setting up for groups, it's advisable to show up early, look for a good background, and shoot some tests before anyone arrives so that you'll be ready to go when they are. It's a good idea to be really clear on where the pictures are supposed to be taken and make sure you have permission to be there. I can't tell you the number of times I have been all set up to shoot a group portrait and sprinklers came on automatically, soaking everything, or a few ball teams showed up at the last minute, demanding to use the field for their scheduled game. Plan ahead.

6.28 I needed four Speedlites set to full power to fill in the shadows of this group portrait of a health care group at their annual picnic. Exposure: ISO 125, f/2.8, 1/160 second using an EF 24-70mm f/2.8L USM lens.

Geometric patterns, such as a diamond or triangular shape, work well when shooting a few people, but after that it's a challenge to be creative with a lot of bodies in the picture. Depending upon how the photos were meant to be used, I have staged pyramids of cheerleaders, pig piles of soccer and volleyball players, and goofy shots of softball and basketball teams after the standard picture was taken, to the great delight of the participants.

As you stage the shot, try to have the most important person relating to the intent of the group front and center in the first row, whether it's grandparents on their anniversary day, children on their birthday, or a CEO at the year-end board meeting. Then attempt to position the others so they fall into "windows" — the cavity of space between two people standing shoulder to shoulder. This creates a pattern much like musical notes on a scale, giving each person some space around their face, and makes the eye dance around the image rather than zipping down a row of faces. The intent is to make everyone an individual and appear that way in the picture.

The size of the group really dictates the Speedlite methods I use to light the shot. For smaller groups, I may use one Speedlite with a softbox or umbrella positioned directly

overhead or off to one side, and another undiffused flash opposite this light to create an edge light or fill.

For larger groups where I need all the power I can get, I'll dispense with light modifiers altogether and use two or more Speedlites. I either aim them directly at the group from an approximate 45 degree angle and feather the light to overlap, or bounce several Speedlites into the ceiling for broad soft light.

Here are some of the techniques that I've found most useful in shooting successful individual and group portrait images for clients:

- ▶ **Focus on the eyes.** They say the eyes are the windows to the soul, but if not, they sure are the most dramatic feature in portraits. With any animate subjects, as long as the eyes are in focus, the photo registers as a sharp photo.

- ▶ **Maintain proportions for kid shots.** Keeping with the subject of eyes, compose shots of kids from their eye level; this means you have to get down there on the ground to shoot. Shooting at their eye level keeps their heads in perspective and places them in their environment the way they see themselves.

- ▶ **Pose groups of people as you'd arrange music.** In this easy-to-remember analogy, you begin by placing the first person and then the next with an eye toward creating a pleasing blend of shapes and sizes within the frame. Create a natural flow from person to person in the group, as if the viewer is following a visual map. Remember your hyperfocal principles, and focus 1/3 into the group with a smaller aperture than you'd use for individuals.

- ▶ **Use contrast for composition strength.** The viewer's eye is always drawn to areas of greater contrast — a light subject against a dark field and vice versa. In addition, the sense of sharpness of a photograph is increased by the skillful use of contrast.

- ▶ **Engage with the subjects.** A primary means of human communication is with the eyes. If you're buried behind the camera, you run the risk of losing the connection with the subject. I get the shot set up, sometimes employ a tripod, and then step from behind the camera to show the subject what I have in mind or just to chat a bit to help the subject loosen up and become more comfortable.

- ▶ **Remember that kids rule.** The wise photographer works with the mood, energy, and flow of young subjects rather than against them. Children can often have short attention spans. Work quickly but be flexible and engage them in the picture-taking process. I save the kids for last and usually have them in the front, because anything closer to the camera appears larger, and anything farther away appears smaller, and this technique spatially balances them with adults.

▶ **Work with the art director.** In the best of assignments, working with the art director, make-up artist, and stylist is a great collaborative project. Most photographers work alone or with an assistant but relish the opportunity to collaborate with a team of other creative types toward a singular goal. But in situations where the art director wants compositions and setups that may not work visually, be diplomatic and shoot the layout their way first, and then talk them through what you'd now like to try. Very often, I've explained my vision successfully and ended up having my compositions published.

▶ **Show instead of tell.** Describing to other people how to pose is hard work. Instead of describing what you want them to do, move to their position and assume the pose or position that you want them to mimic. Portraits are best when the effort becomes a two-way street, so as you demonstrate, talk about your ideas for the session and also ask for the subject's ideas. Be supportive. Smile. Listen.

Find out more on posing and lighting portraits in Appendix A.

Still-Life and Product Photography

In still-life and product photography, lighting is the key to making the image sell. You set a tone using creative lighting to convey the feeling or lifestyle evoked by the product being photographed. You also use lighting to show or diminish texture, highlight color and form, and turn a dull image of shampoo into something consumers can't live without.

Preparations and considerations

When setting up for a product shot, my first consideration is what mood the photo needs to take on, from either the art director or account executive, or simply my own imagination. This leads to selection of background, lighting angle, colors, and composition.

The background is an important consideration when photographing products or still-life scenes. Having an uncluttered background in order to showcase your subject is often best, like many of the product shots in this book, although you may want to show the particular item in a scene. Once all these considerations are established, begin to place the items into the scene, paying close attention to the balance of the composition.

Diffused lighting is often essential in this type of photography. Studio soft-boxes create large, soft light and continuous highlights that cling to the edges of products like a second skin. The idea is often to light it naturally so that it doesn't look as if it were shot in a studio, and the viewer can imagine it sitting right there in his own home.

Even with diffused lighting, some of the shadow areas may need some filling in. You can do this by using a second Speedlite as fill or by using a fill card. Fill cards can be a piece of white foamcore or poster board used to bounce some light from the main light back into the shadows, or it can be silver- and gold-foil card stock purchased from an art supply store. When using two or more Speedlites, be sure that your fill light isn't too bright, or it may cause you to have two crossing shadows. Remember, the key to good lighting is to make the object look sexy and desirable, and promote an emotional response.

6.29 The pillow provides a high-key, simple background for this wedding ring shot. One off-camera hand-held Speedlite positioned very close to the rings and connected to the camera with the OC-E3 cord was used in E-TTL mode to capture this image. Exposure: ISO 100, f/5.6, 1/15 second using an EF 70-200mm f/2.8L USM lens.

Practical pro advice

For beginning practice, try using some personal items. Objects such as jewelry or watches, glassware, or electronic items make great subjects for learning product photography. If you're interested in cooking, try photographing some of the interesting dishes you prepare. Fruits and vegetables are always good subjects, especially when they have vivid colors or interesting texture.

Product photography is all about marketing the item. There are a variety of ways this is accomplished, but the most common ones are adding a splash of color by using gels, using selective focus to pull the viewer's attention to a certain part of the image, or focusing the light from the flash on a specific part of the product, which can help add a little more mystery to the image.

6.30 Halloween jack-o'-lantern and Strobist contest winner, this shot utilized five different light sources. There's a votive candle behind some flame-resistant diffusion material inside the pumpkin, two Speedlites on either side, a third light gelled blue for the background trees at camera left, and light from a sodium vapor street lamp that lights the trees at camera right. Exposure: ISO 1000, f/5.6, 1 second using an EF 100mm f/2.8 Macro USM lens.

Here are some ideas to keep in mind when creating still-life and product photography:

▶ **Because of their small size and generous light output, Speedlites are perfect for lighting small arrangements, still lifes, or products.** The table-top stands that come with the Speedlites are ideal for easily positioning the flashes around the set to light the subject. I rarely use E-TTL in these situations, preferring to adjust the individual flash outputs manually for complete creative control.

▶ **Keep it simple.** The "KISS" rule definitely applies here. Don't try to include too many objects in your composition. Having too many objects is distracting for the viewer and your intent becomes diminished.

▶ **Use items with bold colors and dynamic shapes.** Bright colors and shapes can be eye-catching and add interest to your composition.

▶ **Vary your light output.** Product photography really doesn't have to adhere too closely with natural lighting principles, and you can see evidence of this every day in magazines, TV, and the Internet. Position your Speedlites in such a way that the product becomes the star, stands out from the background, and possesses the brightest highlights.

Other than the required product or arrangement of items, here is a list of things to have on hand or use to make your images stand out:

▶ **Surfaces.** I collect various-size surfaces at my studio that work well for table-top work, such as tile samples, black and colored Plexiglas, brushed-aluminum Formica, and several different types of wood panels that are used to simulate desks and furniture. Be on the lookout for interesting items you can use as a surface, as this is the foundation of your shot.

▶ **The right lens.** Depending on your subject, different lenses produce different optical effects with hard geometric shapes. For products, I use the EF 100mm f/2.8 Macro, EF 50mm f/1.8, EF 24-70mm f/2.8L, and EF 70-200mm f/2.8L IS lenses. Often, the camera angle or lens selection may make the object look askew, even when it's posed correctly. You must tilt or adjust the product so it looks natural, yet hide the items you used to do this.

▶ **Canned air, Q-tips, and small brushes.** Once you have your shot set up, the last thing you want to do is ruin it by trying to remove a speck of dust, lint, or other debris from the setup. These items allow you to remove the intruder without disturbing your assemblage.

▶ **Mineral or castor oil for water drops and dew.** Many items I use in the studio to make food look better actually destroy the taste. Real water will evaporate and is very uncontrollable on set, while these oils stay put and will last in position for days.

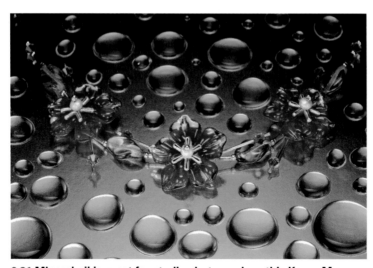

6.31 Mineral oil is great for studio shots, such as this Karen Moyer glass-bead necklace, where I may need some time to experiment with various colors for the background. Exposure: ISO 100, f/20, 1/100 second with an EF 100mm f/2.8L USM lens.

Wedding Photography

Wedding photography has seen a dramatic shift in styles, techniques, and creative challenges in recent years, resulting in large numbers of photographers who are entering the field, lured by the relative ease and workflow benefits that a digital camera can provide. The wedding day itself presents photographers with a huge array of lighting conditions, locations, and subjects and can also be a good test for their equipment and personal temperament.

Today's brides and grooms are also savvier clients because they're conscious of popular trends and "looks," having grown up with more music, video, and media influences than their parents could ever have dreamed of. As such, they are better-educated clients who require a photographer who can produce the images they desire on their special day. A person with a creative eye and superior people skills couldn't find a more satisfying career than that of a wedding photographer.

Preparations and considerations

Many wedding photographers I know keep up with the latest news by attending seminars, joining online forums and associations, and reading bridal magazines. There's a vast array of educational resources and inspirations out there, and the field has grown to produce celebrity icons who travel the country to conduct seminars and workshops in the art and marketing of digital wedding photography.

When preparing to photograph a wedding, make sure all your camera and Speedlite batteries are freshly charged and all your equipment is working properly. A wedding can include lots of flash photos taken over several hours and can tax even the strongest batteries. For this reason I recommend bringing along an additional external battery pack to power the flash, such as the Quantum Turbo, (www.quantumbatteries.com) or the auxiliary batteries from Digital Camera Battery (www.digitalcamera battery.com).

How involved or sophisticated you get with your lighting depends on how much time you have to shoot, the schedule of the day, and how much work you'll have to do yourself. If there's room and time, I'll set up one Speedlite on a stand with either the dome diffuser or some other light modifier attached to shoot wireless E-TTL flash photos. Having a friend or assistant along to move or adjust the Speedlite stand can be a huge time-saver and facilitate your getting the shots you want.

Practical pro advice

When wedding photographers get together, stories are told about cameras that stop working for no apparent reason, mirrors that freeze up, autofocus that won't work, lenses being dropped, tripod legs that stick fast, and flashes that just won't fire. The only way around this dilemma is to have backups of everything. Although this may be impossible when you're just starting out, the option to rent has vast appeal. The ability to try out equipment with possibly rent-to-own arrangements can be an invaluable way to gain experience with new gear and build up your photographic arsenal.

All equipment should be fully checked the evening before, batteries charged, and flashes test-fired. You just never know when something might not work. My nemesis with film cameras was always the sync cord, so much so that I would purchase them by the dozen. Wirelessly triggering my flashes by

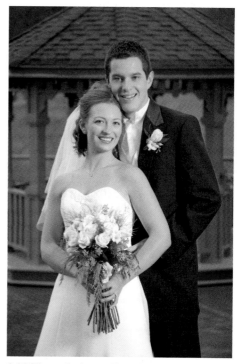

6.32 The soft, beautiful light from a Speedlite in a Westcott Halo octabank adds punch to colors and subtle shadows in this wedding portrait of Sonia and Nathan. Exposure: ISO 800, f/5.6 1/200 second with an EF 70-200mm f/2.8L lens.

remote transceivers is now a dream come true. Whatever equipment you decide to bring along, know its limitations and make sure it's in top condition and operating properly.

Because I'd rather not be changing lenses and possibly missing a key shot, I shoot with a minimum of two Canon EOS cameras and often add a third camera for remote shooting. Being sure to synchronize all three cameras' time stamps beforehand makes the chronological sorting of images in post-production that much easier. The digital cameras are outfitted with a fisheye or super-wide-angle lens and my longest telephoto zoom to cover all the ranges, while my third camera sports the medium-focal-length zooms.

What you decide to pack in your gear bag and how many bags you bring depends on many factors, including the location and duration of the wedding, as well as just how much gear you can transport and safely keep an eye on. Here are my minimum recommendations for shooting a wedding:

▶ **Two EOS digital camera bodies.** You may also find a need for a third camera body, such as an EOS 50D, that offers great frames per second (fps) — ideal for fast-action sequences, including the first kiss, the aisle walk, and the bouquet toss.

▶ **One or more Speedlites.** For fast shooting situations where you are using flash, it's easier to swap out Speedlites when the recycle time slows down rather than change the batteries. An extra Speedlite on a stand comes in handy for portraits, when you need to illuminate the background, or when you'd like to add rim light to the newlyweds to separate them from the background.

▶ **Wide-angle, normal, macro, and telephoto zoom lenses.** My preferences are to have at least three lenses: the EF 16-35mm, the EF 24-70mm, and the EF 70-200mm. This way, you have all your bases covered to capture the portraits, ceremony, details, close-ups, and the overall setting. It's very important to have a wide-angle lens to establish the setting and a longer lens to capture intimate moments from a respectful distance. As you add to your gear, an EF 100mm Macro and an EF 15mm Fisheye lens might be your next considerations to produce unique images and expand your creative capabilities.

6.33 This shot of the cocktail reception following a wedding ceremony was taken with a wide-angle lens and an on-camera Speedlite mounted on a ball head-equipped monopod to capture all the guests. Exposure: ISO 1250, f/8, 1/20 second with an EF 16-35mm f/2.8L USM lens.

▶ **Tripod and monopod.** Have both a tripod and monopod with the same quick-release plates. A tripod with a three-way pan-head allows you to shoot photographs in low light, and a monopod is invaluable as a secondary flash or remote camera grip, often referred to as a "stick." I use this with a ball-head and a fisheye or a wide-angle lens for one-of-a-kind aerial shots of the ceremony and dancing.

▶ **Flash units and brackets.** I typically bring both the 550EX and 580EX II Speedlites and plenty of spare AA rechargeable batteries. A better solution is to use the Compact Battery Pack CP-E4, which shortens flash recycle times and provides more firings before batteries need to be replaced or one of the external third party flash batteries previously mentioned. A flash bracket allows you to get the flash unit off the axis of the camera lens and gives you more flexibility and dramatic lighting options. Using a flash bracket allows the flash to stay above the lens for both horizontal and vertical shooting. Additionally, you may want to include flash modifiers, such as a softbox, an umbrella, or a snap-on diffuser.

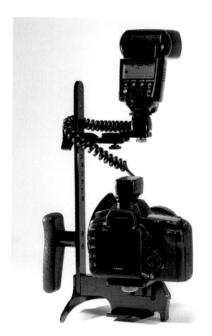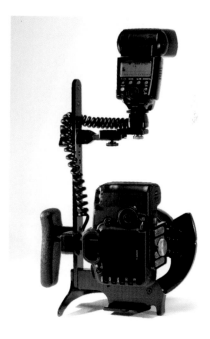

6.34 Although there are many flash bracket brands on the market, I prefer to use one from Custom Brackets (www.custombrackets.com). Using a flash bracket allows the flash to stay above the lens in both horizontal and vertical shooting.

▶ **Some type of flash diffusion for your Speedlites.** Weddings are all about romance and romance means soft lighting on the bride and groom to produce images with wide appeal. Some type of light modifier such as a softbox, umbrella, or a snap-on dome diffuser are always in my lighting kit whenever photographing weddings. If no diffusion is obtainable, bounce your Speedlite off of a ceiling or wall to diffuse and, therefore, soften your light.

▶ **Memory cards sufficient for the duration.** The number of memory cards that you carry depends on how many images you typically shoot and the length of the shooting session. I usually carry a variety of ten cards in sizes ranging from 8GB to 16GB, and I use handy wallets from Think Tank Photo to transfer full cards to and safely store cards until post-processing.

▶ **A laptop computer or portable storage device.** Backing up images on-site, either to a laptop or a handheld hard drive, is an essential part of the workflow throughout the day. Unless you have to, don't erase images off the memory cards after loading them onto the computer or handheld device so that you have two copies of the images at all times. If I have to erase the cards, I make sure my assistant burns DVDs as reliable second sets. If you plan to do on-site slide shows, the laptop is, of course, necessary.

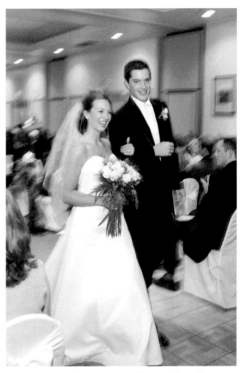

6.35 A slow shutter speed, panning the camera, and an intelligent Speedlite all combine to make this great shot of Sonia and Nathan walking down the aisle. Exposure: ISO 1250, f/8, 1/20 second with an EF 16-35mm f/2.8L USM lens.

Additional gear includes light stands, umbrellas, or softboxes for flash units, a stepladder, a circular polarizer, and PocketWizard Wireless Transceivers to fire remote cameras and flash equipment. When I set up multiple Canon EX-series flash units to add accent or dramatic lighting to a scene, I rely on the Canon Speedlite Transmitter ST-E2 to fire the flashes and control the lighting ratios among the individual Speedlites. To

light larger reception halls, I depend on the more powerful AlienBees or White Lightning monolights triggered by the wireless PocketWizard remote transceivers.

Wildlife and Pet Photography

Wildlife and pet photography can be an immensely pleasurable and satisfying pastime

for those photographers who possess a love for nature and the many other species that roam this earth. Nothing beats the thrill of finding animals in their natural habitat or in a picturesque setting and making the shot.

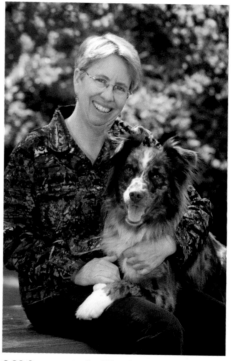

For many photographers, the first foray into wildlife photography may be taking pictures of their pets: the family dog, cat, or goldfish all make great subjects. A photo of your pet already has an emotional response built in because you love and care for it. But when I begin to look for images where there is more going on in the frame, some sort of behavior or ritual that I never noticed before, memorable image ideas can be revealed.

Preparations and considerations

Photographing your pet is a great way to get started in the realm of animal photography. Your little friend is already comfortable with you, and you

6.36 Acupuncturist Marcia Mueller and her dog Bruce, photographed wirelessly with an off-camera Speedlite and bounce reflector in this relaxed portrait. Exposure: ISO 100, f/5.6, 1/160 second with an EF 100mm f/2.8 USM lens.

are both able to read each other's moods. Engage your pet or have someone else do it as you start noticing backgrounds that will work for portraits. Have treats and snacks available and always reward good behavior.

If you have a photo trip or vacation coming up where there is a good chance of seeing a lot of wildlife, I always recommend a trip to a zoo or wildlife reserve to hone your skills and get you in the mental zone of photographing animals. Zoos are a great

resource for practicing your wildlife photography skills and to make decisions on lens selection, check the animal's reaction to flash, and attend to other details that need to be addressed before you take a big trip.

Outdoors with lots of light, shooting in continuous mode will improve the chances of getting a great shot of some animal behavior or activity, which will result in a lot more keepers when a real situation arises but will not be very effective when using flash. The flash will not have time to recycle resulting in lots of underexposed or blurry images. Switch to One-Shot mode when using flash to allow some gaps of time for the flash to recycle.

 Some zoos do not allow the use of flash with the animals. Be sure to check your zoos regulations and guidelines beforehand regarding still photography or video recording.

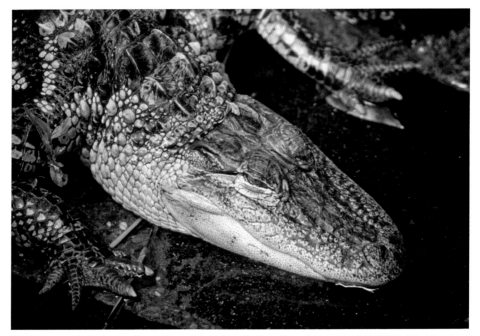

6.37 A crocodile cools off on a hot day in North Carolina. A hand-held 580EX II in E-TTL mode connected to the camera with the OC-E3 shoe cord was positioned camera-right to create some texture on the croc's skin. Exposure: ISO 100, f/5.6, 1/160 second with an EF 100mm f/2.8 USM lens.

To maximize the reach of your flash when shooting wildlife, adjust your Flash Exposure Compensation when using a lens longer than 105mm. The 580EX II and 430EX II zoom range only goes up to 105mm. This doesn't mean you can't use it with a lens longer than that. Adjusting the Flash Exposure Compensation up can get more range out of your Speedlite, but you may experience slower recycling times and shorter battery life.

Commercially available flash extenders like the Better Beamer (available at www.naturephotographers.net) will extend the reach of your flash by a reported +2 f-stops of light over greater distances. Flash extenders attach to the Speedlite flash head, usually with Velcro or tape and contain a Fresnel lens positioned a few inches in front of the flash face to focus and condense the light for transmission over farther distances.

6.38 Using a Speedlite really pops the colors of this Komodo dragon in Cancun, Mexico. Exposure: ISO 100, f/5.6, 1/160 second with an EF 70-200mm f/2.8L USM lens.

Practical pro advice

Much of the same gear I use for travel and landscape photography goes with me on wildlife shoots or when shooting pet portraits for friends. I might include a small bag with my macro shooting gear of extension tubes, close-up filters, and flash bracket if I suspect there might be some good details to be shot. Keep these ideas in mind the next time you're stalking big or small game — photographically, of course!

▶ **Use a long lens.** Whenever possible, use a long telephoto lens. This allows you to remain inconspicuous to the animal, enabling you to catch it acting naturally.

▶ **Tripod and monopod.** Having a lightweight but sturdy tripod, such as those from Manfrotto, Gitzo, and Cullman, is indispensable. In addition, a versatile ball head with a sturdy quick-release plate increases the steadiness and speed of shooting, particularly with long lenses.

▶ **Polarizer and neutral density filters.** A circular polarizer can enhance the saturation and color of certain types of skin and fur, as well as reduce reflections on reflective surfaces. Neutral density filters come in varying densities and allow you to hold back the ambient light by 1 to 3 f-stops to facilitate longer exposures. Split-field neutral density filters allow you to balance exposure between bright skies and darker foreground elements.

▶ **TC-80 N3 Remote Controller.** This cable release connects to the camera via an 80 cm (2.6 ft.) cord. The mode button sets the mode, and the convenient Jog dial, which allows you to enter values using your thumb, sets the time or number of exposures. With this remote, you can set a self-timer, an intervalometer or interval timer, or a long-release or long-exposure timer (for Bulb exposure). The timer can be set for any time from one second to 99 hours, 59 minutes, 59 seconds. The LCD panel can also be illuminated for easy reading.

▶ **Weather-proof camera and lens sleeves.** Some EOS cameras sport extensive weather-proofing seals and gaskets around the battery compartment, memory card compartment, and all of the camera control buttons. Some camera bags, such as those from Lowepro and Think Tank Photo, include water-repellant bags or sleeves that fold compactly and attach to one of the camera bag's interior compartments. For severe weather, you can buy a variety of weather-proof camera protectors from Storm Jacket (www.stormjacket.com).

▶ **Be careful.** Know the behavior patterns of the animals you're photographing and always be aware of their proximity to you. Even domesticated animals such as horses and dogs can be intimidated if they do not know you. Keep your peripheral vision on alert, and never get into situations without an escape plan.

Posing Basics

Why include a section on posing in a book about Canon Speedlites? Simple. As you become better at lighting portraits, more people will be coming to you to make them look their best and chances are, they won't be professional models. They will expect you to direct them in poses that are flattering, reveal their true character, hide or diminish any physical flaws they may have, and end up looking superb. While this is not meant to be a primer on photographic modeling (that could be a whole other book), these basic tips will help you create portraits that both you and your model can be proud of.

To be a successful portrait photographer, you need more than just good photographic skills. It helps immensely to be a "people person" and take an active interest in the person sitting before you having their portrait done. Making them feel comfortable can go a long way toward making the shoot a success.

As you progress, you will develop methods of working that are intuitive, reflexive, and natural. Lighting placement, time of day, and camera settings will all combine to create your signature style. You'll find over time that your work has improved and that confidence will allow you to take on more challenging projects or assignments.

Much in the realm of photographic portraiture had its start in the paintings of the old masters. Wander into any art museum and you will see classic examples of standard portraiture and lighting. While today's cutting-edge styles may come and go, having a good foundation in the basics and knowing how to apply them will bring a depth to your understanding of lighting and portraits.

Begin by setting up the scene or location and "blocking" out the subject's space. Similar to a director's instructions in a movie or play, I show the subject where their acceptable range of movement is to stay in the good light and still make a good portrait. Outdoors or indoors, this will more than likely be a chair, couch, fence, or some other architectural element. Often, the subject will not be aware of the details that the photographer is aware of, such as where they appear against the background and where the shadows fall.

Let's look at some basic poses for individuals:

▶ **Feet placed naturally.** If you're shooting full-length portraits, foot positioning is also very important. You want the feet positioned close enough together, but not so close that it looks like they cannot support the shape of the body. Additionally, if your subject is facing you at an angle, have them place most of their weight on the back leg. This is a slimming technique, and naturally bends the front leg more toward the camera.

▶ **Shoulders at an angle.** This is the most common pose in portraiture. When the subject's shoulders are turned at an angle to your camera, it creates a slimmer profile. Having the shoulders face the photographer full-on makes the subject look unnaturally wide. Figure AA.1 shows a simple portrait taken with the shoulders pointed at an angle to the camera. Try to keep the shoulder closest to the camera lower than the one farther away; this makes it more inviting.

AA.1 Having your subjects pose with their shoulders at an angle to the camera creates a slimmer profile. One 580EX II Speedlite in a Westcott 28-inch Apollo soft box was used as the main and another 580EX II with a Honl grid was used for the background glow. A 42-inch silver reflector positioned at camera-right provided the fill light. Exposure: ISO 100, f/8, 1/100 second with an EF 24-70mm f/2.8L USM lens.

AA.2 A slight tilt of the head makes the eyes break a visual line from the shoulders, as in this portrait of naturopath Reba Akin. The camera was fired between two 580EX II Speedlites connected to white translucent umbrellas and mounted vertically on one Bogen 5001B Nano stand. Exposure: ISO 100, f/5.6, 1/160 second with an EF 70-200mm f/2.8L USM lens.

▶ **Head tilted.** After subjects turn their shoulders so they're at an angle to the camera, have them tilt and turn their head slightly so their head isn't in the same position as their shoulders. When you have your subjects tilt and turn their head slightly, while still making eye contact with the camera, you're also changing the position of the eyes, opening up more of the whites and making the eyes appear larger.

Once you get these basic posing techniques down, you're ready to move on to some more creative portrait-posing techniques. Along with posing and changes in lighting, background, and colors, the diversity of your portrait portfolio will grow and have much broader appeal.

When directing changes to your subject's posture, have them make slight adjustments. A little movement goes a long way when shooting portraits. You want the pose to appear natural, not overworked or contrived.

Refined Posing

Much of what I have learned about posing has come from working with professional models. I notice how they place their bodies evenly into the scene, even if the shot is only going to be of the face or hands. They are extremely aware of where the camera is and only play to that angle. Even though a small percentage of portraits I do are

actually full-length body shots, my approach is to pose the subject as if their entire body is going to be included in the shot. This way, if I do see a good full-body shot developing, I can quickly capture it.

Chances are you may not be working with professional models when just starting out, but likely friends and family members. By following the suggestions below, you can still get professional results regardless.

Positioning the body

In ninety-nine percent of the portrait work you do, slimming the body will be part of the equation. Photography is limited to two dimensions (height and width), and how you handle those dimensions is very important. By turning the body away from the camera instead of straight on, the presented silhouette becomes noticeably slimmer.

While I often have my portrait subjects sit, I ask them not to use the chair back and have them sit erect. Sitting back in the chair often makes the shoulders slump and the neck contract, producing the opposite look to what you want. Sitting erect in the chair also makes the neck look thinner, and turning the head slightly tightens up loose skin around the neck area.

Children often tense up before a camera, and like a turtle going back into its shell, try to scrunch their heads down into their shoulders. I often pantomime "shoulders up-shoulders down" to show them how I'd like them to look. It always helps to show your subjects what you mean in terms of posing. Auditory commands do not always convey your message accurately.

Slimming techniques include the following:

▶ **Torso twisted, with legs slightly separated.** In addition to having your subject turn his or her hips slightly to the left or right, you should also suggest a stance with the legs slightly separated, or one in front of the other. This reduces the silhouette of the body and makes the hips and legs appear slimmer. Black or dark-colored clothing also achieves this effect.

▶ **Leaning on a chair or table.** Have your subject turn at an angle, either left or right (preferably toward the main light), and slightly arch their back. With correct lighting, this places much of the body in shadow, and places more emphasis on the face and upper body.

Clothing can also contribute to or hinder your efforts to capture a thinner appearance for your portrait subject. In situations where my subject is wearing loose clothing, I ask to use some common clothespins to snug up their clothing to the side of the body that is away from the camera; this reduces any obvious wrinkles that may appear.

NOTE A good rule to follow is to never touch your portrait subjects, but there will be times when you will need to to speed things along. Always ask your subjects first if you may adjust hair or clothing or move them into position. Some subjects are very sensitive about this, and it's especially important to keep in mind when working with children.

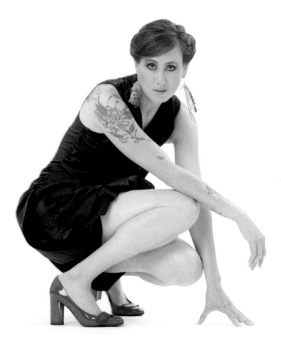

AA.3 This portrait showing the legs and arms in unique positions breaks up the linear quality of this full-body shot of naturopath Anya Chang. Two 580EX II Speedlites fired through a 4 × 6-foot diffusion panel provided the subject illumination while a pair of 550EX Speedlites lit the white background. Exposure: ISO 200, f/3.2, 1/100 second with an EF 70-200mm f/2.8L USM lens.

Positioning the hands and arms

While a majority of my portrait work involves only showing the head and shoulders, I am always aware of where the hands and arms are in relation to the subject's body. You can also achieve some nice portrait variations by including the hands in the image. This has the added effect of showing the jewelry or style details of clothing the subject is wearing.

When positioning the hands and arms, follow these tips:

▶ **Triangular pose using the arms and hands.** Try using this pose as an alternative to standard vertical portrait positioning. Back away slightly with the camera in the vertical position or switch to horizontal framing; then fill the bottom of the frame with your subject's arms folded, filling in the bottom of the triangle, where the arms and shoulders lead up to the peak of the triangle, which is the face of your subject.

AA.4 In one of Ania's senior portraits, the bottom of the frame is filled by her arms and hands on the tree branch, creating the classic triangle pose. One hot-shoed 580EX II Speedlite on a flash bracket was used for this shot and a soft vignette added later in Lightroom 2.0. Exposure: ISO 100, f/5.6, 1/60 second with an EF 70-200mm f/2.8L USM lens.

▶ **Shoulders diagonal.** Shoulders are great for adding an imaginary diagonal line to your portraits and help to break up the symmetrical qualities of the face and body. Lowering the front shoulder creates an inviting line up to the person's face, while raising the front shoulder creates more "attitude" and a perception of detachment.

▶ **One arm away from the body.** Because bodies are so linear and faces are symmetrical, adding more visual interest to the image often involves breaking these perceived lines. Having the subject put a hand on a hip or the waist can break these lines and help define the mid-section.

▶ **Hands relaxed.** Hands included in a portrait can be very beneficial story-telling elements — wearing jewelry, touching another person, and having wrinkles or age spots. Be aware that anything closer to the camera appears larger, and anything farther away appears smaller. This means that hands should be turned to present the slimmest silhouette when included near the face. Hands placed one over top of the other (ring hand up) look more relaxed than with the fingers interlaced. With two people in a portrait, resting one's fingers on the other's shoulder instead of the entire hand conveys caring without possessiveness.

CAUTION Be sensitive to your subject's feelings about their bodies as you shoot. Many people find posing for pictures uncomfortable, and these feelings translate to their body language. The challenge is to get them on your side by showing that you truly care about how they look in the final images. Try posing for portraits with another photographer to get a feeling of what they may be going through when sitting for you.

Positioning the head and neck

Your final considerations before pressing the Shutter button are the positioning of the head and neck and directing the angle of the eyes to help your subjects look their best. Subtle adjustments can add much to the visual interest of the shot, so spend some time on these details to fine-tune your image.

The eyes are often said to be "the windows to the soul" and can be the most important part of a portrait. You make eye contact with the person in the portrait and by doing so, you make a connection with that person. For most business portraits, this is quite true. In these situations, my portrait subjects seek to make a personal connection with their potential clients, employers, or customers. Eye contact communicates that they have nothing to hide, are open and friendly, and are generally good people to know.

When shooting personal portraits, to establish a broader range of looks for the final take, it's often beneficial to have the subject look away from the camera lens, resulting in a more contemplative, quiet expression. Try several different angles, and have them look to the left, right, slightly up, or slightly down. Moving the head around and changing pupil orientation opens up more white around the eyes, making them appear larger.

When shooting portraits, either indoors or outdoors, consider using fill flash to create catch lights in your subject's eyes. Catch lights are tiny reflections in the eyes from the main light source, whether it's a flash, bright sky, or the sun. The eyes are an important element of your overall portrait, and this attention to detail adds to the quality of your portraits.

AA.5 Looking away from the camera can create a more relaxed, informal look to the portrait, such as this one of home remodeler Jim Kitchin. Exposure: ISO 100, f/5.6, 1/60 second with an EF 70-200mm f/2.8L USM lens.

Here are a few more details you need to consider when posing your subjects:

▶ **Hair.** Be sure the hair looks neat and orderly, at least from the camera angle and taking into consideration the current styles. Avoid "windows" where you can see large patches of background through perceived holes in the hair, along with stray hairs going across the face or getting into the eyes, nose, and mouth. While obvious to you, the subject may not feel it there.

▶ **Jewelry and accessory placement.** Avoid being so concerned about getting the face just right that you fail to notice how the jewelry and accessories the subject is wearing look. Necklace clasps hidden and necklaces centered, rings turned the right way, and earrings positioned for best balance all affect the success of your portraits.

AA.6 Photographer Barbara Hill looking left and away from the camera reveals a more contemplative, serene look. The camera was fired between two 580EX II Speedlites connected to white translucent umbrellas and mounted vertically on one Bogen 5001B Nano stand. Exposure: ISO 100, f/5.6, 1/60 second with an EF 70-200mm f/2.8L USM lens.

AA.7 Looking up and turning slightly right, photographer Barbara Hill looks at ease and optimistic about the future in this standard yearbook pose. Exposure: ISO 100, f/5.6, 1/60 second with an EF 70-200mm f/2.8L USM lens.

AA.8 Adding a hand under her chin gives this portrait of business consultant Mitch Peterson a conversational yet professional, no-nonsense look. Exposure: ISO 50, f/8, 1/60 second with an EF 70-200mm f/2.8L USM lens.

 Be aware of your subject's neckline and how it appears in the clothing they're wearing. The neck can reveal much about the subject, such as weight or age. To achieve the most pleasing portrait, consider hiding portions of the neck with clothing, or positioning the camera to reduce the amount of the person's neck shown in the portrait. A good technique to reduce double chins is to shoot slightly down on your subject and have them tip their head up toward the camera.

 For more information on group portrait posing, see Chapter 6.

Posing Positions to Avoid

I've briefly discussed some helpful ideas to keep in mind when setting up your portrait sessions. Try these with your subjects and see how you like the results. While there are no set rules, some posing concepts that you should avoid include the following:

- ▶ **Straight on to the camera pose.** This pose might work well for portraits where you want to make the body appear larger, such as in portraits of sports heroes. At almost all other times, this arrangement looks rather stiff, artificial, and two-dimensional. Avoiding rigid poses that call attention to the symmetrical and linear quality of the human body helps make your subjects look more natural, casual, and three-dimensional. Break up the body shape by bending legs and arms whenever possible.

- ▶ **Using the same pose over and over and lighting it the same way.** Part of the fun of creating portraits is keeping it fresh by regularly changing up your working setup and lighting kit. I look at every subject as unique and may choose different tools, backgrounds, or lenses, depending on the subject and the look I'm going for at the time. Be creative.

- ▶ **The chin being too low or too high.** Head positioning is all-important. Make sure your portrait subject's chin isn't directed too low to a point where the eyes are shadowed, and watch out for having the chin so high that your model looks too snooty, aristocratic, or thug-like.

- ▶ **Negative body language.** Be upbeat. You control the tempo of the portrait session, and any negative vibes emanating from you will surely show up in your viewfinder eventually. You want your subjects to have a good time while having their portraits taken, so always remain positive, communicative, and constructive in the words you say and the body language you display.

Have some fun with your subjects — keep in mind that a successful portrait session is dependent on your subject feeling comfortable, as well as your eye for creativity. When you're calm, the person you are photographing is going to be more relaxed. Encourage your subject to relax and just be natural; keep an eye out to capture any special "looks" they create on their own, even when not posing. Things such as wrinkling their nose, winking, or rolling their eyes can reveal much about a subject's personality. All these little things that we instinctively do everyday can be special moments that end up making a great portrait image.

Planning Poses

Part of the fun of being a portrait photographer is that you get to decide how the portrait is going to look. With a paying client, this becomes a collaborative effort. Obviously, if you're hired by your subject, you must make sure you are both in agreement as to the look, appeal, and poses of the final images. You can shoot a variety of poses rather quickly now with dSLRs, and review the images on the camera's LCD monitor, seeing which poses worked and which ones lacked impact. The important thing to remember is to always talk to your subject and to keep their expectations in mind so that you are both pleased with the final results.

Casual portrait poses

A favorite type of story-telling posing is when you're capturing the subject just as they would be positioned in everyday life: working on a project, playing guitar, or relaxing around the home. The goal with casual posing is to capture the image of the subject as if there were no posing at all.

Some of the best types of casual poses are when parts of the body are positioned to give the impression of relaxation, such as the head resting in a hand, elbows resting on knees, the head resting against a wall or chair, or having the legs crossed when sitting.

Traditional poses

Traditional posing can be referred to as "yearbook," business, or conservative posing. Many media portals use these kinds of portraits for Web sites, speaking engagements, marketing materials, or corporate reports. As a portrait photographer, you are concentrating on artistic styling and design, but there are many situations in which traditional posing is more desirable and where posing is performed in a subtle manner.

Traditional posing includes these characteristics:

▶ **Conservative expressions.** A slight smile, but not laughing, is key with traditional posing. For business media and publications, subjects often have more serious facial expressions.

▶ **Subtle backgrounds.** For traditional portraits, plain, subtle backgrounds of a solid or mottled color, or dyed or painted muslin are most commonly used.

▶ **Seated position.** The most common position for traditional posing is the seated position. It allows the subject to relax and stay in a designated area to be photographed. An adjustable swivel chair with no back is ideal for making small adjustments to the height and angle of your subjects as they face the camera.

▶ **Standing position.** Having subjects stand while taking traditional portraits is very common in the wedding industry, as the participants are often dressed stylishly, in a suit or more formal attire, and standing can make them look and feel more comfortable and also shows off the wardrobe.

AA.9 A traditional business portrait of chiropractor Melanie Brown. I used three Speedlites, one for the main at camera-left, one for the hair light at camera-right, and one on the blue seamless paper background, to create the glow behind her. Exposure: ISO 100, f/5.6, 1/160 second with an EF 100mm f/2.8 USM lens.

Photojournalistic poses

Photojournalists tend to take portraits while their subjects are in the midst of doing what they normally do or while they are engaged in some sort of activity. More commonly known today as environmental portraiture, these images are similar in feel to a casual portrait, but tell a little more back-story about the person being photographed by use of props, background, lighting, and processing.

 For more information on environmental portraits, see Chapter 6.

A pose that doesn't look posed has strong appeal. Many times, you really don't have to pose your subjects at all. They will usually be engaged in some activity and oblivious to you while you work and line up your shot. Watch the activity swirling around you, use your peripheral vision, and look for background elements or props that add impact and depth to the story.

Photojournalistic-style posing has also become increasingly popular in wedding photography in the last decade, and that has attracted a large number of photographers who share those visual interpretations.

Wedding photographers traditionally used standard, conservative poses, but savvy, adventurous photographers of today are using photojournalism techniques in their wedding albums to tell the story of the event and capture all the fleeting emotions of the wedding day.

AA.10 The subject becomes as important as the activity displayed in photojournalistic portraits. This fruit vendor makes eye contact with the camera while working at her stand. Exposure: ISO 500, f/4, 1/1250 second with an EF 24-70mm f/2.8L USM lens.

The most important aspect of photojournalistic portraiture is telling the visual story and giving some insight into the subject's background or motivations. These can be gritty, beautiful, or humorous, but all images in this style go beyond a mere portrait. They resonate with a power to look beyond the face to see the whole person, as the world sees them, rather than how they see themselves. It is only fitting that in our reality-based world of constant change, this is a popular style of photography today.

Glamour style

Glamour-style photography involves shots that are sexy and sultry and that are designed to produce a desired effect on the viewer. The poses are usually visually provocative with a lot of eye contact with the camera for direct connection with the viewer.

The pin-up girls of the 1940s were the first subjects of glamour shots, and today that style can be found in advertising, boudoir, and even wedding and maternity photography. True glamour shots produce an air of romance and sexiness without ever crossing the boundaries of good taste.

For today's digital portrait photographer, thinking of glamour photography as an art form is key to understanding the possibilities of the medium. When shooting glamour-style photographs in your studio or on location, remember to be professional at all times. This is extremely important to build trust and future referrals. Make sure your models are comfortable with the types of poses they are expected to assume, and invite them to suggest poses themselves. Being verbally supportive behind the camera can go a long way to making your subject feel confident and truly beautiful in front of the camera.

Posing for glamour photography usually follows two paths. The first path is where the subject is comfortable with her body and already knows what looks look good to the camera. The second path is where the photographer directs the entire look of the shot through lighting, placement of the model, and location, which is often the case with models who are just starting out.

The poses can be for tight portraits, 3/4 body shots, and full-length images. The flash or flashes should be positioned to take advantage of and define the contours of the body, face, and hair. It usually helps to give your subject a broad area in which to pose, allowing them to feel comfortable moving freely and not confined to a certain rigid lighting pattern. Posing for glamour-type photography should follow all the previously discussed posing suggestions with special emphasis paid to the eyes and, to a lesser extent, the mouth. Even slight changes of expression in these areas, along with the tilt of the head, can create a wide range of looks for successful glamour-style photography.

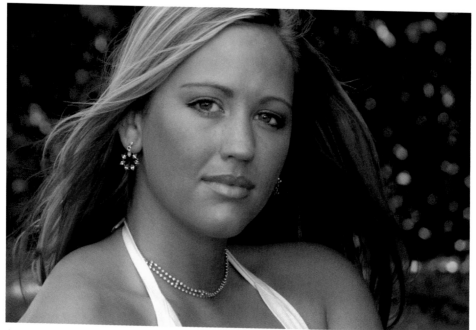

AA.11 Glamour portraits are images meant to convey a lifestyle brimming with a certain vitality and sexuality. Images such as these can be used to market any number of products to a specific demographic. Exposure: ISO 400, f/8, 1/50 second with an EF 100mm f/2.8 USM lens.

Props and clothing accessories can also add visual interest and appeal to the image and can also be used to hide or obscure less-than-flattering features of your subject, allowing them to look their best. Resist the urge to clutter up your image with too many of these items as the intent should always be to show your subject in the best possible light.

Rules of Composition

By this time, I sincerely hope you have a better understanding about photographic lighting in general and your Canon Speedlites in particular. Ideally, you have learned how to begin lighting your subjects and scenes in new and more visually interesting ways. Yet the perfect lighting setup will only get you so far; you also need to consider some rules of good image composition. Granted, *rules* is a pretty strong word for creative types to use, so I prefer to think of them simply as visual guidelines for more well-constructed images.

At first, these concepts might seem strange and uncomfortable, like holding your camera in a different way or composing scenes through a new lens, and you may struggle a bit with applying these rules to your style of photography. Just know that these are the foundations that your best shots will be built upon, and a conscious working knowledge of them is essential to creating more dynamic, compelling images.

Consider these concepts to be tools and techniques that you turn to when a situation or location is not working or has been exhausted photographically. Mentally going through the list of ideas presented here can often yield new ways of looking at camera angles, lens choices, and the like. After all, you can always be on the lookout for ways to expand your style of photography.

Keep It Simple

Keeping your compositions simple is probably the easiest, yet most important, rule in creating powerful, memorable images. Studies have shown that the human eye/brain combination begins to repeat itself, that is, to focus again on areas of the photo it had already registered, after less than four seconds of viewing the total work. In today's image-rich world, that means you have a very limited time to get a hold of your viewer's attention. Keeping it simple means getting rid of visual clutter in the picture, limiting the elements, then arranging them in meaningful ways.

We are bombarded by images more and more everyday for myriad reasons — to sell us products, relate current events, share family milestones, and so on — and eventually, image-overload can set in. You want your images to be clear and to the point. Keeping your compositions simple can go a long way toward this goal.

Ideally, your subject should be immediately recognizable to your audience. When considering a subject to photograph, I rarely come upon a scene wholly formed. This is why photographers make such a distinction, which may seem semantic, between "taking" a photograph and "making" a photograph. It takes careful consideration of all the elements to make a truly memorable image.

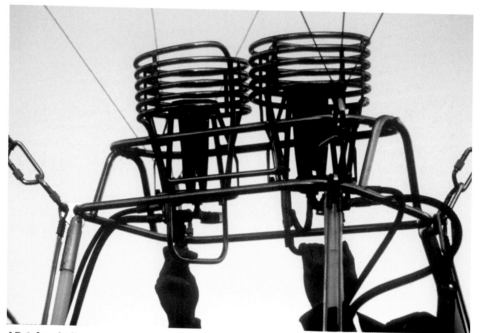

AB.1 At a balloon festival in Vermont, I was initially attracted to the shape and sound of these propane jets but realized the image lacked punch because my background was so dull. Exposure: ISO 100, f/8, 1/125 second with an EF 70-200mm f/2.8L USM lens.

Once you've realized what your subject will be, the next task is to locate a background that "holds" or complements that subject. This often involves walking around the subject if possible, and observing what happens to the background as you move. Suddenly, new ideas form and you may feel like you are looking at a totally different picture than the one you first imagined! Edward Weston once remarked, "My own eyes are no more than scouts on a preliminary mission, for the camera's eye may entirely change my idea."

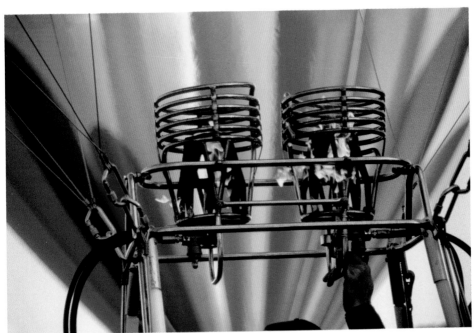

AB.2 As I considered my scene, I noticed another balloon inflated and ready to go aloft, and I knew I'd found my background. Peripheral vision is a great thing! Exposure: ISO 100, f/8, 1/60 second with an EF 70-200mm f/2.8L USM lens.

Try to come up with a background that has a different color, tone or texture than your subject does, so as not to camouflage the subject. Having a brighter-toned subject against a darker background, or vice versa, is another way to make your subject stand out and command more of your viewer's attention. A simple background allows the viewer's eye to linger on the subject and provides the time to make an emotional connection.

To create better photographs, it's helpful to learn to see the world and the events before you as your camera does. When I conducted classes in the film days, my students would often complain that the cost of film and processing was preventing them from shooting more. When I suggested they just go out and shoot without film, they'd look at me like I was crazy! My intent was that they should just spend more time seeing through the camera, looking at subjects they liked, and learning the visual language and interpretations of their lenses.

That disconnect between what the photographer sees on the spot and remembers and what they expected the final photograph to look like is where many photographers stumble. Our eye/brain combination is capable of differentiating between thousands more tones than today's camera sensors or film can and this results in expecting the photo to look exactly how we remembered it looking.

AB.3 A child's hand holds up a fall leaf in the afternoon sun, backlighting it. The viewer's eye catches the leaf, and then follows down the stem to the child's fingers. Exposure: ISO 100, f/5.6, 1/60 second with an EF 100mm f/2.8 Macro USM lens.

Learning to see as your camera and lenses do can go a long way to improving your photography. Spend the time with your camera to learn the way it sees the world, and once you do, you'll be rewarded with spectacular, compelling imagery.

Silhouettes

Using silhouettes as main or supporting elements in your work is a great way of keeping your compositions simple. Whether conscious of them or not, many people respond emotionally to silhouettes in photographs. Silhouettes of hikers, sailboats, or Joshua trees against a beautiful sunset, simplify the composition and have strong emotional appeal. An implied empty shape that only delivers minimal information about that shape adds mystery as well as a contrast to the background. The basic

approach is to find a really dynamic background, and then underexpose the shot by 1 to 2 f-stops or shutter speeds. The following two examples describe how silhouettes can add visual power to your images.

Shooting photos of dragonflies in the Grand Canyon recently, I found a dragonfly that was attracted to a certain branch. I was shooting with my Speedlite quickly, and eventually my flash started taking longer to recycle. A few of the frames were shot when the flash didn't fire, and this produced the silhouette shown in figure AB.4.

AB.4 This silhouette of a Grand Canyon dragonfly against the canyon wall shows the rich, saturated colors and added contrast that I obtained when underexposing intentionally to create a silhouette. Exposure: ISO 100, f/5.6, 1/60 second with an EF 100mm f/2.8 Macro USM lens.

I often employ silhouettes when I have a great background but it or my subject has too much detail that detracts from the scene, or contains information I don't want in my scene. Such was the case when photographing these boys in Trenton, New Jersey, enjoying an open fire hydrant on a hot day shown in figure AB.5.

Silhouettes can be a powerful, graphic way to add punch to your images. If you've never attempted silhouettes before, consider giving them a try.

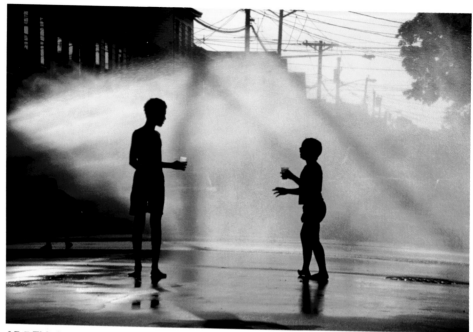

AB.5 This busy, late-summer urban scene focused on the interplay of these two young boys by underexposing by 2 f-stops and using an 85B warming filter. Exposure: ISO 100, f/4, 1/60 second with an EF 100mm f/2.8 USM lens.

Limiting focus

Another way to simplify your images is to limit the focus range in the photo to only cover the subject, rendering any elements in front of or behind the subject as out of focus. This is achieved by using smaller-number apertures (f-stops), all the way down to your smallest, to reduce the amount of depth of field that the image yields. This is one of the main reasons, besides image clarity, that professionals opt for big, expensive lenses. These lenses come equipped with large apertures that are used to throw backgrounds completely out of focus.

By shifting the plane of focus this way, more time is spent looking at the photographer's intended subject and less on the background. This is a great technique to employ when you are stuck with a busy background, such as when shooting urban portraits where architecture, trash cans, and signage can conspire to steal attention away from your subject.

With lenses, "bokeh" is an important consideration. The term *bokeh* is derived from the Japanese word *boke* and means fuzzy. This term refers to the way an out-of-focus point of light is rendered in an image.

AB.6 Glasses in front and behind this champagne bottle are purposely rendered out of focus by using a large aperture. Exposure: ISO 1000, f/2.8, 1/250 second with an EF 24-70mm f/2.8 USM lens.

AB.7 The curved aperture blades of the 70-200mm f/2.8L lens produce pleasing bokeh of these out-of-focus holiday lights. This was shot for a feature on holiday entertaining for an online magazine with three Speedlites, positioned top, left, and right of the dessert. Exposure: ISO 100, f/5.6, 1/15 second with an EF 16-35mm f/2.8 USM lens.

Obviously, bokeh can make the out-of-focus areas aesthetically pleasing or visually obtrusive, and the interpretation is almost entirely subjective. In general, you want the out-of-focus points of light to be circular in shape, and to blend or transition nicely with other areas in the background, and the illumination is best if the center is bright and the edges are darker and blurry.

The Rule of Thirds

One of the easiest ways to start on the path to better compositions is to move away from centering all of your subjects within the frame all the time. You've probably seen unremarkable horizontal photos where one person's face is dead center in the picture, leaving a lot of unused visual real estate on the top and sides. The face appears to float there in the picture. This can easily be solved by switching to a vertical composition and moving in, or left or right, and then composing the subject to bring in more of the background or to imply the subject's movement. I often do this with my travelling companions when I want to make a portrait of them along with some interesting location detail.

Perhaps the most well-known principle of photographic composition is the Rule of Thirds. This is a guideline commonly followed by other visual artists as well. The basic principle behind the Rule of Thirds is to imagine breaking your image down into thirds (both horizontally and vertically) so that you have nine sections or boxes with two vertical and two horizontal lines, each a third of the way across their dimension.

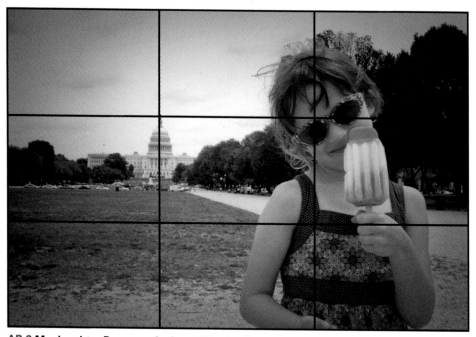

AB.8 My daughter Brenna enjoying a "Patriot Pop" on the National Mall in Washington, D.C. She and the Capitol building fall on the two vertical lines of the rule-of-thirds grid. Exposure: ISO 1600, f/19, 1/750 second with an EF 24-70mm f/2.8 USM lens.

The resulting lines and intersections are your "sweet spots." The objective is to keep the subjects and areas of interest (such as the horizon) out of the center of the image, by placing them on or near one of the lines or intersections that would divide the image into three equal columns and rows.

Two techniques that I've found to be helpful when utilizing the Rule of Thirds are worth noting here. The first one is to try to imply subject motion toward the center of the frame. This adds balance and a direction for the viewer's eye to follow. The opposite approach, centering the subject, may weigh the image down in that direction and give the photo an unbalanced feel.

The second technique applies when shooting landscapes with the sky as an element of the scene. If I have an incredible sky, I place the horizon on or near the lower horizontal line. If I have a bland sky but very good light, I move the horizon up to the higher horizontal line and search out some interesting element in the good light for my foreground.

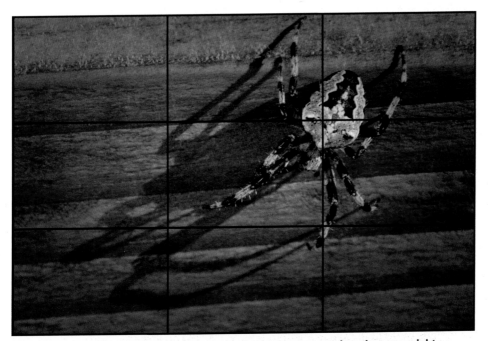

AB.9 Lit by the early morning sun, this garden spider is composed on the upper-right intersecting lines. Including the spider's cool shadow as part of the image balances the implied motion of the spider and keeps the viewer's attention within the frame. A hand-held 580EX II Speedlite connected to the Off-Camera Shoe Cord 3 filled in the shadowed side of the spider. Exposure: ISO 100, f/16, 1/60 second with an EF 16-35mm f/2.8 USM lens.

Field of View

Many times, better compositions can be achieved by merely moving the camera slightly up, down, left, or right. Distracting elements can be eliminated by taking a step or two to either side of the subject. By altering the position of the camera, the background can be changed so that the subject has fewer distractions to compete with. This could be achieved by getting closer, moving laterally, or moving the camera vertically.

Controlling the field of view can also mean getting closer to your subject either optically by changing lenses or physically by moving in. Getting closer to flowers and inanimate objects might be easy, but doing so with other people may make some subjects uncomfortable. This is when it's advisable to switch to a longer focal-length lens to tighten up the frame.

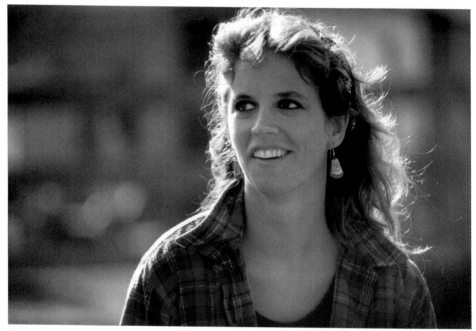

AB.10 This busy background was controlled by using a wide aperture when photographing this ranch hand. You barely notice the cowboys or motorcycle to her right. Backlighting also helps separate her from the background. Exposure: ISO 100, f/2.8, 1/60 second with an EF 70-200mm f/2.8L USM lens.

Also, try not to fall into the habit of shooting all of your images standing up, at your eye level. Children and other animate subjects look much more realistic when photographed from their eye level, not yours, capturing them in the environment from their point of view. Also, remember that anything closest to the camera appears larger and any elements farther away appear smaller. That's the reason why many family portraits are often composed with the children in front and the adults in the back.

In order to get more heroic shots of people, I like to frame them up with the camera about waist high, making them seem more towering and statuesque. By contrast, in tight situations where space is limited, such as a wedding cocktail hour, I hoist a camera with a wide-angle lens attached to a monopod and shoot down on the crowd, triggering the shutter with a cable release. Unique, interesting images are always the goal.

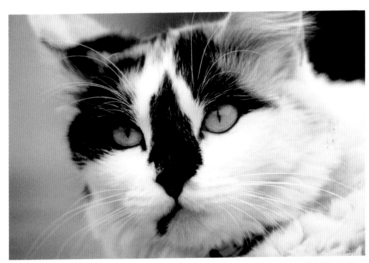

AB.11 Getting right down on the ground with a friend's old kitty for this tight portrait. Exposure: ISO 100, f/8, 1/160 second with an EF 70-200mm f/2.8L USM lens.

After getting the "safe" shots, go for the more interesting, offbeat camera angles. Don't be afraid to stand on a table or chairs (with permission, of course!) or get down and dirty on your belly to create a more interesting camera angle for your subject. Any personal embarrassment you may feel will easily dissipate in a few minutes, but that great shot will live forever.

Leading Lines and S-Curves

Leading lines create an illusion by means of linear perspective and can create a feeling of depth by merging at what is called the vanishing point. Oblique and angular lines convey a sense of dynamic balance and a sense of action. Lines can also direct attention toward the main subject of the photograph, or contribute to the photograph's organization by dividing it into compartments.

A straight, horizontal line, commonly found in landscape photography, gives the impression of calm, tranquility, and space. An image filled with strong vertical lines tends to give an impression of height, power, and grandeur. Tightly angled diagonal lines give a dynamic, lively, and active feeling to the image — a stylistic approach very common in contemporary wedding and portrait photography.

AB.12 Train tracks create an S-curve and seem to disappear into the vanishing point. Exposure: ISO 100, f/5.6, 1/60 second with an EF 50mm f/1.8 lens.

Curved lines or S-curves are generally used to create a sense of flow within a photograph. The eye generally scans these flowing lines with ease and enjoyment as it follows them throughout the image. Compared to straight lines, S-curves provide a greater dynamic influence in a photograph. When paired with soft-directional lighting, curved lines can give gradated shadows, which usually results in a very harmonious line structure within the image. Perspective is also important with S-curved lines; generally speaking, the higher the viewpoint, the more open the lines tend to be.

Symmetry

While I do advise you to let go of the urge to always center your subject in the frame and employ the Rule of Thirds when possible, there are those times when a centered composition does indeed work best. This occurs when I'm shooting a business portrait or I want to just capture a person's expression or some other element for the strongest effect. I look for balancing colors in the background or some architectural items that I can use to frame my subject. Balance is what you're striving for, and sometimes putting the subject directly in the middle creates the most powerful impact.

The "rule of odds" further suggests that an odd number of subjects in an image is more interesting than an even number. An even number of subjects produces symmetries in the image, which can appear unnatural and difficult to balance visually. When shooting engagement sessions or couples, I often compose the shot in a way that creates visual diagonals, balancing the shot by having one person slightly higher than the other or farther away.

Also, pay close attention to the edges of your frame. Avoid having bright colors or sharp focus directly on the edges of your picture. Areas such as these give the viewer's eye an easy way out of the photo and are the main reason many digital photographers today add slightly darker or lighter vignettes to their images to contain the edges of the frame.

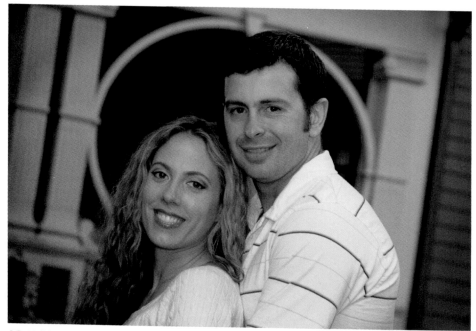

AB.13 I found this interesting structure for the background on a downtown walk during Tiffany and Jake's engagement session. Just a bit of on-camera flash from a 580EX II Speedlite perked up their skin tones and created catch lights in their eyes. Exposure: ISO 400, f/5.6, 1/60 second with an EF 70-200mm f/2.8L USM lens.

Finally, some of the best photography advice of all time came from baseball great Yogi Berra, who said, "You can observe a lot by just looking around."

Resources

At no other time has there been more information available on the Internet for both the creative and business aspects of photography. However, with the vast amount of knowledge found on the Web, it can sometimes be difficult to know where to begin or even where to look. You'll find contradictory information on every topic, from alchemy to Zen meditation, about "the right way" to do a certain thing. My approach is to look for experts on the topic, and once I find someone who makes sense to me, I take their advice and use it. If it works for me, then that becomes my method of working. Similarly, you should find what works best for you.

While this is not an exhaustive list, I offer a selection of my favorite resources to help you learn more about the Canon Speedlite System, photographic lighting, the business of photography, and photography in general.

Informational Web Sites and Blogs

As a digital photographer, you may seem to spend an inordinate amount of time on your computer these days. Make that time more productive by checking out these Web sites and blogs, as they are updated frequently. Or better yet, create RSS feeds for each of these sites for your feed reader or e-mail client, and have updated content delivered right to your computer on a daily basis.

Canon Digital Learning Center (www.usa.canon.com/dlc/). The Canon Digital Learning Center and Explorers of Light program group is a broad-ranging initiative for photographic education and inspiration. Today, the group is comprised of 60 of the most influential photographers in the world, each a master of his or her own creative specialty. Find tips, tutorials, and techniques on exposure, workflow, getting the best color, and more.

Canon Rumors (www.canonrumors.com/). Do you want to stay up to date on the latest rumors revolving around all things Canon? Then check this Web site (which is totally unaffiliated with Canon, Inc.) for all the latest gossip. Where there's smoke, there's fire, so be in the know and be the first to know.

Digital ProTalk (http://digitalprotalk.blogspot.com). This is an informational blog by David Ziser, a professional photographer from the metropolitan Cincinnati area. He concentrates mostly on weddings and family portraits but also does stunning landscape photography. A Canon shooter, David offers useful technical tips, lighting examples, and background stories on some of his finest images.

PixSylated.com (http://pixsylated.com). Created by California commercial shooter Syl Arena, PixSylated is a high-octane Web site devoted to the trends, tools, and techniques that are shaping the world of digital photography today, especially high-speed sync, gang lighting (using many Speedlites together), and color management. Particularly insightful are his weekly "Lessons I Didn't Learn In Photo School" (LIDLIPS), and his Canon Speedlite Wish List for the next generation of Speedlites.

Strobist (www.strobist.blogspot.com). David Hobby, staff photojournalist with *The Baltimore Sun*, has created a groundswell movement of small flash devotees, the Strobist Nation, with his highly informative blog on small flash use. This site has a lot of tips and tutorials on how to effectively use shoe-mounted flashguns on and off camera. It's loaded with lighting ideas and do-it-yourself projects for making light modifiers for your small flash. Start with the Lighting 101 section and continue from there. It can be habit-forming: be prepared to stay up for some very late nights!

Photo Business News and Forum (http://photobusinessforum.blogspot.com/). For those in the business of photography or considering entering the field, this Web site contains essential information about current, relevant business issues facing photographers today. Maintained by Washington, D.C., photographer John Harrington, Photo Business News and Forum explores the best business practices, rights management, and general and advanced business tips and techniques. Lively comment sections usually follow his insightful posts.

Photo.net (http://photo.net). The Photo.net site is an enormous Web site containing equipment reviews, forums, tutorials, galleries, sharing spaces, communities, learning centers, and more. If you are looking for specific photography-related information or are new to photography, this is a great place to start.

Workshops

Workshops and seminars are great ways to submerge yourself in the learning process with like-minded individuals. Both the benefits and huge amounts of photographic information that are shared cannot be overstated. In addition to the workshops listed

here, the previously mentioned photographers, David Hobby, Syl Arena, and David Ziser, all conduct photographic workshops at various times and locations around the country. Check their respective Web sites for schedules.

Ansel Adams Gallery (www.anseladams.com). This is an online Web site and gallery of renowned American photographic giant, Ansel Adams, representing his famous work and that of selected landscape photographers. You can find scheduling of half-, full-, and multi-day workshops, along with an online store where you can purchase posters, reproductions, books, calendars, cards, and more.

Brooks Weekend Workshops (http://workshops.brooks.edu). Conducted at the Institute's fully equipped facilities in Santa Barbara, California, and led by top professionals in their field, Brooks offers rigorous, succinct educational opportunities to amateur and professional photographers, as well as educators. They also provide a valuable forum for the exchange of photographic knowledge and ideas.

Maine Media Workshops (www.theworkshops.com). Known for decades as the Maine Photographic Workshops, these programs offer a unique opportunity to come together in a beautiful, remote environment and join a community of other passionate image makers and storytellers — all gathering together to become better artists. Along with photography, classes include filmmaking, multimedia, design, and book arts instruction.

Mountain Workshops (www.mountainworkshops.org). The Mountain Workshops offer an intense, five-day experience that both sharpens your skills and expands your knowledge of documentary photojournalism, multimedia, and picture editing and design. The workshops are a place where technology, technique, and the love of a good story can combine for a career-changing experience.

Palm Beach Photographic Centre (www.workshop.org/). The Palm Beach Photographic Centre is a non-profit organization, founded in 1985, that offers exciting programs for all skill levels and a variety of interests.

Santa Fe Photographic Workshops (www.santafeworkshops.com). Santa Fe Photographic Workshops are an inspirational resource for all photographers, from enthusiasts to professionals. Offering over 150 educational programs a year, the workshops can help you to learn from today's most influential instructors to inspire your creativity and expand your technical skills.

Online Photography Magazines

Many photography magazines also have Web sites dedicated to photography articles and other information not found in the pages of their magazine. When I was just starting out, I could not wait for my new issues of some of the magazines to arrive in my mailbox and would scour them for hours, picking up tips and techniques to use in my beginning photo business. Now, the latest information is just a mouse-click away and these are some of the best. Again, creating RSS feeds of the sites that offer this feature speeds delivery of the latest content to your e-mail inbox.

Digital Photographer (http://digiphotomag.com). This is a great online resource offering articles, hardware and camera reviews, features, tutorials, photo essays, reader photos, tips, and more.

Digital Photo Pro (www.digitalphotopro.com). This is a one-stop Web site for the latest gear reviews, profiles of the best in the business, techniques, software, business news, and contests.

Nature Photographers (www.naturephotographers.net). This is an online resource for nature photographers of all skill levels, with a focus on the art and technique of nature photography, as well as the use of photography for habitat conservation and environmental photojournalism.

National Geographic (www.nationalgeographic.com). Over 120 years old, "Big Yellow" is still going strong and supports critical expeditions and scientific fieldwork. They encourage geography education for all, promote natural and cultural conservation, and inspire audiences through new media, vibrant exhibitions, and live events.

Outdoor Photographer (www.outdoorphotographer.com). This site provides a host of how-to articles, gear reviews, contests, a forum community, and monthly columns by the best nature photographers working today.

Photo District News (www.pdnonline.com). The online business journal of the photo industry, and originally based in New York City, Photo District News offers insights into running your photography business in a profitable manner. The site offers news, features, gear reviews, contests, resources, an online community, multimedia instructional and entertaining videos, and more.

Shutterbug (www.shutterbug.net). Much like the popular magazine, which comes packed with information and equipment reviews and news each month, the Web site offers a huge array of information about digital imaging, techniques, forums, galleries, links, and more.

How to Use the Gray Card and Color Checker

Have you ever wondered how some photographers are able to consistently produce photos with such accurate color and exposure? It's often because they use gray cards and color checkers. Knowing how to use these tools helps you take some of the guesswork out of capturing photos with great color and correct exposures every time.

The Gray Card

Because the color of light changes depending on the light source, what you might decide is neutral in your photograph, isn't neutral at all. This is where a gray card comes in very handy. A gray card is designed to reflect the color spectrum neutrally in all sorts of lighting conditions, providing a standard from which to measure for later color corrections or to set a custom white balance.

By taking a test shot that includes the gray card, you guarantee that you have a neutral item to adjust colors against later if you need to. Make sure that the card is placed in the same light that the subject is for the first photo, and then remove the gray card and continue shooting.

 When taking a photo of a gray card, de-focus your lens a little; this ensures that you capture a more even color.

Because many software programs enable you to address color correction issues by choosing something that should be white or neutral in an image, having the gray card in the first of a series of photos allows you to select the gray card as the neutral point. Your software resets red, green, and blue to be the same value, creating a neutral midtone. Depending on the capabilities of your software, you might be able to save the adjustment you've made and apply it to all other photos shot in the same series.

If you'd prefer to make adjustments on the spot, for example, and if the lighting conditions will remain mostly consistent while you shoot a large number of images, it is

advisable to use the gray card to set a custom white balance in your camera. You can do this by taking a photo of the gray card, filling as much of the frame as possible. Then, use that photo to set the custom white balance.

The Color Checker

A color checker contains 24 swatches that represent colors found in everyday scenes, including skin tones, sky, foliage, etc. It also contains red, green, blue, cyan, magenta, and yellow, which are used in all printing devices. Finally, and perhaps most importantly, it has six shades of gray.

Using a color checker is a very similar process to using a gray card. You place it in the scene so that it is illuminated in the same way as the subject. Photograph the scene once with the reference in place, then remove it and continue shooting. You should create a reference photo each time you shoot in a new lighting environment.

Later on in software, open the image containing the color checker. Measure the values of the gray, black, and white swatches. The red, green, and blue values in the gray swatch should each measure around 128, in the black swatch around 10, and in the white swatch around 245. If your camera's white balance was set correctly for the scene, your measurements should fall into the range (and deviate by no more than 7 either way) and you can rest easy knowing your colors are true.

If your readings are more than 7 points out of range either way, use software to correct it. But now you also have black and white reference points to help. Use the levels adjustment tool to bring the known values back to where they should be measuring (gray around 128, black around 10, and white around 245).

If your camera offers any kind of custom styles, you can also use the color checker to set or adjust any of the custom styles by taking a sample photo and evaluating it using the on-screen histogram, preferably the RGB histogram if your camera offers one. You can then choose that custom style for your shoot, perhaps even adjusting that custom style to better match your expectations for color.

Glossary

AE (Automatic Exposure) A general-purpose shooting mode where the camera automatically sets the aperture and shutter speed using its metered reading. On some cameras, the ISO settings are also automatically set.

AE/AF Lock A camera setting that allows you to lock the current exposure and/or autofocus setting prior to taking a photo. This button lets you recompose the scene without holding the Shutter button halfway down.

AF-assist illuminator Useful in low-light and low-contrast shooting situations, a feature that automatically projects a red grid onto your subject to aid the camera's autofocusing system. The AF (auto-focus) assist illuminator is located on the bottom front of the flash. The AF-assist beam is compatible with most recent Canon cameras, helping the camera to focus properly in poor light.

ambient light The natural or artificial light within a scene. This is also called available light.

aperture Also referred to as the diaphragm or f-stop setting of the lens. The aperture controls the amount of light that is allowed to enter through the camera lens. The higher the f-stop number setting, the smaller the aperture opening on the lens. Larger f-stop settings are selected by lower numbers, such as f/2 or f/1.2. The larger the aperture, the less depth of field the image will possess. A smaller aperture means that the image will have more depth of field, and that more of the background will be in focus.

Aperture-priority (Av) A camera setting where you choose the aperture, and the camera automatically adjusts the shutter speed according to the camera's metered readings. Aperture-priority is often used by photographers to control depth of field.

backlighting Light that is positioned behind and pointing to the back of the subject, creating a soft rim of light that visually separates the subject from the background.

bokeh The shape and illumination characteristics of the out-of-focus areas in an image, depending on the focal length, optical design, and aperture blade pattern of the lens.

bounce flash A technique of pointing the flash head in an upward position or toward a wall, thus softening the light falling on the subject. Bouncing the light often eliminates shadows and provides a much smoother light for portraits.

bracketing To make multiple exposures, some above and some below the average exposure calculated by the light meter for the scene, either by flash output or exposure settings. Some digital cameras can also bracket white balance to produce variations from the average white balance calculated by the camera.

bulb A shutter speed setting that keeps the shutter open as long as the Shutter button or cable release is fully depressed.

cable release An accessory that connects to a port on the camera and allows you to click the shutter by using the cable release instead of pressing the Shutter button, to reduce camera/shutter vibrations over slow or timed exposures.

Canon EOS Speedlite System Also referred to as simply "Speedlite System," a lighting system that allows for multiple flash capabilities in a wireless environment, taking advantage of communication of exposure information between the camera, master flash unit, and remote Speedlites. Presently, the Canon lighting system includes the

580EX II, 430EX II, 270EX, 220EX, ST-E2 wireless transmitter, MT-24EX Macro Twin Lite, and MR-14EX Macro Ring Lite.

catchlight panel A panel located on the top front of the 580EX II Speedlite. Using the catchlight panel while pointing the flash head straight up provides the light needed to create sparkle in a portrait subject's eyes, called a catchlight, and a small amount of fill flash.

channel Also referred to as communication channel. To avoid interfering with other wireless flash users in the same location, the master and slave units can communicate on one of four channels. Communications in the Speedlite System are partially based on setting the master and all additional Speedlites to the same channel. If by chance another photographer is using the same channel as you are, your Speedlite System units may fire from the other photographer's controls. To avoid this, you can set the master and your other Speedlites to a different channel.

chimping Reviewing images on the LCD right after you've taken them. This is derived from photographers making the "ooooh-ooooh" chimp sound when reviewing impressive images.

color balance The color reproduction fidelity of a digital camera's image sensor and of the lens. In a digital camera, color balance is achieved by setting the white balance to match the scene's primary light source. You can adjust color balance in image-editing programs using the color Temperature and Tint controls.

color temperature A numerical description of the color of light measured on a Kelvin scale. Warm, early, and late-day light have a lower color temperature. Cool, shady light has a higher temperature. Midday light is often considered to be neutral light (5500 K) and flash units are often calibrated to 5500–6000 K.

colored gel A color gel or color filter, or a lighting gel (or simply gel), is a transparent, colored material that is used in theater, event production, photography, videography, and cinematography to color light and for color correction. Modern gels are thin sheets of polycarbonate or polyester, placed in front of a light source. Gels are often used to change the color of a black background when shooting portraits or still-life photos. The name *gel* stems from the early form of filters used in theaters, which were typically made from gelatin.

daylight balance A general term used to describe the color of light at approximately 5500 K, such as midday sunlight or an electronic flash.

dedicated flash A flash unit designed to work with one particular camera system, and which can operate in conjunction with the camera's internal metering. Dedicated flash units exchange information with the camera via a proprietary digital data line. These lines require small data pins on the flash hot shoe to communicate.

depth of field The distance in front of and behind the subject that appears in acceptably sharp focus.

E-TTL mode Evaluative Through-the-Lens metering is a Canon EOS flash exposure system that uses a brief pre-flash before the main flash in order to obtain a more correct exposure. Like TTL, the sensor is internal to the camera and takes its exposure reading via the lens so any filters added to the lens will also affect the E-TTL readings giving more accurate exposure information to the camera.

E-TTL II mode The newest and most advanced evaluative metering system for Speedlites from Canon. The E-TTL II metering system uses a preflash to help determine proper flash exposure.

exposure compensation A setting that allows you to adjust the exposure, in 1/2 or 1/3 stops from the metered reading of the camera, to achieve correct exposure under mixed or difficult lighting conditions.

Flash Exposure (FE) Lock A feature that allows you to obtain the correct flash exposure and then lock that setting in by pressing the FE Lock button. You can then recompose the shot, with the main subject either on the right or the left, and take the picture with the camera retaining the proper flash exposure for the subject.

f-stop A number that expresses the diameter of the entrance pupil in terms of the focal length of a lens; the f-stop number is also the focal length divided by the "effective" aperture diameter. A larger f-number denotes a smaller aperture opening, while a smaller f-number means a larger aperture opening. See also *aperture*.

fill flash/fill-in flash A lighting technique where the Speedlite provides enough light to illuminate the subject in order to eliminate, reduce, or open up shadowed areas typically outdoors on sunny days, though the technique is useful any time the background is significantly brighter than the subject of the photograph. Using a flash for outdoor portraits often brightens up the subject in conditions where the camera meters light from a broader scene.

first-curtain sync The default setting that causes the flash to fire at the beginning of the exposure when the shutter is completely open. See also *second-curtain sync*.

flash color information communication Color temperature information is automatically transmitted to the camera, providing the camera with the correct white balance setting, and giving you accurate color in your image when you shoot photos with a Speedlite.

Flash Exposure Bracketing (FEB) This is a similar concept to Auto-Exposure Bracketing (AEB), only instead of changing ambient exposure settings you shoot a series of three photographs with normal, positive flash compensation and negative flash compensation. You can apply the bracketing value in half, third, or full stop values. FEB auto-cancels once you've taken the three photograph sequence and uses whatever drive mode your camera is set to. FEB can be used in conjunction with both Flash Exposure Lock (FEL) and Flash Exposure Compensation (FEC).

Flash Exposure Compensation (FEC) Adjusting the flash output by +/–3 stops in 1/3-stop increments. If images are too dark (underexposed), you can use FEC to increase the flash output. If images are too bright (overexposed), you can use FEC to reduce the flash output.

flash head The part of the Speedlite that houses the flash tube that fires when taking a flash photo. Flash heads can be adjusted for position. See also *flash head tilting*.

flash head tilting Adjusting the flash head horizontally or vertically by pressing the tilting/rotating lock release button and repositioning the flash head. This is often used to point the flash in an upward position, such as when using bounce flash. You tilt the flash head up toward the ceiling when using the catch light panel on the 580EX II.

flash mode The method the flash uses to determine flash exposure. On most EX-series Speedlites, flash modes include E-TTL, Multi-stroboscopic mode, and Manual mode.

flash shooting distance and range The actual range in which the Speedlite has the ability to properly illuminate a subject. The range, typically between 2 and 60 feet, is dependent on the ISO sensitivity, aperture setting, and zoom head position.

flash sync mode A mode which, set in conjunction with camera settings, allows you to take flash photos in either first-curtain or second-curtain sync. For most flash photos, the default is first-curtain sync. When using first-curtain sync, the flash fires right after the shutter opens completely. In second-curtain sync, the flash fires just before the shutter begins to close. Using second-curtain sync in low-light situations avoids unnatural-looking photos due to subject or camera movement. See also *first-curtain sync* and *second-curtain sync*.

front light Light that comes from behind or directly beside the camera to strike the very front of the subject.

gray card A card that reflects a known percentage of the light that falls on it. Typical grayscale cards reflect 18 percent of the light. Gray cards are standard for taking accurate exposure-meter readings and for providing a consistent target for color balancing during the color correction process using an image-editing program.

group A collection of Speedlites, where each flash shares the same output setting controlled by the master flash unit.

guide number (GN) A number that indicates the amount of light emitted from the flash (at full power). Each model Speedlite has its own guide number, indicating the Speedlite's flash capability based on its maximum capability. The guide number is calculated based on an ISO setting, flash zoom head position, and the distance to the subject.

highlight A light or bright area in a scene, or the lightest area in a scene.

high-speed sync This feature allows you to shoot with flash up to the maximum shutter speed of the camera. With high-speed sync, the camera actually changes the way the flash fires. Rather than a single, strong burst, it tells the flash to send out an ultra-fast series of low-power, flash pulses. Because the flash pulses are so short, the light appears to be continuous. When the high-speed sync mode is not engaged, the camera with a hot shoe mounted Speedlite does not allow you to set the shutter speed to faster than the camera's rated sync speed. High-end flashes such as the 580EX II and the 430EX II have this feature. See also *sync speed*.

hot shoe A camera mount that accommodates a separate external flash unit. It is called a hot shoe because it also provides an electronic connection between the flash and the camera. Inside the mount are contacts that transmit information between the camera and the flash unit, and that trigger the flash when the Shutter button is pressed.

ISO sensitivity The ISO (International Organization for Standardization) setting on a camera indicates the camera's light sensitivity. In digital cameras, lower ISO settings provide better-quality images with less image noise; however, the lower the ISO setting, the more exposure is needed.

Kelvin Different than Farenheit and Celcius degree scales, the Kelvin scale for measuring color temperature is based on absolute zero. The scale is used in photography to quantify the color temperature of light.

leading line An element in a composition that leads the viewer's eye toward the subject or deeper into the scene. See also *S-curve*.

lighting ratio A ratio used to describe the difference in brightness between two light sources. A 1:1 ratio means both light sources are equal. A 1:2 ratio denotes that the second light is half as bright as the first, a 1:4 ratio describes the second light as being one-fourth as bright as the first, and so on.

manual exposure A mode in which the photographer adjusts the lens aperture and/or shutter speed to achieve the desired exposure. Many photographers need to control aperture and shutter independently because opening up the aperture increases exposure but also decreases the depth of field, and a slower shutter increases exposure but also increases the opportunity for motion blur.

master The flash unit that is mounted on the camera when using multiple Speedlites in a wireless flash configuration. The master flash unit controls the flash output of all remote units. The built-in Speedlites of some camera models can also act as a master flash. The master flash unit is also sometimes called a commander. See also *remote* and *slave*.

metering Measuring the amount of light utilizing the camera's internal light meter. For most flash uses, Speedlites emit a preflash for the camera's light meter in order to achieve a properly exposed photo.

midtone An area of medium brightness; a medium-gray tone in a digital image or photographic print. Midtones are usually found halfway between the darkest shadows and the brightest highlights.

mirror lock-up A camera function that allows the mirror, which reflects the image to the viewfinder, to flip up without the shutter being released. This is done in order to reduce vibration from the mirror moving on slow or timed exposures or to allow manual sensor cleaning.

modeling light A secondary light, usually tungsten or halogen, built into a studio strobe in order to visualize what the flash output will look like. The Canon EX series Speedlites have a modeling "flash" that fires a short burst of rapid flashes that allow you to see the effect of the flash on the subject.

multiple flash setup A configuration that uses multiple Speedlites, wired or wirelessly, to illuminate a subject and/or scene. This allows the photographer to create natural-looking photographs by creatively placing multiple flashes in different positions (and/or flash output) to achieve the desired lighting results.

noise Extraneous visible artifacts that degrade digital image quality or that are creatively added in post-production for effect. In digital images, noise appears as multicolored flecks, also referred to as grain. Noise is most visible in high-speed digital images captured at high ISO settings.

Programmed auto (P) A program mode where the shutter speed is automatically set to the camera's sync shutter speed when using a Speedlite. On the camera, the shutter speed and aperture are automatically set when the subject is focused.

quick flash A state the Speedlite enters into before recycling to full power as indicated on the flash by a green ready light. Quick flash fires the unit at 1/6 to 1/2 power but enables it to fire faster. For full flash, wait till the pilot lamp turns red. The Quick Flash only will fire in Single drive mode, not in Burst mode.

red-eye reduction A function of certain EOS cameras that is used to prevent the subject's eyes from appearing red. The camera emits a bright light before the shutter is opened that shrinks the pupils. As a general rule, the farther the flash head is located from the axis of the camera lens, the less chance you have of experiencing the red-eye effect. You can combine red-eye reduction with slow-sync in low-light situations.

remote A radio device that triggers cameras or off-camera flashes to fire. See also *master* and *slave*.

scene modes Available on some cameras, automatic modes in which the settings are adjusted to pre-determined parameters, such as a wide aperture for the portrait scene mode and high shutter speed for the sports scene mode.

second-curtain sync A camera/flash setting that allows the flash to fire at the end of the exposure, right before the second or rear curtain of the shutter closes. With slow shutter speeds and flash, this feature creates a blur behind a moving subject, visually implying forward movement. See also *first-curtain sync*.

Shutter-priority (Tv) A camera setting where you choose the shutter speed and the camera automatically adjusts the aperture according to the camera's metered readings. Action photographers often use Shutter-priority to control motion blur.

shutter speed The length of time the shutter is open to allow light to fall onto the imaging sensor. The shutter speed is measured in seconds, or more commonly, fractions of seconds.

side lighting Light that strikes the subject from the side, often utilized to show the texture of the subject.

silhouette A view of an object or scene consisting of the outline and a featureless interior, with the silhouetted object usually being black. The term has been extended to describe an image of a person, object, or scene that is backlit, and appears dark against a lighter background.

slave A Speedlite used in a multiple flash configuration that is not attached to the camera; also a remote triggering device. The Speedlite attached to the camera is called the master, while all the other Speedlites are referred to as remotes, or slaves. See also *master* and *remote*.

stroboscopic flash A flash mode on the 580EX II that fires multiple flashes with which to capture multiple images of a moving subject in a single photographic frame. A dark background helps greatly for successful multi-stroboscopic images.

sync speed The fastest shutter speed that you can set the camera to and have the flash expose for the whole exposure duration. Canon cameras will prevent you from setting a faster shutter speed when a Speedlite is attached to the camera and turned on. See also *high-speed sync*.

TTL (Through-the-Lens) A flash metering system that reads the light passing through the lens that will expose film or strike an image sensor.

tonal range The range from the lightest to the darkest tones in an image.

tungsten lighting Common household lighting that uses tungsten filaments. Without filtering or adjusting to the correct white-balance settings, pictures taken under tungsten light display a yellow-orange color cast.

vignetting The darkening of edges on an image that can be caused by lens distortion, using a filter, or using the wrong lens hood. This is also used creatively in image editing to draw the viewer's eye toward the center of the image.

white balance A setting that you use to compensate for the differences in color temperature common in different light sources. For example, a typical tungsten light bulb is very yellow-orange, so when adjusted properly, the camera's white balance setting adds blue to the image to ensure that the light looks like standard white light.

wireless remote A controller that communicates with its respective devices via infrared (IR) signals (and in some cases, via radio signals) and that can be used to trigger cameras or flashes. See also *master* and *slave*.

zoom head Also referred to as the Speedlite's flash head, the mechanism that can automatically move the flash tube forward or backward during automatic flash operations to match the focal length of the lens being used.

Index